ART AND SOCIETY

ART
AND SOCIETY

HERBERT
READ

SCHOCKEN BOOKS • NEW YORK

First published in U.S.A.
by Pantheon Books Inc.

First SCHOCKEN edition 1966

Third Printing, 1974

Copyright © 1966 by Herbert Read
Library of Congress Catalog Card No. 66-26728
Manufactured in the United States of America

PREFACE
to the 1966 edition

This book was first published in 1936 and was a contribution to the problems then being earnestly discussed in the wake of the Russian Revolution. The rise of fascism (a doctrine also much concerned with the place of the artist in society), a second world war, the *engagement* of artists in the European Resistance—all these subsequent events have given a new urgency to what, in my Introduction to the first edition, I announced as the main theme: 'the nature of the relations which subsist between society and the individuals who are responsible for the creation of works of art'.

It should be noted that I used an undogmatic tense—the relations which subsist between society and its artists, not the relations which *should* subsist. In this matter, as in all questions of social organization, I was and remain stubbornly permissive. I do not believe that artists can be disciplined without disastrous effects on their creative energy; I do not believe that the arts can be 'organized' by state departments and I look sceptically on all our efforts to promote art by state patronage (though this scepticism has not prevented me from trying to guide such patronage into the least harmful channels). Art, again to repeat one of my earlier asseverations, is 'an autonomous activity, influenced like all our activities by the material conditions of existence, but as a mode of knowledge at once its own reality and its own end. It has necessary relations with politics, with religion, and with all other modes of reacting to our human destiny. But as a mode of reaction it is distinct and contributes in a vital sense to the process of integration that we call a civilization or a culture'.

Nothing that has happened in the past thirty years has compelled me to change this point of view—neither my observations in such countries as Russia, China, or Jugoslavia, nor

PREFACE

the reading of a considerable number of books on the subject
published subsequently to my own. I would, however, empha-
size once more my awareness of the introductory nature of my
own first approach to the subject. I myself have since enlarged
on it in books such as *Icon And Idea* (1955) and *The Origins
of Form in Art* (1965). In all my writings on art I have always
been conscious of the social significance of this human activity.
I did not quote Herder in the present work, but I can claim,
in the words devoted to this first sociologist of art in a recent
essay by Sir Isaiah Berlin, that my life, like his, has been
devoted to the idea that 'all men are in some degree artists, and
that all artists are, first and last, men, fathers, sons, friends, citi-
zens, fellow worshippers, men united by common action,' and
that as a consequence, 'the purpose of art is not to exist for its
own sake ... or to be utilitarian, or propagandist, or "socialist
realist"; still less, of course, should it embellish life or invent
forms of pleasure or produce artifacts for the market. The artist
is a sacred vessel through which blows the spirit of his time and
place and society; he is the man who conveys, as far as possible,
a total human experience, a world'.[1]

I could not summarize in more appropriate words my own
philosophy of art, though I must not claim to have been always
consistent in the presentation of such a philosophy. To live
with artists, to be oneself an artist, to speak constantly for
artists—all this has been a complex and often hasty activity, in
which I may from time to time have failed to maintain the clear
outlines of such a philosophy. Others may care to give this
philosophy a label, but my own instinct is to leave it imprecise:
art is everything that gives enduring form to man's apprehen-
sion of the vital forces within us, and I know of no philosoph-
ical category, save humanism itself, that embraces its totality.

In my peroration of thirty years ago (page 135) I expressed
an optimistic view of the future of art that now seems very
naïve. I try, like Panglos, to remain an optimist, but the course

[1]*Encounter,* Vol. XXV, No. 2 (August, 1965), p. 46.

PREFACE

of recent developments in Western civilization justifies a cynicism as disillusioned as Voltaire's. Everywhere the masses turn, not to 'the conditions of great art', but to what is insidiously destructive of all art, namely, entertainment. To inveigh against what might be defended as 'the simple pleasures of the poor' is far from my intention. The reality is a powerful and ruthless entertainment industry that knows only too well how to exploit the alienation and boredom of the masses. The cinema, broadcasting, popsingers and jazz—these are the more obvious forms of amusement and distraction. To question the cultural value of such entertainment is to invite charges of puritanism, snobbery, or intolerance, all of which are far from my state of mind. All that is necessary is to make a distinction between art and entertainment and then in all our cultural activities to maintain that distinction. The very people who should be concerned with this distinction—our educational authorities, our potential ministries of culture—are the ones who succeed in blurring it. As I have argued in the sixth chapter of this book, the problem is essentially one of education. That fact is now widely recognized. The small Society for Education through Art, which was founded about the time this book was first published, has since become an International Society for Education through Art, with many branches throughout the world and thousands of active members. Slowly a lever is being raised against the deadweight of indifference and misunderstanding, but the weight seems to increase as quickly as the forces gather behind the lever. Archimedes who gave us this metaphor was also an optimist, but in our circumstances it is difficult not to give way to a feeling of despair. We are sustained only by the belief that life itself, which has survived so many cataclysms, is now and ever has been intimately linked to the sense of beauty.

July, 1966 H.R.

PREFACE
to the second edition

This new edition of my book embodies a complete revision of the text, and the addition of an essay on Hogarth which was originally contributed to a symposium entitled *From Anne to Victoria*, edited by Professor Bonamy Dobrée (London: Cassell & Co., 1937). The illustrations have also been reviewed and rearranged, and I wish to express my gratitude to the owners of the various works of art for their kindness in giving me permission to reproduce them, and in some cases for supplying me with the necessary photographs.

The substance of the book was originally delivered as lectures during my tenure of the Sydney Jones Lectureship in Art at the University of Liverpool, 1935-6.

May, 1945 H. R.

CONTENTS

CONTENTS

values. Plato's theory of art and education. The happy medium. Producer and consumer. Educating the instincts. The process of education.

The process of integration. An age of transition. Expressionism. Superrealism. An art of pure form. Functional art. Socialist realism. The price of revival.

ILLUSTRATIONS

bottom they illustrate the evolution of ornament from naturalism (a lizard) to abstraction. (*British Museum.*)

11. Circular gold plaque with geometricized figure. Mexican. (*British Museum.*)
12. Bushman rock-paintings at Cala, Tembuland, South Africa. (*Photograph by A. M. Duggan-Cronin. Copyright of the McGregor Museum, Kimberley.*)
13. Detail of plate 12.
14. Bushman rock-painting from South Africa. (*British Museum.*)
15. Hunting scene. Assyrian 7th century B.C. (*British Museum.*)
16. Stone *churinga* (sacred stone slab) from Central Australia. (*British Museum.*)
17. Engraved patterns on rocks at Klipfontein, Griqualand West, South Africa. (*Photograph by A. M. Duggan-Cronin. Copyright of the McGregor Museum, Kimberley.*)
18. Carved wooden mask from the West Ivory Coast, Africa. (*Charles Ratton Collection, Paris. Photograph by Museum of Modern Art, New York.*)
19. Reindeer engraved on rock. From Limeuil, France. Old Stone Age. (*Saint-Germain Museum. Photograph by G. Baldwin Brown.*)
20. Gemsboks and kudu engraved on rock. From Klipfontein. For comparison with the palaeolithic engraving illustrated on plate 19. (*Photograph by A. M. Duggan-Cronin. Copyright of the McGregor Museum, Kimberley.*)

between pages 32 and 33

21. Tiger; silver plaque. Chinese (Han dynasty, 206 B.C.–A.C. 220). (*British Museum: Eumorfopoulos Collection.*)
22. Painting of a dog. Spanish; 17th century. This and the previous plate illustrate the extremes of geometricized and naturalistic art, between which come the stylized types illustrated in plates 3 and 4.
23. Head of a Buddha. Red Sandstone. From the Mathura district, United Provinces. Kushan dynasty; 2nd century A.D. (*Victoria and Albert Museum.*)
24. Mask of a Bodhisattva; carved wood, lacquered. Japanese. Fugiwara period, 986–1159. Plates 23 and 24 illustrate the diffusion of a single religious type over a wide geographical

area and during a millennium of years. (*Victoria and Albert Museum.*)

25. A celestial flute-player, carved in yellow sandstone. From a Jain temple on the Satrunjaya Hill, near Palitana, Bombay Presidency. Solanki (Chalukya dynasty); 11th century. (*Victoria and Albert Museum.*)

26. Silk tissue. Spanish; 15th century. Perhaps executed by a Moorish craftsman; an example of the geometric ornament developed under Islamic influence. (*Victoria and Albert Museum.*)

27. Earthenware jug decorated with Kufic characters. Persian; 13th century. Another example of the use of non-naturalistic motives in Islamic art. (*Victoria and Albert Museum.*)

28. The so-called Westmacott Athlete, possibly a copy of Polykleitos's Kyniskos, 'the boy boxer from Mantineia'. About 450–40 B.C. (*British Museum.*)

29. Study for a Scourging of Christ, by Rembrandt. About 1646. (*Wallraf-Richartz Museum, Cologne.*)

30. Iconoclasts breaking the images. Psalter painted in the popular style at Constantinople. Dated 1066. (*British Museum. Add. MS. 19352.*)

31. Christ in Glory. From the Eadwine Psalter, executed at Canterbury in the 12th century. Illustrating the diffusion of a popular style under cover of the monastic system. (*Trinity College, Cambridge.*)

32. Miraculous Icon of Our Lady of Tikhvin, revealed in 1383. Novgorod copy of a Graeco-Italian icon. Tikhvin Monastery. (*From N. P. Kondakov: 'The Russian Icon,' Vol. II (Prague, 1929), plate 12.*)

33. Virgin and Child, by Master Michiel, Netherlandish. About 1520. (*Berlin, Kaiser Friedrich Museum.*)

between pages 48 and 49

34. Stone relief, part of a cross shaft. From Easby Abbey, Yorkshire. 8th century. (*Victoria and Albert Museum.*)

35. Back of a bronze mirror, found at Desborough, Northants. Early Iron Age (late Celtic); 1st century B.C. (*British Museum.*)

ILLUSTRATIONS

51. Figure of a workman from Wells Cathedral. About 1220.
52. 'L'inspiration du poète,' by Poussin. 1636–8. (*Musée du Louvre, Paris.*)
53. Corps de St. Adraien, by Frans Hals. 1664. (*Frans Hals Museum, Haarlem.*)
54. 'The Night Watch,' by Rembrandt. 1642. (*Rijksmuseum, Amsterdam.*)
55. 'Calais Gate,' by Hogarth. 1748. (*National Gallery, London.*)
56. 'The Shrimp Girl,' by Hogarth. (*National Gallery, London.*)
57. 'Le 28 juillet—Liberté guidant le peuple,' by Delacroix. 1830. (*Musée du Louvre, Paris.*)

between pages 128 *and* 129

58. 'The Third-class Waiting-room.' Drawing by Daumier. (1808–1879.) (*Victoria and Albert Museum.*)
59. 'The temptation of St. Anthony,' by Jerome Bosch. 1450–1516 (*Lisbon Museum.*)
60. 'An Old Jew,' by Marc Chagall.
61. Self-portrait, by Otto Dix.
62. 'Quand l'heure sonnera . . .', by René Magritte. 1933. (*Collection E. L. T. Mesens.*)
63. Relief, by Ben Nicholson. 1935.
64. House at Coombe, Surrey. Architect: Maxwell Fry.
65. Porters. Ancient Egyptian wood carving.
66. 'The Defence of Petrograd,' by Alexander Deineka. 1927. (*Tretyakov State Gallery.*)

INTRODUCTION

No kind of human activity is so permanent as the plastic arts, and nothing that survives from the past is so valuable as a clue to the history of civilization. For many thousands of years our knowledge of the customs and beliefs of mankind is derived from surviving works of art, and it is only comparatively recently in the history of the world that the written record comes to our aid. Yet though these remnants of feeling and expression have been much studied for the sake of the information they give us, the actual nature of the activity which we call æsthetic, and which gives rise to such objects, remains a psychological problem. Still less attention has been given to the social genesis of art, and to the nature of the relations which subsist between society and the individuals who are responsible for the creation of works of art. It is to this latter problem that I intend to devote this book.

The subject in all its ramifications could only be adequately treated in a work of encyclopædic scope. It would be necessary to review the whole history of art, and to show phase by phase how each style and mannerism arose out of the climatic and economic conditions of the time and place, and how art as one expression of human knowledge and aspiration was woven into the general pattern of the prevailing culture. Such a task, which would be in effect an interpretation of history in all its cultural aspects, will no doubt one day be undertaken by some outstanding genius. For the present we must confine ourselves to less grandiose projects. What I intend, therefore, is to explore the general nature of the links which must presumably exist between the form of society at any given period and the forms of the contemporary art. This is still a sufficiently vast subject, round which I must make some preliminary definitions. It is necessary to distinguish, in the first place, between art as an economic factor—art, that is to say, in so far as it is a quality belonging to objects which are produced to satisfy practical needs; and art as the expression of ideals, spiritual aspirations and myths—the ideological aspect of art. That the

ideological aspects of art are also in some sense a reflection of the prevailing methods of economic production is a general proposition to which I give full assent. But, to take a simple illustration of the distinction I have in mind, the factors which led to the building of cathedrals in the Middle Ages, and the factors which determined the particular form of these cathedrals, are not necessarily the same. They may represent, in fact, quite distinct processes of development.

The essential nature of art will be found, neither in the production of objects to satisfy practical needs, nor in the expression of religious or philosophical ideas, but in the artist's capacity to create a synthetic and self-consistent world, which is neither the world of practical needs and desires, nor the world of dreams and fantasy, but a world compounded of these contradictions: a convincing representation of the totality of experience: a mode, therefore, of envisaging the individual's perception of some aspect of universal truth. Art is what it has become the fashion to call a dialectical activity; it confronts one thesis, say that of reason, with its antithesis, say that of the imagination, and evolves a new unity or synthesis in which the contradictions are reconciled.

To some extent a survey of the various forms assumed by society and their corresponding types of art has already been made by sociologists, and a certain order has been imposed on the phenomena which we have to study. My own approach will be much more deductive. That is to say, I begin with a thesis which I hope to prove—a thesis about the nature of art and the function of art in society. I believe that we have reached a certain crisis in the development of our civilization in which the real nature of art is in danger of being obscured; and art itself is dying of misuse. It is not altogether a question of indifference—art can survive indifference, as the history of art in England proves. It is rather a question of forcing art into false moral issues; of confusing art, which is an intuitive faculty, with various modes of intellectual judgement; of making art subordinate, not merely to political doctrines, but also to philosophical points of view. But art, I shall maintain, is an autonomous activity, influenced like all our activities by the material conditions of existence, but as a mode of knowledge at once its own reality and its own end. It has necessary relations

with politics, with religion, and with all other modes of reacting to our human destiny. But as a mode of reaction it is distinct and contributes in its own right to that process of integration which we call a civilization or a culture.

The practice and appreciation of art is individual; art begins as a solitary activity, and only in so far as society recognizes and absorbs such units of experience does art become woven into the social fabric.[1] The strands in the 'pattern of culture' represent the supernormal activity of a few individuals, however communal the pattern itself may be; and the value of the pattern will depend on the delicacy with which the relationship between the artist and society is adjusted. Art, as we shall see, is fundamentally an instinctive force; and instincts are apt to recoil into a shell of unconsciousness if treated too deliberately. We begin by admitting that art can only develop in a favourable climate of social amenities and cultural aspirations; but art is not something which can be imposed on a culture, like a certificate of respectability. Actually it is like a spark springing, at the right moment, between two opposite poles, one of which is the individual, the other the society. The individual expression is a socially valid symbol or myth.

I shall begin by examining the function of art in primitive society, and then pass to the higher types of social organization which appear and reappear during the course of history. Since it is necessary to treat the subject within a limited space, I shall confine myself to very broad types of society, and shall not attempt to trace the intricate counterplay of forces within such societies. Accepting the ideology of each period as 'ready-made', I shall try to ascertain the give and take between the ideology and the artist. In most cases the ideology of a period is embodied in its religion, or its mythology, as we might say more generally. There is a danger, however, of taking the local fusion of two aspects of a culture—its art and its mythology—as a necessary and universal

[1] Cf. Ruth Benedict: *Patterns of Culture* (London, 1935), p. 253: 'Society in its full sense as we have discussed it in this volume is never an entity separable from the individuals who compose it. No individual can arrive at the threshold of his potentialities without a culture in which he participates. Conversely, no civilization has in it any element which in the last analysis is not the contribution of an individual'.

law, and though that fusion has taken place at important stages of the world's history—in Ancient Greece, in Mediæval Europe, in Buddhist India—that fusion is by no means so complete as a superficial examination of such periods would lead us to suppose, and at other periods there is evidence which definitely forbids a generalization. It might give the reader confidence if at this stage I were to quote the opinion of a distinguished anthropologist to this effect—and anthropologists rarely regard art as an independent phenomenon, as anything but one of the subordinate cultural features of a civilization. But, says Dr. Ruth Benedict, 'as a matter of history great developments in art have often been remarkably separate from religious motivation and use. Art may be kept definitely apart from religion even where both are highly developed'. And she proceeds to give instances from the civilizations she has studied: 'In the pueblos of the South-west of the United States, art-forms in pottery and textiles command the respect of the artist in any culture, but their sacred bowls carried by the priests or set out on the altars are shoddy and the decorations crude and unstylized. Museums have been known to throw out South-west religious objects because they were so far below the traditional standard of workmanship. "We have to put a frog there," the Zuñi Indians say, meaning that the religious exigencies eliminate any need of artistry. This separation between art and religion is not a unique trait of the pueblos. Tribes of South America and of Siberia make the same distinction, though they motivate it in various ways. They do not use their artistic skill in the service of religion. Instead, therefore, of finding the sources of art in a locally important subject matter, religion, as older critics of art have sometimes done, we need rather to explore the extent to which these can mutually interpenetrate, and the consequences of such merging for both art and religion'.[1]

The American evidence which Dr. Benedict quotes can, of course, be fully substantiated from the history of more civilized communities. The great Iconoclastic Controversy which nearly wrecked Christianity in the seventh and eighth centuries will throw a surprising light on the question; and apart from Christianity

[1] *Patterns of Culture*, p. 38. Cf. also Robert H. Lowie: *Primitive Religion* (London, 1925), p. 263.

there is ample evidence of the possibility of art and religion diverging in Persia and Spain. Spain is a particularly interesting case because there, for several centuries, we find two rival cultures, one Mohammedan and the other Christian, the one producing a great secular art almost completely divorced from religion, the other, in similar economic and climatic conditions, producing a wholly religious art.

I think we shall find, therefore, that there is sufficient evidence for assuming the dialectical nature of art. It is not a by-product of social development, but one of the original elements which go to form a society. Culture, as Dr. Benedict insists, is diverse, and this diversity of culture 'results not only from the ease with which societies elaborate or reject possible aspects of existence. It is due even more to a complex interweaving of cultural traits.' It follows that in the process of isolating those strands which we call art, we may for the time being lose sight of the general pattern. As Freud has observed in a similar case, if for the purposes of investigation one isolates from every other mental process a single psychic activity like the dream (or like art), one is enabled to discover the laws which govern it; if one then puts it back into its place, one must be prepared to find that one's discoveries are obscured and interfered with when they come into contact with other forces.[1]

That fact must be my excuse for not attempting a schematic study of the subject in the manner of Comte or Spencer. The best we can do is to select typical periods and then determine the relation of the art of the period to the rest of the prevailing cultural traits.

I shall not pretend to exhaust more than the surface of such a fertile field. I want chiefly to vindicate its importance. For it is a curiously neglected subject, and if its significance is not flatly denied, it is often ignored. The general attitude in this country and the United States is represented by a popular writer such as Mr. H. G. Wells. In two impressive volumes, *The Outline of History* and *The Work, Wealth and Happiness of Mankind*, this modern pantologist gives, or professes to give, a survey of all the activities of the human race. Art, you will find, does not occupy a very conspicuous place. In the first of these works (where, incidentally,

[1] Cf. *New Introductory Lectures*, English trans., p. 43.

INTRODUCTION

Shakespeare is only mentioned in a footnote) the plastic arts are referred to in half a dozen places, and in one of these the reason for this comparative neglect is given: 'Artistic productions, unlike philosophical thought and scientific discovery, are the ornaments and expression rather than the creative substance of history'. In the second work, in a sub-section of a chapter, the existence of art is more fully recognized. Five pages are devoted to it. Along with sport, it is explained as an outlet for mankind's surplus energy. What energy man can spare from war, commerce, science and other practical activities, he expends in these useless but quite delightful occupations—painting, sculpture, poetry, music, dancing, cricket, football and other forms of mental or physical gymnastics.

This is not an original point of view—it has been advanced with a certain seriousness by a sociologist like Karl Groos—but Mr. Wells no doubt derived it from his master, Herbert Spencer. However scientific it may be made to seem, this view of art is actually a typical product of philistinism, and its wide acceptance would only be possible in an Anglo-Saxon community. Centuries of moral prejudice and of that scientific arrogance which is one of the by-products of puritanism have made us essentially art-shy. This book will have served its purpose if it is received as an effective protest against this, our worst intellectual disgrace.

Art must rather be recognized as the most certain mode of expression which mankind has achieved. As such it has been propagated from the very dawn of civilization. In every age man has made things for his use, and followed thousands of occupations made necessary by his struggle for existence. He has fought endlessly for power and leisure and for material happiness. He has created languages and symbols, and built up an impressive fund of learning; his resource and invention have never been exhausted. And yet all the time, in every phase of civilization, he has felt that what we call the scientific attitude is inadequate. The mind he has developed from his deliberate cunning can only cope with objective facts; beyond these objective facts is a whole aspect of the world which is only accessible to instinct and intuition. The development of these obscurer modes of apprehension has been the purpose of art; and we are nowhere near an understanding of

6

mankind and of the history of mankind until we admit the significance and indeed the superiority of the knowledge embodied in art. We may venture to claim superiority for such knowledge because whilst nothing has proved so impermanent and provisional as that which we are pleased to call scientific fact and the philosophy built on it, art, on the contrary, is everywhere, in its manifestations, universal and eternal.

With such a conception of art, we cannot regard the function of the artist as merely the production of objects within the economic field—not, that is to say, as the making of buildings, furniture, utensils and other more or less utilitarian things. Art is a mode of expression, a language which may make use of such utilitarian things much as language itself makes use of ink and paper and printing machines: to convey a meaning—by which I do not mean a message. In all its essential activities art is trying to tell us something: something about the universe, something about man, or about the artist himself. Art is a mode of knowledge, and the world of art is a system of knowledge as valuable to man as the world of philosophy or the world of science. Indeed, it is only when we have clearly recognized art as a mode of knowledge parallel to but distinct from other modes by which man arrives at an understanding of his environment that we can begin to appreciate its significance in the history of mankind.

Chapter One

ART AND MAGIC

... in the domain of art certain important forms of it are possible only
at a low stage of its development.

KARL MARX, *Critique of Political Economy*

The use which I am going to make of the term 'primitive' is perhaps
wider than might be expected. I apply the word 'primitive' to a stage
of development rather than to a particular place or time, or to a
particular type of humanity; and in this sense include not only the
art of primitive races in various parts of the world to-day, but also
the art of mankind in general when that art was at a primitive
stage of development in prehistoric times. We shall also find some
very apt comparisons in the art of a primitive race much nearer to
us—I mean the art of our children, who in their early years seem
to recapitulate the development of art in mankind's childhood.

A general survey of all these kinds of primitive art would reveal
many similarities and many differences, and what is striking in
such a survey is the fact that these similarities and differences have
little or nothing to do with period or place. The same character-
istics are found at wide intervals of time without any apparent
connection; they reappear, not only at different periods, but also
in distant places.

But before we consider the significance of these facts we must
first consider one general criticism which if valid would make it
impossible for us to draw any conclusions from the evidence of
primitive art.

THE SIGNIFICANCE OF THE CAVE-PAINTINGS

It has been suggested (for example, by M. Camille Schuwer[1])
that we have no right to make a distinction between the utilitarian

[1] 'Sur la signification de l'art primitif.' *Journal de psychologie*, vol. xxviii, pp.
120–162.

and the artistic activities in primitive man: that primitive man does everything he does for a purpose, in total disregard of what we are pleased to call æsthetic qualities. Even if we cannot see the purpose of an object, and innocently suppose that it was made for its own sake, for the beauty of its form and colour, that is merely our ignorance; further knowledge would enable us to recognize some exclusively utilitarian, social, magical or religious purpose in any work of primitive man. The question is rather a subtle one. No one denies that the presence of artistic qualities in an object made for an exclusively practical purpose presupposes the existence of artistic faculties: the question is whether the recognition of artistic qualities in an object is a notion *in the primitive mind* independent of the recognition of the utilitarian purpose. For us it is comparatively easy to separate the two values—utility and beauty; though it is still possible to find primitive minds in our midst whose only comment on a work of art is: 'I can't see the use of it'.

The discovery of the existence of what we acknowledge to be a highly developed artistic faculty in prehistoric man has caused considerable trouble to anthropologists and to sociologists in general. Indeed, when the first cave-paintings of the palæolithic period were discovered in Spain in 1880, their authenticity was immediately questioned, and they were actually dismissed by the scientific world as forgeries. It was not until rock-paintings of a similar type were discovered in France in 1895 and 1897 under conditions which made any doubt of their genuineness impossible that the earlier discoveries were reconsidered and accepted.

Since then the significance of these primitive rock- or cave-paintings has been variously interpreted.[1] The general view is that the paintings, which are almost entirely of animals, have a magical significance. Primitive man, it is supposed, believed that by making a representation of an animal he thereby acquired power over it, and would be successful in hunting it for his food. Primitive art, therefore, was nothing if not practical. But though this theory can be supported by evidence from the practices of primitive people of to-day, there are certain difficulties in the way of

[1] There is an excellent summary of the whole discussion in *The Old Stone Age*, by M. C. Burkitt. (Cambridge, 1933). Chapter xii.

accepting it without qualification, as Professor Lévy-Bruhl has pointed out.[1] Those primitives whom we may assume to be nearest in type to palæolithic man—the natives of Tasmania and Australia—are also associated with rock-paintings, and it has been established beyond any doubt that these paintings play a part in fertility rites.[2] The paintings are retouched at the beginning of the rainy season to ensure the fertile reproduction of animals, plants, and even human beings. But from our point of view, which is that of æsthetic appreciation, there is a distinction to be drawn between the summary and even crude paintings done by the natives of Australia and Melanesia and the finished and life-like representations of the Old Stone Age. The former, one might say, are adequate enough as ritualistic symbols; the latter more than adequate. It is true, as Professor Lévy-Bruhl has pointed out, that we must not assume that prehistoric man had the same mental attitude towards animals which we have; judging from the reactions of primitive peoples to-day, it is neither the physical strength nor any of the visible attributes of an animal which impress him, so much as its invisible and mysterious powers. But again one must ask, why then did primitive man of the Stone Age represent the external appearance of the animals with such vividness and actuality?

From our point of view, in fact, it does not matter so much exactly *why* the primitive painted these representations of animals; what we have to decide is whether the mental attitude in question affects the æsthetic quality of the representations—whether, to put the matter with a directness not justified at the present stage of our enquiry—whether the art which is a symbol of mental constructions is qualitatively better or worse than the art which is a direct representation of living objects or natural appearances. We may have to decide, of course, that the two kinds of art are not comparable; but we shall have avoided a good deal of the prevalent confusion if we make it clear that one kind of mental attitude implies one kind of art, another kind of mental attitude another kind of art.

[1] *La mythologie primitive.* Paris, 1935, p. 145 ff.
[2] Cf. A. P. Elkin: 'The Secret Life of the Australian Aborigines'. *Oceania,* III (1932).

THE SIGNIFICANCE OF THE CAVE-PAINTINGS

There is one further qualification to be made: I have spoken of the palæolithic cave-paintings as representations of living objects or natural appearances, but it must be understood that something more than photographic realism is involved. The paintings are, in fact, highly selective stylizations of the object—so vital that we cannot doubt that the man who painted them took a disinterested pleasure in the manner in which he did his job. An attempt has been made to explain this perfection as due entirely to the cave-man's *desire* to make his representations magically effective—'par le désir d'obtenir l'efficacité', as M. Schuwer expresses it. But when this critic uses the word 'desire' I think he has given his case away. Primitive man has a *desire* to paint efficaciously. He has the desire to make one painting more effective than another. That is to say, he distinguishes between one painting and another, but surely not by the magical results obtained from it. It is quite fantastic to imagine that the stylistic mannerisms of the Altamira paintings were arrived at by a process of trial and error. Mr. Burkitt's suggestion, that 'there must have been definite schools where the technique of drawing and painting was learned' is a more likely hypothesis.[1] But the only point I wish to make at this stage is that the paintings reveal a scale of values; and such values are not those of verisimilitude, but of vitality, vividness and emotive power, which are precisely æsthetic qualities.

Admitting the æsthetic nature of palæolithic art, its interpretation, as I have already noted, remains a vexed question. At the one extreme there are anthropologists who are unwilling to concede to man of the Old Stone Age any such degree of mental development as a system of magic would imply, and who therefore regard these cave-paintings as entirely aimless, the product of the enforced leisure of hunters. They explain the vividness and æsthetic value of all the drawings as due to the intense images which must have haunted the minds of primitive men, dependent for their lives on their animal prey. At the other extreme are anthropologists who read a magical significance into every stroke they can discover in

[1] *Op. cit.*, p. 210. '. . . the various figures were not drawn by chance artists, but . . . the whole is the product of professionals and was drawn by them for some ritual purposes . . . there must have been definite schools where the technique of drawing and painting was learned.'

the gloomy bowels of a cave. The position I take up is an inter-
mediate one: the magical significance of some of the drawings is
beyond question; but there is no reason to assume that every
drawing had this kind of significance. Primitive man was already
human, and must surely have enjoyed the creative activity he was
endowed with, and pursued it for its own sake. In other words, the
art existed independently of the magic; had its separate origin and
only in the course of time came to be associated with magical
practices. For such a conclusion there is ample evidence.

THE ORIGINS OF ART

It is difficult to find a satisfactory word in English to describe the
earliest type of primitive art. It is an art of the senses, an art which
delights in liveliness, in a concentration on the essential vitality or
characteristic elements of animals. Such an art is organic, vitalistic,
sensuous. Its opposite type is abstract art—art which takes no
delight in the organic nature of things, but tends to deform them in
the interest of some ulterior motive, which motive may be religious,
symbolist or intellectual, or perhaps merely unconscious. Both
types of art have in common that quality which we call *form*, for it
is only by its form that we can distinguish art from other methods
of expression.[1]

Naturally the art of the Stone Age must have undergone a
process of development in which the cave-paintings at Altamira
represent the highest point,[2] but any reconstruction of the process
leading to this finished product is very hazardous. We must
remember that we are dealing with a period from 10,000 to 20,000
years ago. Any art that was recorded on more ephemeral materials,
such as wood or clay, must have perished. The cave-drawings and
engravings only survive because of the exceptional protection they
have received from the ravages of time. Nevertheless, aided to
some extent by our observations of the development of the artistic
faculty in children, a certain reconstruction of the development in

[1] For a more detailed discussion of this distinction, see *Art Now*, chap. iv.

[2] Burkitt (*op. cit.*, pp. 186–94) distinguishes a chronological sequence of four
phases, based on stratigraphical and other evidence, and connected with
different cultures. The Altamira paintings belong to the fourth phase, which
must be dated towards the end of Magdalenian times.

primitive times is possible. If you give a child pencil and paper as soon as it is capable of holding such things, at about the age of one, and watch the untutored use it makes of them, you will notice that at first it will merely make strokes and scratches. Then it becomes interested in the movement as it is recorded by the pencil on the paper. The next phase is represented by swaying rhythmic scribbles of lines and circles. These gradually become more complicated and involved, until the child's 'drawing' is a maze of lines. Suddenly in this maze the child will recognize chance forms: here and there a circle and a line or two have, for the child, an unmistakable resemblance to its mother. Other lines cross to form a roof, and only a line or two more need be added to make a house. Having thus *by chance* created a representation of an object, the child has then the wish or desire to repeat its triumph—to do deliberately what it has previously done by chance.[1]

Can we trace a similar development in the art of prehistoric man? I believe we can. At Gargas in the Pyrenees there are certain striated marks made by the fingers of a caveman on the clayey surface of his cave—marks which he might at first make involuntarily as he crept along.[2] Deliberate drawings of animals made by the same method, by the finger on the surface of the damp clay, are to be seen in the same cave, and also in a cave at La Clotilde de Santa Isabel near Santander, as well as at Altamira.

It is quite evident, in some of these examples, that representative forms emerge as if by chance from the mass of scratched lines. Aided by the vivid images which constitute his memory of such things, the caveman is able to improve his scratchings until he has evolved an exact graphic representation; exact in the sense that it corresponds with his mental impression of the object rather than with his visual observation. The mind, that is to say, the unconscious eye, is often a more effective observer than the conscious eye.

There is one other feature of the cave-drawings of the Old Stone Age which bears on this question of the chance origin of art. Many

[1] In *Education Through Art* (p. 121) I have given some evidence which suggests that this evolutionary development is not universal among children. A minority begin by making a deliberate attempt at representation.

[2] The suggestion sometimes put forward that these marks are imitations of the scratches made by bears seems rather far-fetched, though scratches actually made by bears are found.

of the animals are drawn round natural bosses or projections in the rocks which give plastic relief to the drawings when completed. It seems as if the animal was first suggested to the caveman by the formation or the marking of the rock's surface and that he then developed this suggestion until he had arrived at a close approximation to his mental image of the animal. The part played by suggestion in the origination of art is also borne out by the few remains of sculpture-in-the-round which have been found.

The further steps on the road to complete realism follow inevitably. Having discovered that lines could be made to symbolize objects, and that the sense of reality could be heightened by taking advantage of a favourable ground on which to work, the artist (in the caveman as in the child) next attempts to represent solidity or roundness by an elaboration of his lines. He discovers, for example, that lines hatched inwards from the outline of the object immediately suggest roundness. From hatched lines he proceeds to planes of colour, and when finally he has discovered that the effect may be heightened by the juxtaposition of two or more colours, and by the shading of these colours, he has at his command all the means used by civilized man.

If we may accept this account of the development of art in art's childhood, then I think one fact must strike us as strangely significant. One would naturally expect that early man, as well as the child, would attempt first of all to represent an object as he sees it in all its naturalness or verisimilitude. Since we see things as tone and colour, light and shade, the most direct or obvious representation of things would reproduce these qualities. It is strange, therefore, to observe that the child and the caveman begin by abstracting from reality and making a graphic outline of the object. They make a representation and not a reproduction.

ART AS AN INDIVIDUAL TALENT

All these characteristics of palæolithic art tend to prove that however communal or practical may have been the uses to which primitive man put art, nevertheless, art itself was the exercise of an individual talent. Without going so far as to suggest, with Mr. Burkitt, the existence of actual schools where the primitive artists

acquired their mastery of the techinque of painting, we must dismiss any idea that the paintings were the casual products of the enforced idleness of a tribe of hunters, or even the practical by-products of magical cults. Doubtless the paintings were associated with such activities, but the pre-requisite condition of their production was the existence of rare individuals of exceptional sensibility and expressive skill.[1]

The evidence from modern anthropology, we may here note, points to the same conclusion. For example, Dr. Seligmann reports that 'throughout Melanesian New Guinea the artistic tendency attains its highest expression in wood carving and in each community there is at least one expert in this art. These experts are hereditary craftsmen, having been taught their trade by their fathers or maternal uncles, and in turn take as pupils their own or their sister's sons. They are shown special consideration, and are fed by the men by whom they are employed, and there is no doubt that their work is appreciated by their fellows, many of whom also carve, though their work is generally inferior to that of the experts.[2]

Margaret Mead reports that among the Mundugumor people of New Guinea 'basket-makers are the women who were born with the umbilical cord twisted around their throats. Males so born are destined to be artists, to continue the fine tight tradition of Mundugumor art, the high-relief carving on the tall wooden shields, the low-relief stylized animal representations on the spears, the intricate painted designs on the great triangles of bark that are raised at yam-feasts. They it is who can carve the wooden figures that fit into the ends of the sacred flutes, embodiments of the crocodile spirits of the river. Men and women born to arts and crafts need not practise them unless they wish, but no one who lacks the mark of his calling can hope to become more than the clumsiest apprentice'.[3] The association of an arbitrary accident (birth with

[1] Cf. Baldwin Spencer: *Native Tribes of the Northern Territory of Australia* (London, 1914), p. 432: 'In the Kakadu, Umoriu, Geimbio, Iwaidji and other tribes excellent rock and bark drawings are met with. There is a great deal of difference in the capacity of various men in this respect, some of them being much better than others'. See also p. 37 below.

[2] *The Melanesians of British Guinea*, by C. G. Seligmann, M.D. (Cambridge, 1910), p. 36.

[3] *Sex and Temperament in Three Primitive Societies*. London, 1935, p. 172.

the umbilical cord round the neck) with a specialized talent, however unscientific it may be, is nevertheless a recognition of the existence of individual variability in artistic powers. The native recognizes this natural fact and wishes to give it due significance in his social organization or cultural pattern; it matters little, from our present point of view, that he adopts an entirely irrational method for securing this end.

PRIMITIVE MAGIC

We know too little—we know nothing—of the actual rites practised by palæolithic man, to enable us to generalize about the relationship between magic and art in that remote age. The subject will be more appropriately considered at a later stage in connection with peoples who still practise magic. We can only assume that in the Stone Age as in primitive communities to-day, it was a practice having little in common with what we normally understand by religion. We may assume that it was dark and secret and cruel; an attempt inspired by the aggressive instinct of emergent man to impose his will on the rest of the mysterious creation of which he was a part, but for which he had no rational explanation. Primitive man, we can assume, was essentially a creature of his emotions; he lived, as it were, in an emotional continuum, and did not distinguish very clearly between the image and the reality; indeed, the image, in its indestructibility, might well be much more terrifying than the thing of flesh and blood. 'How is this?' said the eighteenth century Jesuit, Father Dobrizhoffer, to the Abipones of South America, 'You daily kill tigers in the plain without dread, why then should you weakly fear a false imaginary tiger in the town?' 'You fathers don't understand these matters,' they replied with a smile. 'We never fear, but kill, tigers in the plain, because we can see them. Artificial tigers we do fear, because they can neither be seen nor killed by us.' We may be sure that the caveman argued in much the same way.

ART IN THE NEW STONE AGE

I want to pass now to the art of the New Stone Age—of the period, that is to say, stretching from about 10,000 B.C. to the

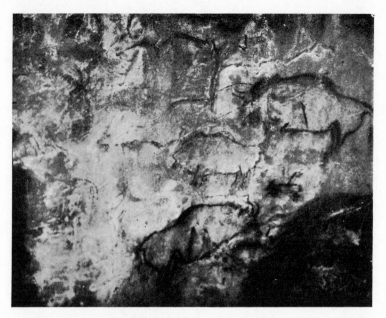

PLATE 1. The art of the Old Stone Age. Cave-paintings at Niaux, South France. About 20,000–10,000 B.C.

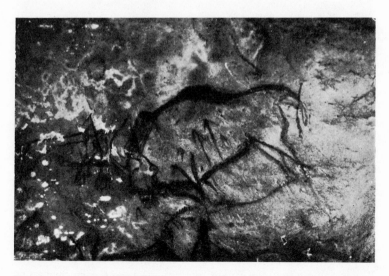

PLATE 2. A painting from the same cave at Niaux. This shows clearly the arrows which play such an important part in the discussion on the origin and purpose of palaeolithic art

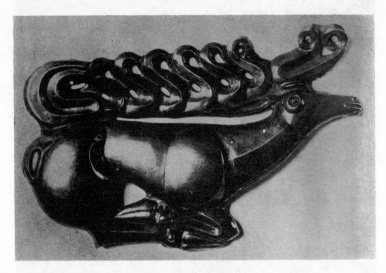

PLATE 3. Reindeer. Shield-decoration of gold from the Kuban district (Caucasus). 7th–6th century B.C.

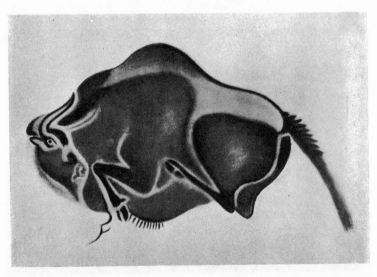

PLATE 4. Bison from the cave at Altamira, near Santander, Spain. Old Stone Age; about 20,000–10,000 B.C.

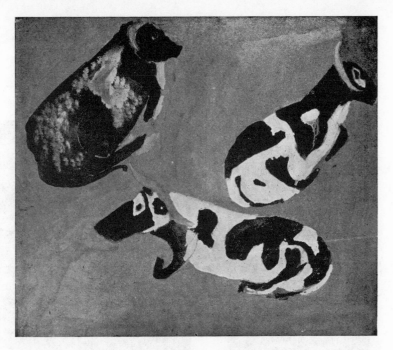

PLATE 5. Cattle. A painting by a boy aged 13

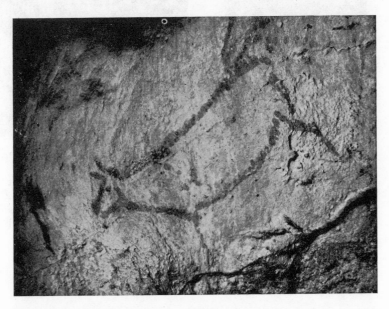

PLATE 6. Cave-painting at Covalanas, near Santander, Spain. Old Stone Age. This painting has the particular interest of showing a tentative method of outlining the object in 'dabs' of colour

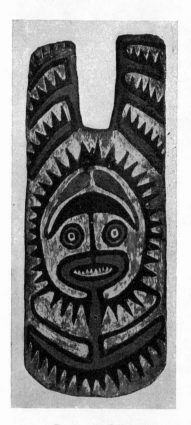

PLATE 7. Painted wooden shield from the Papuan Gulf.

PLATE 8. Earthenware beaker from Susa. About 5,000 B.C. This object illustrates the gradual transition from organic to geometric decoration. The frieze of flamingos round the rim is already scarcely recognizable as such, and the ibex's horns are well on the way to becoming a detached circle, its body two triangles

PLATE 9. Earthenware vase decorated with incised geometric ornament. Found at Bschanz, Wohlau, Germany. New Stone Age

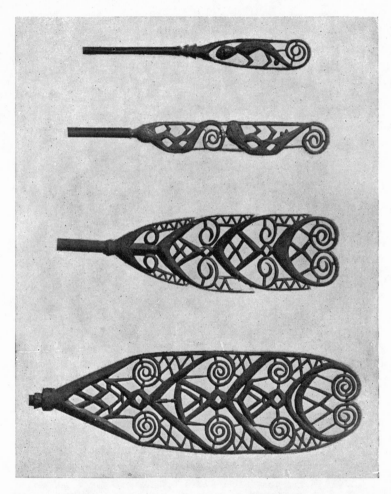

PLATE 10. Lime-spatulae from the Anchorite Islands. Read from top to bottom they illustrate the evolution of ornament from naturalism (a lizard) to abstraction

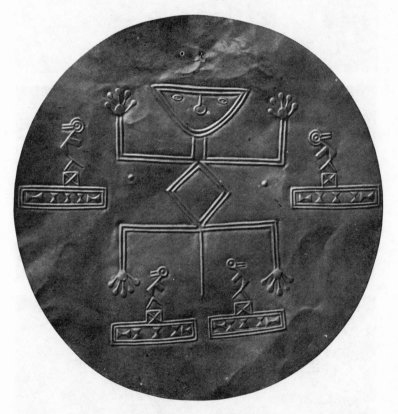

PLATE 11. Circular gold plaque with geometricized figure. Mexican

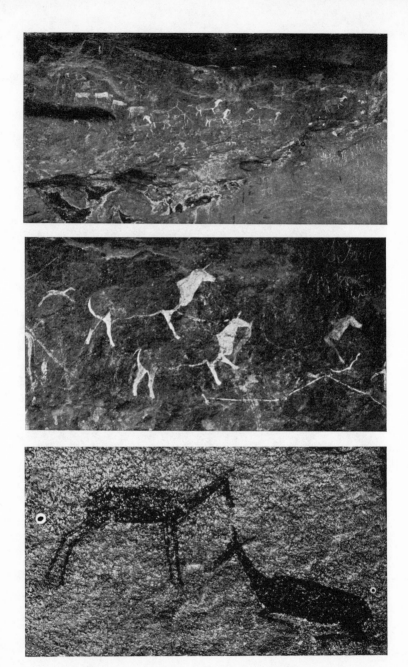

PLATE 12. Bushman rock-paintings at Cala, Tembuland, South Africa
PLATE 13. Detail of plate 12
PLATE 14. Bushman rock-painting from South Africa

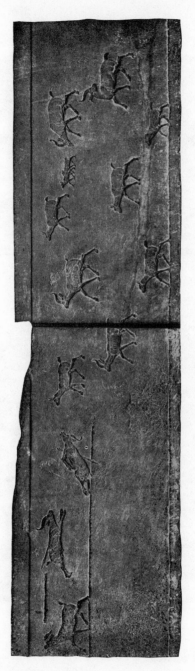

PLATE 15. Hunting scene. Assyrian; 7th century B.C.

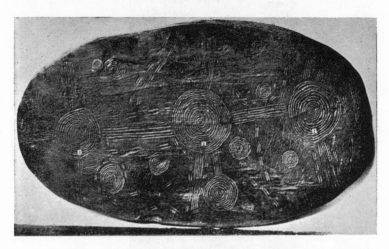

PLATE 16. Stone *churinga* (sacred stone slab) from Central Australia

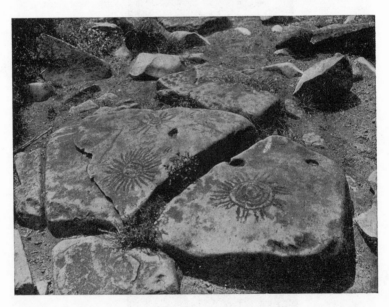

PLATE 17. Engraved patterns on rocks at Klipfontein, Griqualand
West, South Africa

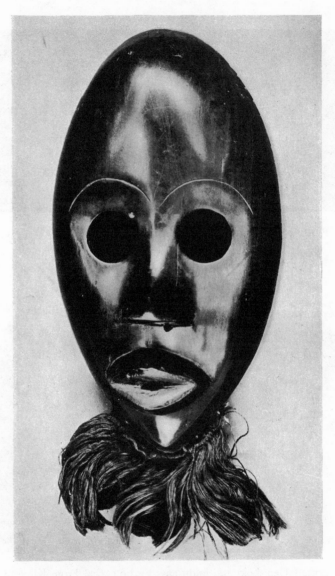

PLATE 18. Carved wooden mask from the West
Ivory Coast, Africa

PLATE 19. Reindeer engraved on rock. From Limeuil, France.
Old Stone Age

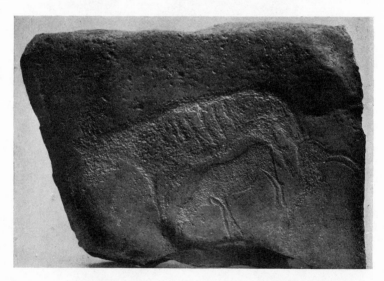

PLATE 20. Gemsboks and kudu engraved on rock. From Klipfontein.
For comparison with the palaeolithic engraving illustrated above

fringes of historical times—it is difficult to give a precise date because the style of art which we call neolithic persisted to very different times in different parts of Europe; in the North, for example, we still find traces of it in Celtic and Scandinavian art of the eighth to tenth centuries of our era.[1] Neolithic art is almost entirely different from the art of the preceding Old Stone Age. The vivid representations of animal forms, and everything that suggests organic life, disappear. Instead, we have various types of geometric ornament, applied mainly to pottery and stone implements, and little else. It has been suggested that this apparently cataclysmic change in the nature of art is merely an effect of chance ; that the organic type of art characteristic of the Old Stone Age did persist throughout the New Stone Age, but that it has not survived the ravages of time. Men ceased to use caves for the purposes from which the art of the Old Stone Age had arisen, but nevertheless the same art was practised in more exposed situations, on more perishable materials. But there are several difficulties in the way of accepting this theory. It seems unlikely that no traces whatever of naturalistic art in the neolithic period should have survived.[2] Surely in some sheltered coign, in some favourable climate, representative fragments of such art would have been unearthed! But we need not rely entirely on a negative argument. I would point rather to the art of pottery, the main source of our knowledge of the art of the New Stone Age. Pottery is made from a very plastic material and lends itself, as we see in the pottery of other periods, to a naturalistic style of decoration; yet in all the pottery of the neolithic period we find no trace of any such naturalism, and it is

[1] There is no agreed system of dating the prehistoric periods. Dr. Herbert Kühn in his latest work, *Die Vorgeschichtliche Kunst Deutschlands* (Berlin, 1935), adopts the following scheme for the area he is concerned with (Northern and Central Europe):

OLD STONE AGE	about 20,000–8,000 B.C.
MIDDLE STONE AGE	8,000–about 2,000 B.C.
NEW STONE AGE	about 2,000–1,600 B.C.
BRONZE AGE	1,600–750 B.C.
IRON AGE	50 B.C.–A.D. 300
PERIOD OF THE WANDERING TRIBES	A.D. 300–A.D. 800
VIKING PERIOD	A.D. 800–A.D. 1,050

[2] There are a few exceptions like the rock-engravings in Norway, which are mostly of a summary and even geometric type; and a few amulets of amber. See Kühn, *op. cit.*, pp. 226–31.

surely incredible that the pottery of the period should not have reflected contemporary naturalistic art in some degree. We may conclude, therefore, that such a naturalistic art was practically non-existent over long stretches of time.

Unless we can establish that the geometrical art which replaced the naturalistic art of the Old Stone Age involves the same basic æsthetic elements as the earlier art, our general thesis is endangered. We might, of course, demonstrate that climatic changes and an entirely new social and economic organization of life were factors sufficient to explain the completely different nature of art—nothing would be easier. But from the normal point of view we have to explain not so much a change in the nature of art as the almost complete atrophy of the artistic impulse in man—at least the disappearance of the individual work of art within an undifferentiated mass of pattern-making as monotonous as the standardized products of our own machine age.

The art of the New Stone Age is adequately represented by any collection, or selection, of the pottery of the period. The ornament on such pottery consists mainly of bands of linear designs of various kinds—circles, strokes, chevrons, and dots. There is an endless variety of such patterns, but in the mass they are decidedly boring. Though they might be classified in some way, they all come under the term geometric, and it is merely their general character which concerns us now.

GEOMETRIC ART

A German writer of the last century, the architect Gottfried Semper, evolved a theory of the origin of art based on this geometric style. Man first made useful things—tools and vessels. Vessels, for example, were made out of skins, shaped and sewn together; or baskets out of woven rushes and osiers. When the use of clay was discovered, it was a substitute which took over the shapes or forms of the earlier vessels of leather and wicker-work, and in taking over these forms the craftsman was unintelligent enough to imitate the seams and checker-work of the prototype. These had played a decorative function in the earlier objects, and the new clay vessels looked bare and blank without a similar

surface ornament. Once freed from the bonds of necessity, such decoration was elaborated and refined until in time man became capable of decorating his work, not merely with ornamental patterns, but also with representational designs. It is a plausible theory, but quite inadequate. It ignores the fact that geometric art existed before some of the processes which it is supposed to have imitated; and it ignores the quite decisive fact that the earliest types of art we know are not geometric, but organic.[1] We must therefore seek for another explanation.

It is right to see some connection between geometric art and technique; it is wrong to assume that this connection explains the origin of art in general. The development of the two types of art, organic and geometric, represents what we might simply call the swing of the stylistic pendulum, or more scientifically, an alternation in the dialectical process which constitutes the history of art.

If we examine a series of flint implements, from the beginning of the New Stone Age onwards, we shall find a gradual improvement, not only in technical efficiency, but in what we might call 'finish'. The chipping becomes finer and finer, until at last the stone is polished smooth. Among the more refined types of flint implement, certain of which may have had a ceremonial rather than a practical purpose, we find some deliberately decorated with a pattern, and the pattern is one which obviously has been suggested by the marks made in the process of chipping the flint.

In the same way, the geometric patterns on neolithic pottery would arise naturally in the process of potting. The first pots were not thrown on the wheel, but moulded by hand. Some were no doubt rounded directly, but the larger pots were formed by first coiling a rope of clay round a sandy core or matrix which was afterwards scooped out. In the process of coiling and smoothing the clay, markings of a geometric character would be made at first involuntarily, and from these suggestions the potter afterwards developed a geometric ornament of a more conscious character.

But all this would not have happened without a *will* directed to that end. It is not *how* a geometric style came into existence that should interest us, but *why*. It is possible to hold that it is not so much

[1] So far as possible I propose to use geometric and organic, abstract and representational, as contrasted or antithetical terms.

a question of will, as of lack of will, and in particular cases it can be shown that a geometric pattern has evolved from a naturalistic representation, though these always belong to decadent phases of naturalistic periods. The artist becomes so slick in his work that he tends to repeat his designs without much thought or accuracy. His designs are copied by other artists and further distorted, and a stage may be reached at which the craftsman is repeating a motive of which he no longer knows the significance. In some cases it is possible to trace the whole course of the evolution of an abstract design from its naturalistic prototype. This is particularly true of the geometric art of the South Seas. Dr. Seligmann, in the work from which I have already quoted, observes: 'To determine whether the portrayal of natural objects or the production of pleasing forms was the original intention of the artist it is necessary to examine a series of the products of each ethnic group. . . . In spite of the amount of conventionalization that has taken place but little experience is needed to make it clear that the Massim art was naturalistic in origin. The matter is less certain among the Motu and the related tribes of the Central Division, who have the Massim as their eastern neighbours and Elema (Papuan) tribes of the Papuan Gulf on the west. These two peoples possess the two richest and most distinctive styles of decorative art in British New Guinea. . . . It has already been stated that the decorative art of the Motu and kindred tribes is "geometrical", and the angular character of the figures is especially obvious in their tattooing which is always done by women. Nevertheless there is good evidence that certain geometrical designs originated as naturalistic representations, and I am inclined to believe that the whole of the art of the Motu and the cognate tribes of the Central Division has been developed from a naturalistic beginning'.[1] But by the nature of their origin, such geometric patterns can only co-exist with naturalistic designs, and though their æsthetic appeal is the same as any other type of geometric ornament, they only confuse the present issue, which is concerned with a universal will to abstraction, involving the whole æsthetic consciousness of an age.

[1] *Op. cit.*, pp. 37–8.

SYMBOLISM

Even within such an age, we must distinguish two kinds of geometric art. In decorating his pottery with geometric ornament, neolithic man was only moved by the desire to fill a space. *Horror vacui* is one of the permanent characteristics of man's psychology.[1] We have an inborn desire, when making something, to break the blank surface of the object with some kind of ornament. The natural kind of ornament is one which arises in the process of manufacture—some development, for example, of the marks left by the flaking of stone, the adzing of wood, the weaving of fabrics. The first type of geometric art, therefore, arises from technical pursuits and is devoid of any aim to express ideas. But art as normally conceived is precisely the expression of ideas, in form and fable, rhythm and colour. What I now wish to emphasize is the fact that even this second type of art, art expressing ideas, can take on a geometrical aspect. This will be made very clear by a consideration of the art of savage peoples, which will be the subject of the next chapter. There we shall find a type of geometric art entirely different from the type which arises out of a technical process. In the latter type the will and the achievement were contained within the process of making; there was no extraneous influence. But in the other type the motives are adapted to a symbolic purpose, and whilst serving as ornament, serve also to suggest, but not to represent, specific things or their properties. The representative image is deprived of its lifelikeness, though not of its vitality. It is characteristic of such works of art that they are not disinterested creations, like the ornament on neolithic pottery, but objects made for ritualistic or cult purposes. That is to say (and this is an important distinction) the savage is not creating a work of art directly from visual memory, or directly relying on visual sensibility, like the cave-painter at Altamira, but is representing, by plastic means, an idea. His cult or religion requires an idol, a mask, a totem—something which is not naturalistic, but symbolic. If further his religion is of the type sometimes called animistic, seeing spirits and personalities in natural phenomena, then in fear

[1] I have dealt with this phenomenon more fully in *Art and Industry*, 2nd edn. (1944), pp. 32-3.

of such forces he will tend to deceive them in his naïve way—thus creating a substitute for reality, thus evading actuality.

To what extent the geometric art of the New Stone Age is abstract symbolic art in this sense, or purely disinterested ornament, is a question we need not discuss. In either case it may or may not satisfy our æsthetic standards; but in so far as these standards are satisfied, the appeal is obviously not due to an ideological significance of which we are entirely ignorant nor to a symbolic content which we cannot recognize, but simply to those qualities of rhythm, symmetry and vitality which are specifically æsthetic qualities.

SUMMARY

To summarize thus far: we have three types of primitive art, two of which are geometric, one organic. The geometric types are differentiated, one as a disinterested ornamental art arising out of and during the course of technical processes; the other as a purposive art determined by symbolic ends. The former type of geometric art is obviously not of much interest to our enquiry: it is art produced in response to economic demand and is merely a question of function in relation to material and skill. But geometric art of a symbolic kind produced in response to the spiritual requirements of a community is perhaps even more significant than the more familiar kind of symbolic art expressed in representational forms. To arrive at a more exact understanding of the possible interaction between art and symbolism we must turn to certain types of primitive art still produced by uncivilized races.

Chapter Two

ART AND MYSTICISM

Les Iroquois n'ont à proprement parler qu'une seule divinité qui est
le songe.

Relations des Jésuites (1636)

In the last chapter I laid unusual stress on certain geometric types
of art, perhaps because they are least appreciated; but actually the
organic type of art prevails in most phases of society. In the
primitive phase it is represented, not only by palæolithic art, but
also by the somewhat different style of prehistoric art known as
Capsian, remains of which are found in the south-east of Spain
and in Northern Africa. In the primitive art of more recent times
it is represented by the art of the Bushmen, to some extent by the
art of the Australian aborigines, and by the art of the people of the
polar regions. All these several types have characteristics in
common. The Capsian type, which belongs to the palæolithic
period, differs only in unessential features from the contemporaneous
art of northern Spain (Altamira) and of the south-west of France.
It adopts the silhouette instead of the outline, but in its organic
rhythm, its emphasis on vitality and movement, and its fondness
for hunting scenes, it corresponds closely to the Franco-Cantabrian
type. The Bushman art of South Africa again, is almost embar-
rassingly similar to Capsian art, for whilst one is palæolithic, say
20,000 years old, the other is comparatively recent, the latest
examples belonging to the nineteenth century.

I will not offer any explanation of this extraordinary survival
into the present age of a style of art belonging to prehistoric times.
It may, of course, be a coincidence; but just as in northern
Europe we find the geometric art of the neolithic period surviving
into historic times (then known as the art of the La Tène period,
Viking and Celtic art), so we may venture to suppose that in
Africa the palæolithic culture has survived into still more recent

23

times. And when we are dealing with periods reckoned in tens of thousands of years, we dismiss as insignificant the few hundred years which separate La Tène and the Bushmen. 'The great scientific interest of the Bushmen resides precisely in the fact that they are, amongst other things, complete actual representatives of the artistic mentality of the Palæolithic Age. Thanks to this fortunate fact it comes about that we find still living in Africa to the present day what long since became extinct in our continent, where it is only preserved in our caves and rock shelters as an obscure fossil art.'[1]

BUSHMAN AND NEGRO

What I must now emphasize is the astonishing contrast which we find in the same continent and at the same time between African bushman art and African negro art. But it should not be so astonishing on closer examination, for it is a repetition of the contrast between palæolithic art and neolithic art—between all naturalistic and geometric types of art. But in Africa we find the contrast clearly stated, in conditions which can still be investigated.

Our first impulse is to seek for an explanation in the mode of life of the peoples in question, and there we find it. For both in social

[1] Cf. Hugo Obermaier: *Bushman Art* (Oxford, 1930), p. 44. Cf. also p. 43 of the same work:

'The paintings of eastern Spain show no convincing proof that the human type which is depicted in them belonged to the Bushman group. Nor is it permissible, on grounds of an outward correspondence in form and style between the arts of the two peoples, to believe in a racial identity of the artists, and so to trace European diluvial art back to a Bushman parentage. Such a conclusion would contain serious sources of error, for it is quite possible, even probable, that other types of men were working in ancient Europe, who had racially nothing in common with the Bushmen . . .

Though so remote from one another in time, the primitive Europeans and the Bushmen, to-day almost extinct, are yet close to one another in that they both reflect one and the same cultural condition. In the cultural life of the one, as of the other, not only do all the necessary, and more important, material and economic elements reappear, but the social, ethical and artistic also. Nomadic, stone-chipping hunters, they are both under the spell of essentially the same mentality; the arts of both derive from the same psychical source, are the product of an artistic outlook and feeling essentially the same. Not all primitive races pass uninterruptedly along these predetermined, fixed paths, and still fewer succeed in achieving the highest form of spiritual life attainable by them, the same culmination in art.'

organization and in religion the bushman and the negro are widely separated. The bushman belongs to a nomadic type of society—he gets his food where he can find it, hunts for it as an individual, and has little or no sense of co-operation and communal organization. His religion, like that of the caveman in the Old Stone Age, is predominantly *magical*.

The negro, on the other hand, is a settler. He is organized into a community which seeks to cultivate the earth for the common benefit. His religion is predominantly *animistic*.

ANIMISM

I use this distinction between 'magic' and 'animism' fully aware that the terms have a very controversial significance in anthropology. Animism may be briefly defined as belief in the existence of spiritual beings. Into that most difficult problem, the exact nature of a spiritual being in the mind of the primitive, we need not enter. But there is one modification of the general theory of animism which is relevant to our enquiry. Tylor, who first elaborated the theory, was inclined to assume that for the primitive, all objects of a sacred character, animate as well as inanimate, were inhabited by a spirit. But Dr. Marett[1] has suggested a separate category to which he has given the name 'animatism'; denoting thereby that class of objects which we should regard as inanimate, but which the savage regards as animate. In such cases, it is not a question of a particular stone being the house of a spirit; the stone itself has its spirit; it is alive.

Dr. Marett makes a further point, endorsed by Professor Lowie,[2] to the effect that 'both animism and animatism are essentially non-religious, becoming religious only in so far as the emotional attitude characteristic of religion clusters about their objects'.

Animism and magic, in my use of the terms, are but the subjective and objective aspects of primitive religion (analogous to the positive and negative aspects for which Dr. Marett has proposed the terms 'mana' and 'tabu'). The distinctive characteristic of magic is its concreteness. The basis of magic, according to Sir

[1] *The Threshold of Religion*, 3rd edn. (1914). [2] *Primitive Religion*, p. 134.

ART AND MYSTICISM

James Frazer, is a belief in *coincidence*, as opposed to *causation* of any
kind. The event 'happens' in correspondence with another event.
Everything acts in accordance with a law of sympathy, the assump-
tion being 'that things act on one another at a distance through a
secret link, due either to the fact that there is some similarity
between them, or to the fact that they have been at one time in
contact, or that one has formed part of another. For example
'among the Tharumba and neighbouring tribes, if a sorcerer
obtains some of the excreta, hair, nails, or other parts of the
enemy's body, he takes it to a 'squeaking tree' and places it
between the touching surfaces of the two branches causing the
'squeak'. When the wind blows, this fragment is squeezed and
ground to atoms, and the owner is believed to suffer in the same
way'.[1] Now the type of art which is called into being by, or is con-
sistent with such practices (and magic is essentially a practical
activity, not a subjective state) is one which represents an object in
all its essential vitality, in all the intensity of its existence. So
magical society demands a naturalistic art, an art which is actual,
sensational and representational.

It is worth observing, incidentally, that the anthropologists are
apt to make, quite unjustifiably, a judgement of value between
such a type of art and the more abstract or geometrical types
characteristic of other forms of society. They protest their scientific
detachment in, for example, the sphere of religion, but in the
sphere of art are guilty of the most elementary prejudices. Take
the case of Dr. Marett: '. . . in principle I contend that the func-
tion of a psychological treatment of religion is to determine its
history, but not its truth'.[2] But on a question of art he can make
such rash assertions as: 'Magdalenian man drew better, it is true,
than does the Australian, though perhaps not better than the
Bushman, about whose ceremonies we unfortunately know so
little. And, sad to say, it is too often the case that good religion and
good art tend to thrust each other out; so that the religious man
turns towards his ugly Byzantine Madonnas, while the Florentine

[1] R. H. Mathews, *Ethnological Notes on the Aboriginal Tribes of New South Wales
and Victoria*, 1905. Quoted by Géza Róheim: *Animism, Magic and the Divine
King*, 1930.
[2] *Op. cit.*, p. xiv and *passim*.

26

artist makes glorious pictures and statues for popes and cardinals who are men of the world in the worst sense. We may allow ourselves to conceive, however, that sometimes religion and art may go together, that the artists may try to serve God by drawing nobly'. Obviously, in Dr. Marett's view, Heaven and the Royal Academy are not far apart.

Bushman art does not present us with any clear evidence of the origin of the æsthetic activity, and we are not at liberty to assume that it was merely called into being by the symbolical or magical purposes for which we find it used. Here, as in palæolithic art, we should rather assume, on the psychological probabilities of the case, that both magical art and art for its own sake existed side by side. And there is nothing in Bushman art to contradict our further assumption that magical art was, for any ideal genetic or evolutionary reconstruction of events, preceded by art simply—by art which had no other aim than the disinterested pleasure aroused by the plastic process of creation.[1] It is even possible, as I have already suggested, that the artist, in virtue of his creative faculty, gradually assumed the rank and power of magician. Since magic has been recognized as the origin of science as well as of religion, the part played by art in the liberation of the general culture of mankind has been fundamental.

THE NATURE OF ANIMISTIC ART

In contrast to magic, which is materialistic in its presuppositions, animism tends to seek an explanation of events in active agents, such agents being invisible and spiritual. It involves a dualistic world, a world of bodies and souls, causally connected. Behind the

[1] Such, too, is the conclusion reached by an eminent French authority, G. H. Luquet (*Journal de psychologie*, vol. xxviii., pp. 390–428 [1931]). Cf. also R. H. Lowie, *Primitive Religion*, p. 260: 'Frankly casting aside such timidity (Wundt's), I will postulate the æsthetic impulse as one of the irreducible components of the human mind, as a potent agency from the very beginnings of human existence. In other words, I hold with Jochelson that "the æsthetic taste is as strong and spontaneous a longing of primitive man as are beliefs". Accordingly, its interaction with other such elements rather than its derivation from qualitatively distinct phenomena will form the subject of this chapter; nay, I shall not be afraid to suggest that sometimes the ostensibly religious is rather to be traced to an æsthetic source than vice versa'.

phenomena of existence are mysterious powers, powers which can only be conceived imaginatively. And this phrase 'conceived imaginatively' is a key to the art of animistic peoples. Their art is an attempt to symbolize the spirituality behind appearances. It does not therefore strive to represent any actuality, any living presence: it strives to get beyond the actual, to get to the transcendental. How, then, can primitive man represent the transcendental? Only by abstracting from reality, by seeking an essential structure, a skeleton of the object. He geometricizes his representation of the object, and in this geometric figure finds a symbol of the spiritual reality.

The actual relationships between art and magic on the one hand, and art and animism on the other hand, are not easy to unravel. As I have already said, modern anthropologists have largely discredited the somewhat naïve psychology underlying the theories of Tylor and Frazer. Under the influence of the materialistic hypotheses which dominated the science of their time, these great pioneers of anthropology were inclined to rely too much on a simple philosophy of cause and effect. They assumed that the myths and rites of primitive peoples were so many attempts *to explain* the phenomena of nature. But we must not attribute to such peoples the formal processes of our own mental activity. Undoubtedly they believe in a world of supernatural spirits—of forces and influences beyond the reach of normal sensational awareness. But there is no necessary or logical correspondence between the natural and the supernatural; in fact, the primitive mind does not recognize such a category as 'nature'. His world is integral; matter and spirit are not distinct, but interpenetrate. Supernatural forces vie with natural forces in the same sphere of reality. 'Myths, funeral rites, agrarian practices and the exercise of magic,' says Professor Lévy-Bruhl, 'do not appear to originate in the desire for a rational explanation: they are the primitives' response to the collective needs and sentiments which are profound and of compulsive force.'[1]

[1] Lucien Lévy-Bruhl: *How Natives Think* (Les fonctions mentales dans les sociétes inférieures). Trans. Lilian A. Clare. London, 1926, p. 25. For a discussion of the fundamental part played in the evolution of human society by prescientific theories of cause and effect, more particularly those which imply a doctrine of retribution, see Julius Kelsen, *Nature and Society* (Chicago University Press, 1944).

COLLECTIVE REPRESENTATIONS

The same authority has explained in more detail the nature of the 'collective representations' which are the native's mode of picturing reality:

'In the current parlance of psychology which classifies phenomena as emotional, motor, or intellectual, "representation" is placed in the last category. We understand by it a matter of cognizance, inasmuch as the mind simply has the image or idea of an object. We do not deny that in the actual mental life every representation affects the inclinations more or less, and tends to produce or inhibit some movement. But, by an abstraction which in a great many cases is nothing out of the ordinary, we disregard these elements of the representation, retaining only its essential relation to the object which it makes known to us. The representation is, par excellence, an intellectual or cognitive phenomenon.

'It is not in this way, however, that we must understand the collective representations of primitives. Their mental activity is too little differentiated for it to be possible to consider ideas or objects by themselves apart from the emotions and passions which evoke these ideas or are evoked by them. Just because our mental activity is more differentiated, and we are more accustomed to analysing its functions, it is difficult for us to realize by any effort of imagination, more complex states in which emotional or motor elements are *integral parts* of the representation. It seems to us that these are not really representations, and in fact if we are to retain the terms we must modify its meaning in some way. By this state of mental activity in primitives we must understand something which is not a purely or almost purely intellectual or cognitive phenomenon, but a more complex one, in which what is really 'representation' to us is found blended with other elements of an emotional or motor character, coloured and imbued by them, and therefore implying a different attitude with regard to the objects represented.'[1]

It is not necessary to follow Lévy-Bruhl into all the implications of his theory of a pre-logical mentality—a theory which has met with as much criticism as the older theories of Tylor and Frazer.

[1] *Op. cit.*, pp. 35–6.

His description of primitive modes of thought does, however, throw some light on the nature of primitive art. While not explaining the existence or origins of such art, it does seem to offer a reasonable hypothesis for the actual forms which primitive art assumes. Lévy-Bruhl insists, moreover, on the mystical nature of the forces which call such art into being. 'If I were to express in one word', he says, 'the general peculiarity of the collective representations which play so important a part in the mental activity of undeveloped peoples, I should say that this mental activity was a *mystic* one . . . employing the word in the strictly defined sense in which "mystic" implies belief in forces and influences and actions which, though imperceptible to sense, are nevertheless real.' And that, let me point out, is the sense in which I too am using the word 'mystic'.

There is a clear distinction between this kind of mysticism, and that contemplative faculty practised, for example, by the Christian mystics. Here again, Lévy-Bruhl has given us the clue:

'The superstitious man among us, and frequently also the religious man, believes in a twofold order of reality, the one visible, palpable, and subordinate to the essential laws of motion; the other invisible, intangible, "spiritual", forming a mystic sphere which encompasses the first. But the primitive's mentality does not recognize two distinct worlds in contact with each other, and more or less interpenetrating. To him there is but one. *Every* reality, like *every* influence, is mystic, and consequently *every* perception is also mystic.'[1]

Let us now see how we can relate this mystical mentality of primitive man to his artistic activity.

TYPES OF SAVAGE ART

Excluding the type of abstract ornament for which there may be a materialistic explanation (the elaboration of subordinate details under the stress of *horror vacui*) there remain three distinct types of savage art:

 (i) purely abstract design;
 (ii) geometricized or distorted representations of natural phenomena;

[1] *Op. cit.*, p. 68.

(iii) vitalized or enhanced representations of natural pheno-
mena, similar to those of the Old Stone Age.

It is possible that all three types may exist side by side, but
generally a high degree of naturalism excludes a co-existent
abstractionism.

As an example of purely abstract design we may take the decor-
ated *churungas*, or mystical stones, which come from Australia. The
one which is illustrated has been explained in the following way
by the native from whom it was acquired:

It comes from the Ngalia tribe and represents the tonanga or
grasshopper totem. The story indicated by the symbols is as
follows:

'At a place called Ngapatjimbi there were a number of grass-
hoppers. They came out of the ground and flew up, and coming
down they went into the ground again. In the meantime they
multiplied, and after the next rain came out at the places indicated
by the smaller spirals. They went up and down as men. The men
went to Wan'tan'gara, and going into the cave turned into
churunga.'

The parallel straight lines show the roads the grasshoppers made
by breaking down leaves, etc., and the double track-marks repre-
sent the tracks of the grasshoppers.

Another specimen from the Loritja tribe, representing the
Malalbera or Wild Cat totem, is described as follows:

'A large number of Wild Cat Men came from the South. While
walking one man's leg grew sore, consequently he had to remain
behind; later he followed the tracks of the other men for some dis-
tance. Seeing a Creek bed which appealed to him he decided to
stay there. All the others went on North. While here in this creek
he made short excursions in all directions to get lizards to eat. He
never went far because he was lame. Eventually he grew tired,
went into the cave, and turned into a churinga.'[1]

That gives what might be called a reading of the design on the
stone. I am not claiming that these stones are great works of art; I

[1] *British Museum Quarterly*, Vol. X., No. 1 (1935), pp. 26–7. Those interested
in analogies between primitive art and modern art should compare these stories
with Paul Klee's description of one of his own drawings which he called 'Going
for a walk with a line'. (See *Art Now*, pp. 141–2.)

would not, on the other hand, dismiss them as being entirely devoid of æsthetic interest. Their significance lies in the fact that the native makes an abstract design—that is to say, he draws or engraves a symbol which does not represent a natural object, but does represent an idea—even a succession of ideas. Moreover, it would seem that the native imbues the whole plastic mass of the object with vitality. Shape, or what in German is called the *Gestalt* of the object, is not arbitrary: it is determined by the same forces that determine the shape of a man or a beast. Form is a function of the included spirit. This necessary connection between form and content is well illustrated by F. H. Cushing's observations among the Zuñi Indians of America:

(The Zuñis) 'no less than primitive peoples generally, conceive of everything made . . . whether structure or utensil or weapon . . . as living . . . a still sort of life, but as potent and aware nevertheless and as capable of functioning not only obdurately and resistingly, but also actively and powerfully in occult ways, either for good or for evil. As for living things they observe every animal is formed, and acts or functions according to its form—the feathered and winged bird flying, because of its feathered form, the furry four-footed animal running and leaping, and the scaly finny fish swimming . . . So the things made or born in their special forms by the hands of man also have life and function variously according to their various forms.'

'The forms of these things not only give their power, but also restrict their power, so that if properly made, that is made and shaped strictly as other things of their kind have been made and shaped, they will perform only such safe uses as their prototypes have been found to serve.'[1]

Lévy-Bruhl, who quotes these observations, makes the following comment:

'It is not correct to maintain, as is frequently done, that primitives associate occult powers, magic properties, a kind of soul or vital principle with all the objects which affect their senses or strike their imagination, and that their perceptions are surcharged with animistic beliefs. It is not a question of *association*. The mystic

[1] F. H. Cushing, 'Zuñi Creation Myths', *E. B. Rept.*. xiii, pp. 361–3. Quoted by Lévy-Bruhl, *op. cit.*, p. 41.

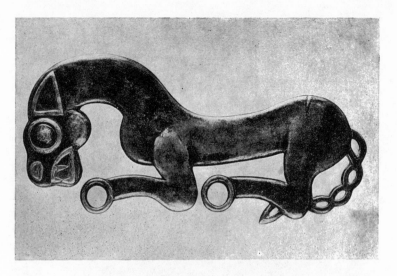

PLATE 21. Tiger; silver plaque. Chinese (Han dynasty, 206 B.C.–A.C. 220)

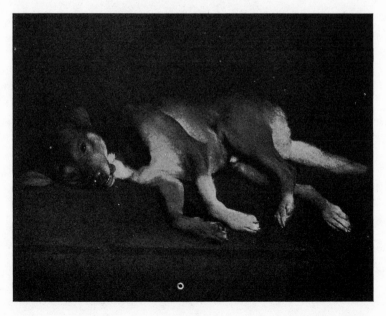

PLATE 22. Painting of a dog. Spanish; 17th century. This and the plate above illustrate the extremes of geometricized and naturalistic art, between which come the stylized types illustrated in plates 3 and 4

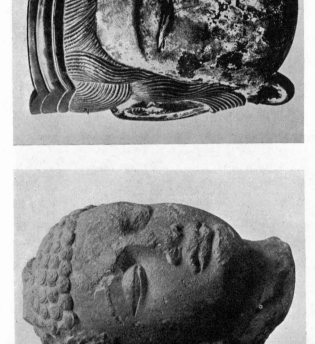

PLATE 24. Mask of a Bodhisattva; carved wood, lacquered. Japanese (Fugiwara period, 986–1159). Plates 23 and 24 illustrate the diffusion of a single religious type over a wide geographical area and during a millennium of years

PLATE 23. Head of a Buddha. Red Sandstone. From the Mathura district, United Provinces. Kushan dynasty; 2nd century A.D.

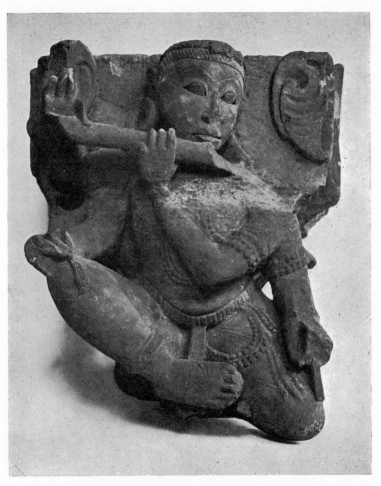

PLATE 25. A celestial flute-player, carved in yellow sandstone. From a Jain temple on the Satrunjaya Hill, near Palitana, Bombay Presidency. Solanki (Chalukya dynasty); 11th century

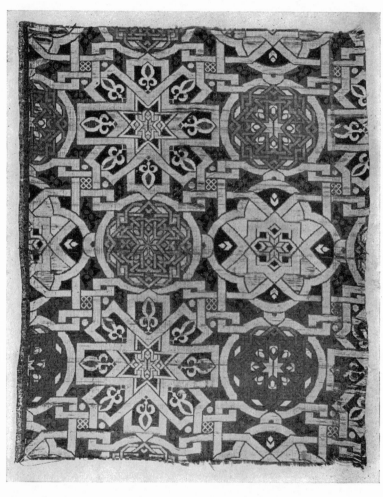

PLATE 26. Silk tissue. Spanish; 15th century. Perhaps executed by a Moorish craftsman; an example of the geometric ornament developed under Islamic influence

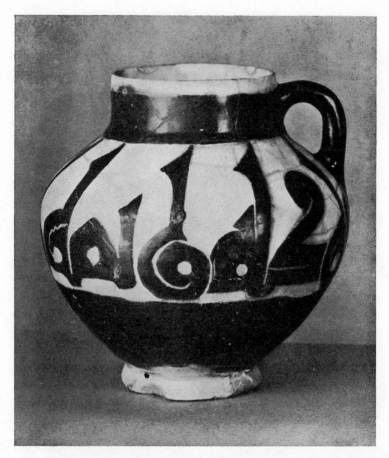

PLATE 27. Earthenware jug decorated with Kufic characters. Persian; 13th century. Another example of the use of non-naturalistic motives in Islamic art

PLATE 28. The so-called Westmacott Athlete, possibly a copy of Polykleitos's Kyniskos, 'the boy boxer from Mantineia.' About 450–40 B.C.

PLATE 29. Study for a Scourging of Christ, by Rembrandt. About 1646

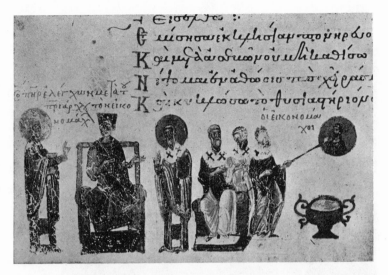

PLATE 30. Iconoclasts breaking the images. Psalter painted in the popular style at Constantinople. Dated 1066

PLATE 31. Christ in Glory. From the Eadwine Psalter, executed at Canterbury in the 12th century. Illustrating the diffusion of a popular style under cover of the monastic system

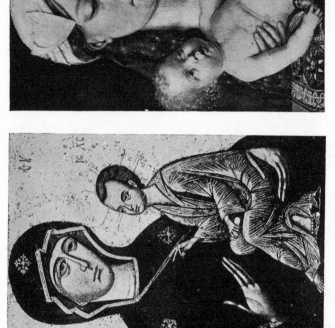

PLATE 32. Miraculous Icon of Our Lady of Tikhvin, revealed in 1383. Novgorod copy of a Graeco-Italian icon. Tikhvin Monastery

PLATE 33. Virgin and Child, by Master Michiel. Netherlandish; about 1520

properties with which things and beings are imbued form an integral part of the idea to the primitive, who views it as a synthetic whole. It is at a later stage of social evolution that what we call a natural phenomenon tends to become the sole content of perception to the exclusion of other elements, which then assume the aspect of beliefs, and finally appear superstitious. But as long as this "dissociation" does not take place, perception remains an undifferentiated whole.'[1]

It seems possible to agree, therefore, that the primitive does not differentiate his æsthetic activity as such. It is simply part of his life-activity—a complex activity involving all his faculties in a world of mystic perception which is a single unity. But the inclusion of the æsthetic faculty in an undifferentiated life-process does not destroy its identity, nor its variability in individuals. To suggest that the æsthetic impulse does not exist for the primitive because he can by no means be aware of it, is to confuse the fact of consciousness with the fact of existence. All this evidence from the primitive stage of human culture goes to show that the æsthetic impulse is one of the 'irreducible components of the human mind', and our problem is to determine the conditions and consequences of its functioning. It is to be understood, however, that I am leaving on one side the possibility that the so-called æsthetic impulse may be closely associated or even identical with other equally obscure impulses. For example, from a psycho-analytical point of view the interpretations which the Australian natives make of the designs on their churungas are so many secondary explanations, that is to say, evasive rationalizations, of motives which are actually unconscious and connected with the sexual obsessions of the individual. Dr. Róheim has analysed the designs from this point of view, and his arguments seem to me to be quite convincing.[2] But in this respect primitive art differs in no way from art in general, and therefore this aspect of it will be dealt with when we come to discuss the possible relations between art and the unconscious.

The observations of anthropologists, in so far as they touch the

[1] *Op. cit.*, p. 44.
[2] *Australian Totemism.* By Géza Róheim. (London, 1925). Cf. also O. Rank: *Das Trauma der Geburt* (1924).

phenomena of art, are generally made from the point of view of a perceiving spectator. We must now consider the same elements from the point of view of the creative agent. And for this purpose we shall find the anthropologists of very little use. We have to make our own deductions from the evidence they unconsciously provide.

THE NATIVE ARTIST

The *churungas* I have mentioned are admittedly not very impressive works of art, and though much finer abstract designs could be found, they never attain the æsthetic significance of the more naturalistic types of primitive art. We have to wait until modern times before art of any great æsthetic significance becomes consciously abstract. But that is another story. What, then, is the nature of the æsthetic activity in the individual in this first, primitive type of abstraction?

The native is moved by some compulsive force at three stages:

 (*a*) to make a design of some sort;

 (*b*) to make an abstract rather than a naturalistic design;

 (*c*) to make particular forms in a particular way.

Let us consider these three processes in turn.

Obviously the compulsion to *act*, to make an object which is not in the strict sense a utilitarian object, is due to feelings which the individual shares with the rest of the community—to the prevailing mysticism. Such mysticism is an integral part of the native's *Weltanschauung*, and the *Weltanschauung* as such is shared by all his fellows. When he makes a *churunga* or a *nurtunja* (sacred pole), the individual native is merely participating in the traditional ritual of his tribe. The impulse to make a design is, in that case, in the broad sense religious.

But we cannot say that all design-making is necessarily religious—that the native only makes a design when impelled by a religious motive. Spencer and Gillen, in their famous work on *The Native Tribes of Central Australia*, give decisive evidence on this point:

'When asked the meaning of certain drawings . . . the natives will constantly answer that they are only play work, and mean nothing . . . but . . . similar drawings, only drawn on some cere-

monial object or in a particular spot, have a very definite meaning.
... The same native will tell you that a special drawing in one
spot has no meaning, and yet he will tell you exactly what it is
supposed to signify when drawn in a different spot. The latter, it
may be remarked, is always on what we may call sacred ground,
near to which the women may not come.'[1]

We can only conclude, therefore, that the design may or may
not be the result of a religious impulse; in other words, that the
impulse to make a design *may* be purely autonomous—the con-
clusion we came to in the case of prehistoric man. It is what is read
into the design, rather than the act of making it, that is religious.

Why then, to come to the second stage, does the design take on
an abstract form?

Lévy-Bruhl is inclined to assume that the form of the design is
quite arbitrary, and that it only acquires significance from the
mystic force which inheres in it, but which it in no sense *represents*.
How else explain the fact, related by Spencer and Gillen in
Australia, by Von den Steinen in Brazil, by Parkinson in the
South Seas, that a design can mean one thing in one place, and
something quite different in another place? In short, there is no
coherent system of symbolism involved. The design is a design—
art for art's sake—and only acquires its extra-æsthetic or ideo-
logical significance from its environment—its position in time and
place.[2]

Dr. C. G. Seligmann, in his work on *The Melanesians of British
New Guinea* (Cambridge, 1910), gives evidence to the same effect
(p. 34): 'The Papuo-Melanesians feel no imperious necessity to

[1] Spencer and Gillen: *The Native Tribes of Central Australia*, p. 617. Quoted
by Lévy-Bruhl, *op. cit.*, p. 116.

[2] 'The explanations of the decorations have been given me by the Baining
themselves; there can be no doubt on this point therefore, since those who
execute them associate a definite idea with their drawings, although in every
case we are unable to see the connection, for the design does not in any way
resemble the object in question. We see how incorrect it is to interpret the orna-
mental decorations of a primitive people according to their resemblance to
any object known to us. The Baining see in these conventional designs a shell,
a leaf, a human form, etc. The idea is so firmly fixed in their minds that one can
see the stupefied wonder on their faces when they are asked the meaning of
these designs: they cannot conceive that anybody should fail to recognize at
once the meaning of the decorations.' R. Parkinson: *Dreissig Jahre in der
Südsee*, p. 627.

attach a meaning to any of the forms they carve on wood or the patterns they tattoo on their bodies, the verses of their songs or the figures of their dances. If the reason for a particular carving, tattoo pattern or dance figure be asked, the answer "our fathers did so before us" is usually given as a sufficient and final explanation. . . .'

Dr. Seligmann, indeed, goes further than most anthropologists, asserting that 'No better example of the acceptance of a work of beauty as such, and the purposeful ignoring of any non-æsthetic value, could be adduced, and facts such as this certainly tend to support the belief that the Papusian delight in art is largely autotelic. This idea is further strengthened when it is noted how many objects are covered with carving, with scratched or incised lines, or have patterns burnt on them, the great majority of which must, on the evidence of careful and repeated enquiry, be declared to be devoid of all magic or other non-æsthetic purpose.'[1]

If no coherent symbolism is involved, it would seem to follow logically that the native, in making an abstract design, is not governed, *in the actual process of making*, by any forces external to the purely æsthetic impulses transmitted by the tools he uses, by the material he works on, and by the sensibility he has of such abstract qualities as rhythm, balance, precision, etc.

So much established, or admitted, in the case of primitive abstract designs, we have next to ask ourselves whether the same conclusion holds good of the other two categories of primitive art—geometricized and vitalized representations of natural phenomena.

CONVENTIONAL ART

If we take the paintings of Australia or New Guinea which represent human beings and animals in a more or less summary fashion, without any naturalistic actuality, we can say:

First, that they have a commonly accepted significance—
Human beings are always meant to be human beings,
animals are meant to be animals;
Secondly, that the significance of the drawings is the same
for the whole community—there are no private references.

[1] *Op. cit.*, p. 35.

Thirdly, that the representations are used in certain ceremonies—as, for example, when they are renewed before the rainy season to ensure fertility.

The drawings are, therefore, symbolic. They stand as shorthand representations of general ideas, and are understood as such by the people in general. But as Lévy-Bruhl rightly insists, they are not necessarily on that account intellectual or cognitive phenomena. The image of the animal, that is to say, is not a detached counter; it always carries with it the emotions and associations evoked by the presence of the animal itself.

If, then, we turn our attention to the individual artist drawing under these conditions, we can easily imagine that he is working under a compulsive force altogether different from the detached intellectual attitude of the civilized painter. A civilized artist in drawing an animal will, no doubt, have a certain intuitive understanding of the beast's nature; and the vitality of his drawing will perhaps depend on the degree of this understanding as well as on his ability to translate such an understanding into plastic form. How otherwise explain the difference between a Pisanello or a Gaudier-Brzeska and a Paul Potter or a Landseer? Anthropologists do not stress these individualistic factors, though they generally tacitly assume them. Professor Lowie devotes a whole chapter to the subject of 'Individual Variability',[1] but strangely omits any consideration of artistic powers. He does, however, notice the marked difference in the narrative skill of natives, and observes that 'what is so conspicuously true of the literary sphere holds in equal measure for the intellectual as a whole'—in which ambiguous term, we may perhaps assume, are included variations in æsthetic sensibility and artistic capability.

But that is broaching the larger question which can only be discussed adequately at a later stage of our enquiry. What I wish to emphasize now is that this special intuition, sympathy, understanding—call it what you will—when present in the native gives birth to the first type of primitive art: vitalistic representation. The second type we have described as geometricized or summary; it has no sympathetic relation with any external form of life. Since it is summary it is satisfied with a minimum of essentials—two dots

[1] *Primitive Religion*, Chap. XI.

and a stroke inside a circle will suffice to represent a human face. There is probably a distinction between mere summariness, which indicates a feeble æsthetic impulse, and geometricization properly speaking, which far from being summary is often very involved—a complication rather than a simplification of the natural appearance. In the second case we have a choice between regarding the wilful complication of the design as mere *horror vacui*, or as the expression of a more profound flight from reality. If we are materialists we shall be satisfied with the former explanation; an explanation which I personally cannot accept as adequate for all phases of geometricized art.

A German anthropologist, Herbert Kühn, has drawn attention to this contrast in a passage which I would like to quote:

'The most prominent feature of the art of the Bushman is the naturalistic and sensory character of its informing spirit. Naturalism is of course merely a relative term. If the art of the Bushman is placed alongside that of the African negro, excluding the art of Benin and Yoruba, Bushman art will then be seen to be much closer to the natural model; it is more strictly realistic and truer to nature. The feeling for reality in this art is quite other than that of the art of the negro.

'The Bushman, more closely related to nature, experiences more strongly the plastic character of the object; its form, colour and movement. To him the object is reality, not symbolism or essential meaning, as it is to the animistically-inclined Negro. The Bushman's view of life is magical and his art stands in the closest relationship to this type of experience. The magical view of life knows nothing of the significant relationship between meaning and being; in magical thought there is being only in actual, objective reality. Thus also the art of this phase recognizes only the real and the copy of the real. It has no idols, no portraits of the gods; that which is depicted is the reality of everyday experience.

'Animals are represented running, grazing, lying, falling; men hunting, dancing, disguised as animals. Fabulous creatures, such as the snake, death, a being which appears to belong to the transitional conception between magic and animism, still retain naturalistic forms.'[1]

[1] *Bushman Art*, by Hugo Obermaier and Herbert Kühn. (Oxford, 1930), p. 19.

CONVENTIONAL ART

In the end it comes to this: that if symbolism is the only require-
ment, there is, at any rate in the primitive stage of civilization, no
effective criticism of the form the symbol takes. Symbolism, far
from encouraging a higher æsthetic standard, is entirely indif-
ferent; and being satisfied with the most summary representation
of the object, image or idea, tends actually to discourage any
elaboration in the interests of purely æsthetic qualities.[1]

If, however, not a mere symbol, but an operative agent is
required, as in magic, then there is a compulsion to make the work
of art as vital as possible. It need not be an exact representation of
the object, for the native has sufficient sense to see that vitality is a
quality inherent in the life and action of the object—a dynamic
force within the object rather than the outer static form. A running
antelope is obviously different in form from a standing antelope:
form varies with immediate function. An effective representation
will aim at seizing the functional activity rather than the static
being. Under such an impulse, which is supplied naturally by a
belief in sympathetic magic, a highly vitalistic type of representa-
tional art will develop.

SCYTHIAN ART

I am far from implying that such art will develop only when
aided by magical beliefs. We have only to glance at another type
of society, differing in many respects from the palæolithic and
bushman types, to find a similar art divorced, so far as our know-
ledge goes, from any analogous beliefs or practices. I refer to the
so-called 'animal style' of the Scythians. The Scythians were
nomadic hordes which dominated Southern Russia between the
eighth and the third centuries B.C. In the first period, down to and
including the sixth century, the art of these peoples shows a
definite similarity to the art of the Bushman. It is confined almost
entirely to the representation of animals, and it represents them in
a very vitalistic manner, concentrating on their most typical
features and characteristic movements. It differs from bushman
and palæolithic art in its tendency towards decorative stylization
—the horns of the deer, for example, are elaborated into an almost

[1] Cf. the discussion of this question in Lowie, *op. cit.*, pp. 263-6.

abstract ornament—a tendency which grows more marked with the further development and ultimate decadence of this art. Moreover, the art of the Scythians is exercised exclusively on objects of use or ornament—harness-trappings, tent-poles, buckles, etc.— and is devoid of any suggestion of magic or mysticism. It is not until the end of the sixth century that the art becomes in any sense an expression of ideas, and from that moment its vitality is lost.

We may therefore conclude that the vitality of the art was due to a close relationship between man and the animal world—in some sense, perhaps, a participation of man and animal in the same world of spiritual forces, and to that extent a mystical art. But more essentially this relationship was physical: the relationship of hunter and hunted—a tense nervous dependence in which man acquired a visual and imaginative conception of the animal world, and by which he was impelled to a plastic expression—the urgent need of an æsthetic objectification of the visions which haunted his imagination.

THE GENERAL NATURE OF NEGRO ART

I shall make no attempt to classify the types of animist art, the mystical art of the negroes; it is a task which even the expert in this field has declined to undertake.[1] The ordinary European eye can hardly distinguish between the varieties of belief, of custom and of ritual expressed in these masks and idols; to him they all seem more or less monstrous. But though for our purposes there is no need for scientific discrimination, we must not be blinded by modern and limited æsthetic prejudices. For all their crudity, these objects possess the essential elements of great art. The negro, as Gobineau pointed out, possesses in the highest degree the sensual faculty, without which no art is possible. Perhaps the very fact that he was not conscious of his gift; that he only exercised it sporadically and then generally in the service of his ritual, is the clue to its unfailing vitality. For though, as we have seen, neither magic nor mysticism are effective *causes* of art, they may be the appropriate *occasions*, saving the artist from that self-consciousness

[1] Georges Hardy: *L'art nègre.* (Paris, 1927). Cf. p. 115.

and introspective analysis which, as we shall see, spell the death of art.

It may be objected that the sense in which I have taken mysticism is too elementary, even too derogatory, for such a high-sounding and, in the later stages of civilization, such a really profound spiritual state. But our subject is art and society, and I am only concerned with mysticism as a social phenomenon—as an organized or at any rate organic system. The higher and finer types of mysticism are extremely individualistic, and so transcendental that they may have no connection whatsoever with the objectivity of the plastic arts. *My tendency all the time, a tendency derived from the historical facts, is to see two directions in human sensibility, one leading to the abstraction of the word and the idea, the other to the visual plasticity of the material art-form; and the more these tendencies diverge and keep distinct, the purer and more coherent each is of its kind.*

SUMMARY

We have been surveying art in its primitive phase. Such art cannot be compared with the developed art of civilized man, for whom the life of the intelligence has become a necessity. But here we are concerned with essentials, and in its essentials art has little or nothing to do with the intelligence. It is an exercise or activity of the senses, elemental as the primary emotions of love, hate and fear. It is not the possession of any particular race or races; but is diffused generally over the whole world. But in its creative aspect it is a limited activity—that is to say, it is confined to special individuals who through special faculties of sensation or special skill in expression, can appeal to the mute emotions of their fellow men. The primitive artist is the individual who can best interpret or present the mystical world; the community accepts his lead and appreciates his skill. Art is closely related to skill, not only because some forms of art arise out of technical processes, but also because all kinds of æsthetic conception require technical skill for their presentation. But art is more than skill because skill is purely functional, whereas art is essentially disinterested. Art without function is always in danger of developing self-consciousness; nevertheless, art begins where function ends. Where functional forms are equal

in operative efficiency, there is still room for the æsthetic sensibility to make a choice—to say that this spear-head is more beautiful than that, this axe more beautiful than that, and, to come to our own time, this aeroplane or motor car more beautiful than that.

In all æsthetic problems we are finally driven to the psychological solution. In particular we need the distinction between social psychology and individual psychology, the former to help us to explain the collective values of art, the latter to help us to explain the plastic sensibility of the artist.

Let me formulate the conclusions we have reached in our examination of art in primitive types of society. We have distinguished three general aspects of art in its relation to society.

I. Art which is communal because it arises in the course of the technical processes involved in the manufacture of necessary utilitarian objects. Social customs demand the object; modes of manufacture and qualities of material determine the form and to some extent the decoration; functional and psychological needs select the forms and organize the ornament.

Such art is hedonistic, *a matter of purely sensational pleasure, and essentially of an abstract (geometric) nature.*

II. Art which is communal because it gives expression to mystical ideas of a generally accepted nature, or is used in the service of the rites associated with such ideas. Again we can say that social customs demand the object; and its form is still governed by the nature of the tools and materials used; but the selective principle is no longer purely sensational, but ideological.

Such art is purposive *(pedagogic, ritualistic, experimental) and essentially of a symbolic nature.*

III. Art which is individualistic, expressing the feelings and emotions of the artist. If sympathetic relationship has been established between man and the outer world, the artist is impelled to represent natural phenomena in all their essential vitality. The artist thus becomes representative and to that extent art is still communal.

Such art is expressive *(emotive) and essentially of an organic (representational) nature.*

These three aspects of art, which we can already discern at the

primitive stage of man's development, remain the general types throughout the history of human society. Man emerges from the chaotic darkness of prehistory; his consciousness evolves out of fear and loneliness and desire; he forms tribes and societies and adopts various modes of economic production, and in the process his soul is swept by those alternations of superstition and joy, of love and hate, of intellectual confidence and humble faith, which transform his life, making and unmaking dynasties and nations and civilizations. But throughout all this welter of forces and contradiction of aims the æsthetic impulse, like the sexual impulse, is essentially constant. It has these different aspects—hedonistic, purposive and expressive—and sometimes one and sometimes another will dominate a whole epoch. But all these aspects relate to one reality. For the essential nature of art is not given to it by a civilization or a religion, but is an indefeasible faculty of man himself—a certain disposition of sensation and intuition which impels him to shape things into forms or symbols which are æsthetic to the degree that they take on harmonious proportion and rhythm.[1] In subsequent chapters I shall offer some explanation of the nature of this impulse, but meanwhile I must ask the reader to accept the fact of its existence.

[1] 'But the difficulty', as Marx expressed it, 'is not in grasping the idea that Greek art and epos are bound up with certain forms of social development. It rather lies in understanding why they still constitute with us a source of æsthetic enjoyment and in certain respects prevail as the standard and model beyond attainment.' *Critique of Political Economy*: Introduction.

Chapter Three

ART AND RELIGION

What is demanded for artistic interest as also for artistic creation is, speaking in general terms, a vital energy, in which the universal is not present as law and maxim, but is operative in union with the soul and emotions.

HEGEL, *Aesthetik*

In passing from prehistoric and uncivilized types of society to types we should normally regard as civilized, our problem becomes immensely more complicated. But for many centuries it may still be treated as mainly a problem of the relation between art and religion. The whole of the spiritual and emotional life of the community is organized under the ægis of the prevailing religious hierarchy, and though there is a vast amount of æsthetic expression embodied in utilitarian forms of art, such forms are not very significant for our enquiry. I shall not ignore them, for they often provide a touchstone for the prevailing æsthetic sensibility of a period. But the main flow of æsthetic energy is poured into religious channels.

At the same time, it must be made clear that from the point of view of this book, religion is merely one among several aspects of society, and that it should not occupy our attention to the exclusion of the other aspects. That must be my excuse for dealing with art and religion rather than with art and religions. Religions are of many varieties, and at the extremes may seem to have little in common. Nevertheless, excluding primitive religion which has already been dealt with, I propose to divide them into four general types, which types will, I think, enable us to deal adequately with those social aspects of religion that find expression in art.

RELIGION AND CIVILIZATION

But first let us see how the religion of civilized societies differs from the religion of primitive societies. There is, of course, no

absolute or historic break of continuity; religion has evolved gradually, like all human institutions. But when the interval is long enough, we become aware of the fact that differences of degree have at some point or other become differences of kind. Such a difference in kind is to be observed the moment the human mind, in its perception of reality, begins to distinguish between a natural and a super-natural order of existence. We have seen how, according to Lévy-Bruhl, in primitive man 'the mystic properties with which things and beings are imbued form an integral part of the idea. . . .' The primitive regards the thing and its properties as a synthetic whole. 'It is at a later stage of social evolution that what we call a natural phenomenon tends to become the sole content of perception to the exclusion of other elements, which then assume the aspect of beliefs, and finally appear superstitious.'[1] But in the later stage of religion with which we are now concerned 'the superstitious man, and frequently also the religious man, among us, believes in a twofold order of reality, the one visible, palpable, and subordinate to the essential laws of motion; the other invisible, intangible, "spiritual", forming a mystic sphere which encompasses the first'.[2]

Later in the work from which I have quoted, Lévy-Bruhl identifies this development with conscious or logical thought (and hence his general characterization of primitive mentality as pre-logical). The distinction is so important for our purpose that I must quote his exact words:

'. . . Collective representations as a rule form part of a mystical complex in which the emotional and passionate element scarcely allows thought, as thought, to obtain any mastery. To primitive mentality the bare fact, the actual object, hardly exists. Nothing presents itself to it that is not wrapped about with the elements of mystery: every object it perceives, whether ordinary or not, moves it more or less, and moves it in a way which is itself predestined by tradition. For except for the emotions which are strictly individual and dependent upon the immediate reaction of the organism, there is nothing more *socialized* among primitives than their emotions. Thus the nature which is perceived, felt, and lived by the members of an undeveloped community, is necessarily pre-

[1] *Op. cit.*, p. 44. [2] *Op. cit.*, p. 68.

determined and unvarying to a certain extent, as long as the organized institutions of the group remain unaltered. This mystical and prelogical mentality will evolve only when the primitive syntheses, the preconnections of collective representations, are gradually dissolved and decomposed; in other words, when experience and logical claims win their way against the law of participation. Then, in submitting to these claims, "thought", properly so-called, will begin to be differentiated, independent and free. Intellectual operations of a slightly complex kind will become possible, and the logical process to which thought will gradually attain, is both the necessary condition of its liberty and the indispensable instrument of its progress.'[1]

As I have already admitted, Lévy-Bruhl's theories have met with a good deal of criticism, especially from anthropologists; but this particular hypothesis belongs to a wider biological sphere, and has an *a priori* probability which cannot be denied. After all, at some stage in human evolution perception did begin, so to speak, to turn in on itself and thus to distinguish between the process of perception and the objects external to this process. And this was the beginning of that 'thought' which is common to all civilized peoples, and the justification of their claim to be regarded as civilized. Nothing is more typical of that thought than the division of reality into an order of natural events which takes place before the eyes, which *happens*, and an order of spiritual events which takes place out of human sight or perception, but which offers some acceptable explanation of why and how life unfolds in all its complexity and inevitably.

Mysticism may still survive into this new epoch of human consciousness and be rarefied and made sublime by exceptional individuals; but for the vast majority of men, who now possess this faculty of thought, religion is an explanation, even a rational explanation, of the structure of the universe and of the destiny of man.

ART AS INTERMEDIARY

It will at once be seen how radically this transformation of human consciousness alters the significance of art. In the pre-

[1] *Op. cit.*, p. 109.

logical stage, as we have seen, art could not be clearly separated from nature; a natural stone would serve the purpose of a work of art just as well as a sculptured one; the image of an animal was as real as the animal itself; the same design could represent totally different things. But now, caught up in the process of logical thought, the work of art becomes an intermediary between the world of natural phenomena and the world of spiritual presences. It becomes either a symbol to express a mental or emotional state, or a representation or imitation of a natural object. In either case it it is a vehicle which conveys information, a means of communication. In some countries the picture still survives as the only mode of written communication; Chinese script, for example, still uses in its radicals an element which is a representation of the visual image, the pictogram.

Once the notion of two orders of existence, one visible and one invisible, is established, obviously any attempt to render the invisible visible will be of the greatest interest and importance. Indeed, it will be such a dangerous and speculative privilege that its exercise will have to be controlled by those responsible for the cohesion of the social unit. And since that cohesion always depends on spiritual factors (for even the completely rationalistic economic unity of a modern society like the U.S.S.R. could not survive without the ideology of communism) the tendency to control art in the interests of the prevailing religious system will be inevitable. Our problem is precisely to determine what effect such control has on art regarded as an autonomous activity. We assume the existence of the æsthetic impulse (there is sufficient evidence for the assumption); we ask how that impulse has fared under the dominion of religion.

TYPES OF CIVILIZED RELIGION

We must first distinguish those four types of civilized religion to which I have already referred. David Hume made a broad distinction between superstition and enthusiasm (or fanaticism). Hume's distinction is perhaps not very scientific. 'Weakness, fear, melancholy, together with ignorance are', he says, 'the true sources of superstition.... Hope, pride, presumption, a warm

imagination, together with ignorance, are the true sources of enthusiasm.' Hume takes a wholly objective and rationalistic view; he judges religions by their externals. But the actual distinction, which leads surely enough to his distinction between superstition and fanaticism, is psychological; it is the distinction between extravert and introvert attitudes, between a spiritual energy directed outwards to rites and ceremonies and all the objective symbols of an invisible world, and a spiritual energy directed inwards to meditation and self-examination and a direct personal communion with this same invisible world. Now though such a distinction is primarily valid within the sphere of individual psychology, the predominance of one or other type is liable to be determined by climatic or racial factors and the distinction in effect becomes valid for religions in their collective aspect. We might say that these two psychological tendencies account for all the varieties of religion known to the civilized world, but it would be a generalization without much value. For these psychological tendencies are universal, and it would seem to follow, therefore, that in every country and at all times we should find extravert and introvert, ritualistic and meditative types of religion. But though such a state of affairs has come about in the modern world, particularly in countries like our own where tolerance has been the rule for some centuries, throughout the greater part of history we find religions clearly differentiated into distinct and even antagonistic groups. Actually our psychological categories ignore the time factor—the gradual process of the evolution of religion and the variations in the rate of that evolution in different parts of the world. The process as a whole may most simply and with evident historical truth be regarded as tendency towards rationalization. As Professor Whitehead has said:

'Religion, so far as it receives external expression in human history, exhibits four factors or sides of itself. These factors are ritual, emotion, belief, rationalization. There is definite organized procedure, which is ritual: there are definite types of emotional expression: there are definitely expressed beliefs: and there is the adjustment of these beliefs into a system, internally coherent and coherent with other beliefs.

'But all these four factors are not of equal influence throughout

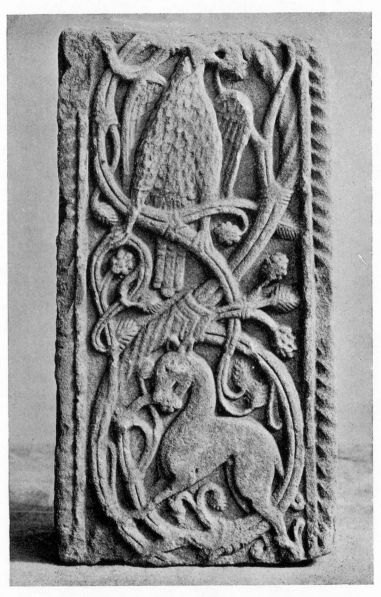

PLATE 34. Stone relief, part of a cross shaft. From Easby Abbey,
Yorkshire. 8th century

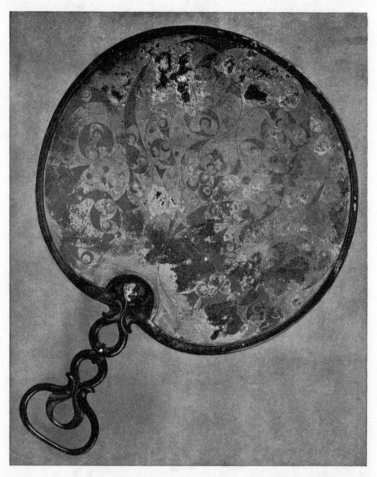

PLATE 35. Back of a bronze mirror, found at Desborough, Northants.
Early Iron Age (late Celtic); 1st century B.C.

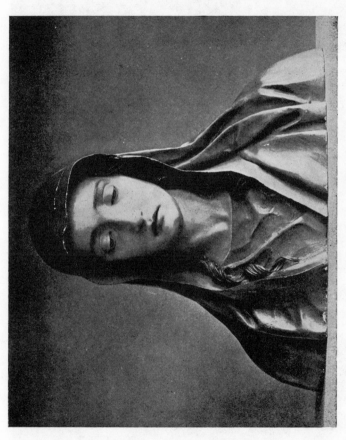

PLATE 36. La Virgen de los Dolores. Bust in painted wood, probably the work of Martinez Juan Montanez (d. 1649). Spanish; 17th century

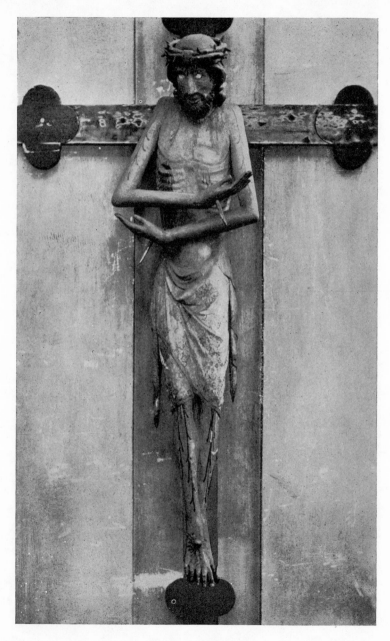

PLATE 37. Crucifix in the Neumünster, Würzburg. About 1000

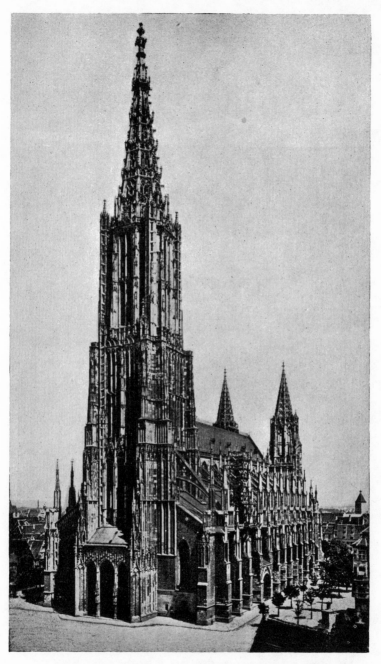

PLATE 38. Ulm Cathedral. Begun in 1377. The spire, completed according to the original plans in 1890, is the highest in the world (528 ft.)

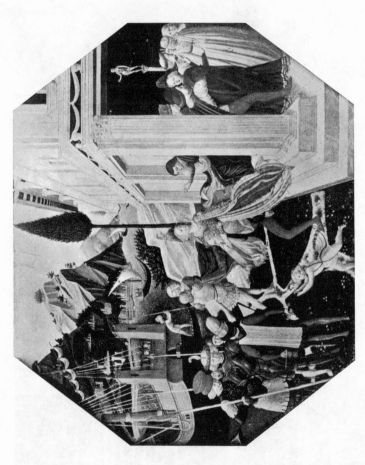

PLATE 39. The Rape of Helen. By Benozzo Gozzoli (1420–1498)

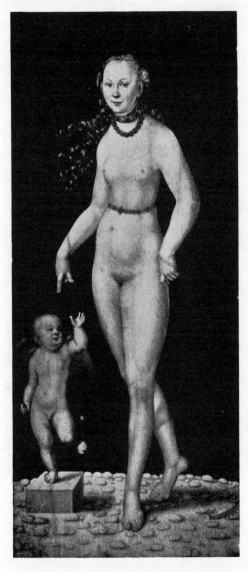

PLATE 40. Venus and Cupid. By Lucas Cranach
the Younger (1515–1586)

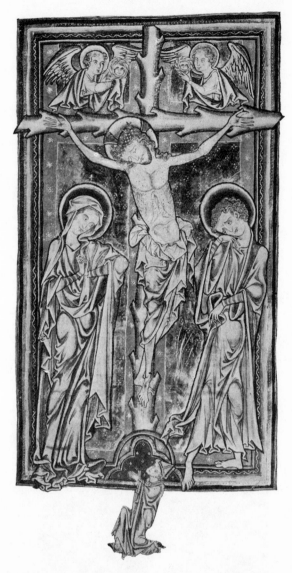

PLATE 41. The Crucifixion, miniature from the Evesham Psalter (a manuscript written and illuminated in the Abbey of Evesham, Worcestershire). English; middle of the 13th century. The kneeling figure is probably the abbot who commissioned the psalter

all historical epochs. The religious idea emerged gradually into human life, at first barely disengaged from other human interests. The order of the emergence of these factors was in the inverse order of the depth of their religious importance: first ritual, then emotion, then belief, then rationalization.'[1]

We shall find, I think, that these four factors correspond fairly well with types of religious art. The art of primitive man, undifferentiated from the whole of his emotive and practical life, was already ritualistic. It was ceremonial, communal, and from the individual point of view, unreflective. And so, as far as we can judge, was the art of the earliest civilized epochs, in Egypt, Mesopotamia and China. Already in neolithic art, those objects which are no longer strictly utilitarian, but primarily æsthetic, are known or assumed, by archæologists, to be ceremonial—objects used in ritual. The same is true of the earliest art of the East— the bronzes and jades of the Han and pre-Han periods.

Ritual generates emotion. Man discovered that what he had done as a necessity of his propitiatory existence, could be repeated with pleasure without any urgent necessity; that the hunting rites, the fertility rites, the rain rites, served as exercises worth doing for their own sake, and without any immediate objective. The activity in itself gave birth to pleasant emotions. To quote Professor Whitehead again: 'In this way emotion waits upon ritual; and then ritual is repeated and elaborated for the sake of its attendant emotions. Mankind became artists in ritual. It was a tremendous discovery—how to excite emotions for their own sake, apart from some imperious biological necessity. But emotions sensitize the organism. Thus the unintended effect was produced of sensitizing the human organism in a variety of ways diverse from what would have been produced by the necessary work of life.

'Mankind was started upon its adventures of curiosity and of feeling.'

From our present point of view, we might say that mankind was started upon the production of art as an independent activity. Though the arts—not only painting, sculpture, architecture and the rest of the plastic arts, but also drama, poetry and dancing— might still have a necessary connection with religion, they were

[1] A. N. Whitehead: *Religion in the Making* (Cambridge, 1926), pp. 18-9.

49

now autonomous activities, conscious of their own æsthetic standards and developing according to their own traditions.

Religion, too, was conscious of the separation, and began to organize itself conceptually, independently of ceremony and ceremonial objects. This is the stage of belief—of the elaboration of myths. Still following Whitehead's account, we can say that 'religion, in this stage of belief, marks a new formative agent in the ascent of man. For just as ritual encouraged *emotion* beyond the mere response to practical necessities, so religion in this further stage begets *thoughts* divorced from the mere battling with the pressure of circumstances. And once the stage of thought is reached, then begins the slow process of reflection, comparison, co-ordination, ending in complete rationalism'.

Now these four stages in the evolution of religion—ritual, emotion, belief, rationalization—imply if not an increasing distance between art and religion, at least an increasing critical attitude on the part of religion towards art. Ritual involves art—needs art for the creation of its ritualistic objects. Religious emotion, too, will inevitably tend to objectify itself in plastic form. So far art and religion are interdependent. But when we reach the stage of the formulation of belief, art may or may not be necessary; it will prove at any rate useful for the elaboration of symbols, those shorthand notes of belief, and pre-eminently for instructional purposes—as a pictorial language for the illiterate. But at the rationalizing stage of religion, when religion becomes more than anything else an affair of philosophical concepts and of individual meditation, then there is bound to grow up a feeling that religion can dispense with such materialistic representations as works of art —indeed, such objects will come to be regarded as definitely antagonistic to the life of the spirit.

If we accept the supremacy of the life of the spirit, then I think we are bound to agree with Hegel, and conclude that 'art is, and remains for us, on the side of its highest possibilities, a thing of the past'. 'The fair days of Greek art,' Hegel declared, 'as also the golden time of the later middle ages, are over. The reflective culture of our life of to-day makes it inevitable, relatively both to our volitional power and our judgment, that we adhere strictly to general points of view, and regulate particular matters in conson-

ance with them so that universal forms, laws, duties, rights, and maxims hold valid as the determining basis of our life and the force within of main importance. What is demanded for artistic interest as well as for artistic creation is, speaking in general terms, a vital energy in which the universal is not present as law and maxim, but is operative in union with the soul and emotions, just as also, in the imagination, what is universal and rational is enclosed only as brought into unity with a concrete sensuous phenomenon,'[1]—a passage which shows how rightly Hegel, almost alone among modern philosophers, understood the nature of art; and shows, too, how necessary it will be to affirm the autonomy of æsthetic values if we are to avoid his pessimistic conclusions.

Far, therefore, from accepting the common assumption that art is the handmaid of religion, and even dependent on religion for its very existence, we must be prepared to find that religion, in its later historical manifestations, is definitely opposed to art—a conclusion for which certain aspects of primitive art prepared us.[2]

It would be a mistake, however, to regard the process of rationalization as in any sense uniform. There are as many rationalizations as there are religions, but actually they conform to three main types, each having extremely different reactions in the sphere of art. Each of these three rationalizations is in effect a different conception of the order of the universe, that is to say, of the idea of God.

RATIONALIZATION OF RELIGION

There is first the Eastern Asiatic type which gave rise to the religion of Buddha. Following Professor Whitehead I have called this development 'rationalistic', but Buddhism is based on a faculty very distinct from the usual implications of rationalism.

[1] *The Philosophy of Fine Art.* Trans. by F. P. B. Osmaston. (London, 1920.) Vol. I, pp. 12–13.

[2] Cf. G. G. Coulton: *Art and the Reformation* (Oxford, 1928), p. 22: 'Though it is true that Art and Religion, from A.D. 1000 to 1600 and later, went through a very similar evolution, yet it was not entirely the course of Religion which dominated that of Art; we have no real excuse for talking of Religion as the bed through which the stream of art flowed. Each evolved in accordance with wider social influences. . . .'

ART AND RELIGION

Far from relying on the intellect, with its dependence on the senses, Buddhism deliberately rejects this mode of knowledge in favour of an intuitive or instinctive apprehension; to some extent, that is to say, it retains the primitive mode of apprehension. 'The same fear of the world, the same need for liberation lives in him (Oriental man), just as it did in man of the first phase of the development. But with this difference, that in Oriental man all this is not something preliminary which recedes before growing intellectual knowledge, as it did in primitive man, but is a stable phenomenon, superior to all development, which is not *before* all knowledge, but *beyond* it.'[1] In this intuitive comprehension of the world, the world is one order, impersonal and unchangeable, and, moreover, part of one universal order, which is self-ordering. There is no dualism of creator and created; God is immanent and the whole of existence, including human life, is subordinate to the incomprehensible process of being.

The second type of rationalism is that evolved by the Semitic religion—the concept of a 'definite personal individual entity, whose existence is the one ultimate metaphysical fact, absolute and underivative, and who decreed and ordered the derivative existence which we call the actual world. This Semitic concept is the rationalization of the tribal gods of the earlier communal religions. It expresses the extreme doctrine of transcendence'.[2]

There is, thirdly, the extreme monist concept of God, which we usually call pantheism. The world is one aspect of the godhead, a phase, perhaps, of a being in the process of development, but nevertheless, as in the Semitic concept, an entity whose existence is the one ultimate metaphysical fact. As a type of religion, it has not the same importance for us as the immanent and transcendent types, firstly because it has not given rise to a distinctive world religion, and secondly because it tends to merge, as a matter of historical fact, in the Semitic type and its various derivatives, among which we should include Christianity. But the Semitic type and the Eastern Asiatic type are directly opposed to each other, and have very diverse effects on the development of art.

[1] W. Worringer: *Form in Gothic* (Eng. trans. London, 1927), p. 36.
[2] Whitehead, *op. cit.*, p. 68.

BUDDHISM

Buddhism, which conceives nature as animated by an immanent force, which force is the one order to which the whole universe conforms, must inevitably affect the whole basis of art, in so far as art is a representation of reality or of the super-reality behind natural appearances. The quality which strikes us most in Buddhism is resignation; the submission of the individual to this all-forming spirit of the universe, this destiny. The artist shares that humility, and his only desire is to enter into communion with that universal spirit. This desire has all sorts of consequences: it leads to a preference for landscape-painting above figure-painting. 'We hold the view,' writes a modern Chinese painter, 'that the human capacity for calculated action and behaviour has led to all kinds of evil conduct. The human body grows corrupt from the crooked thoughts it harbours, and so we do not care to paint it'.[1] Nature is more sublime, nearer to the universal essence, than humanity. But what the artist sees of nature he realizes is only the deceptive outward appearance of things. He will therefore not strive to imitate the exact appearance, but rather to express the spirit. This implies a certain abstraction, an expressive stylization of infinite sublety and refinement which has only the remotest analogies with the similar qualities we have seen in primitive art.

It is not within my present scheme to trace the influence of a religion like Buddhism on the forms of Eastern art; I am only concerned with the uses to which society puts art, and Buddhism is merely one example of the religious use. But there is one curious feature of the Buddhist influence on Chinese art which has a general bearing on our enquiry. Buddhism was introduced into China between the fourth and sixth centuries of our era. But some of the most essential qualities of Chinese art are present long before the coming of Buddhism, and if the art continues to express the new religion, it is only because the religion was adapted to a prevailing mode of life. Chinese Buddhism is, in fact, a religion differing in many respects from Indian Buddhism, and even has a distinct name (Amidism). And as the religions differ, so do their manifestations in art, even in the art of literature. A well-known

[1] Chiang Yee: *The Chinese Eye* (London, 1935), p. 10.

French authority on Eastern art, René Grousset, has made an interesting comparison between Buddhist poetry in India and China:

'We have only to compare an Indian Buddhist poem . . . with the poetry of the Buddhist literati of the T'ang age. . . . In the Indian poems, on the one hand, we find, no doubt, a delightful poetry rich in every subtlety of feeling and sensuous delight, but, whether in one sphere or the other, appealing to a plastic sense which makes India appear to us, on the whole, as a wider Greece. . . . Among the Chinese, on the other hand, we find a poetry which is a record of subtle impressions and seems to shrink, not only from profusion, but even from too concrete a materiality: a poetry of impressions, powerfully but often briefly recorded, barely hinted at before they become blurred; a poetry which, instead of seeking concrete expression, as it did in India, by descending from its metaphysical inspiration into the material world of images, seems to be for ever ascending the transcendental path from its starting-point in reality towards its bourne in the immaterial and unexpressed.'

M. Grousset goes on to point out that we may even regard this attitude of mind as one of the constant factors in Chinese thought. 'At the very origins of Chinese thought—for instance, in the Chou bronzes—we found an ideal of art of an immanent and potential order, consisting in a sense of the mystery diffused through things and of latent cosmic forces.'

This fact is of the utmost significance for our enquiry, for it implies that beyond art, and beyond religion, there are elements of a more stable and fundamental nature which determine the forms of religion no less than of art. What those elements are it is difficult to say—or rather, the obvious explanation seems too simple. For that explanation is ultimately the climatic one, with the economic factors which in their turn also to some extent depend on climate. Over any considerable period climate will determine the habitat, the physique, the economic life and finally the ethos or soul of a people.[1] And so long as these material factors

[1] Cf. for an extreme statement of the influence of climatic factors on human development—*Race, Sex and Environment: A study of Mineral Deficiency in Human Evolution*, by J. D. de la H. Marett. London, 1936.

remain constant, whatever kind of religious thought or artistic style is imported into the country, will be adapted and modified until it conforms to the fundamental spiritual attitude. To prove this we do not need to rely on the solitary example of Buddhism in China; we need only trace the modifications which Christianity underwent as it spread from its Semitic centre. The Greek Church in the East, the Roman Church in the West, and the Protestant Church in the North—these are not so much one religion professing the gospel of Christ, as three religions with a common origin but totally distinct growths, each growth being determined by the basic motives of climate and habitat.

The relevance of religion, therefore, to our enquiry is merely contingent. Religion is not an essential to art; nor art to religion. The æsthetic impulse is inherent in man, and the only question is to what extent a particular religion educates or inhibits that impulse.

SEMITIC RELIGION

Just as certainly as Buddhism makes use of art, making art an ideal vehicle of communication with the divinity in things, equally certainly does the second main historical type of religion, the Semitic, discountenance art. This attitude is unquestionably bound up with its inveterate personification of the deity. Once you combine the notion of divinity with the notion of individuality, anthropomorphic complications are bound to ensue. The deity will be man writ large, and it will be difficult not to ascribe to him some of the weaknesses as well as the virtues of mankind. Above all, such a god will be a jealous god, intolerant of rivals and of any form of divided loyalty. So not only will it be blasphemous to attempt to represent such a god in material shape, but the worship or reverence of any kind of image will be idolatrous. And so we get the phenomenon of a great world religion altogether devoid of a corresponding plastic art. When in the course of time another great religion branches off from Israel, we find it taking over this among many other tenets, and prohibiting the making of images. This religion is Mohammedanism, and though some sects in Persia and India allowed the painting of figures in two dimensions,

in general the ban was universal and effective over the whole Islamic world. This did not, of course, imply a complete stultification of the æsthetic impulse; in architecture and in the crafts generally, where an abstract type of art was suitable, this impulse had free play, and flourished exceedingly. Indeed, the great interest of Islamic art is precisely this: that the æsthetic impulse, dammed up in the humanistic direction, insists nevertheless on an outlet, which outlet takes the form of a decorative and non-figurative art which cannot be paralleled elsewhere in the world. For art, like murder, will out.

GREEK RELIGION

If I now refer briefly to Greek religion and its relations to art, the way will be clear for a more extensive consideration of Christian art. Art and religion seem to have found a state of perfect equilibrium in the Hellenic epoch, and for that reason it might be thought we should have given this period our closest attention. But actually the Greek view of religion does not fit in very well with our underlying presuppositions. Or rather, in its fully developed and typical form, Greek religion has carried the process of rationalization so far that religion has become philosophy, and the particular problem we are considering no longer exists.

Let me quote a few detached sentences from Lowes Dickinson's summary of the Greek view of religion:

'By virtue of this uncritical and unreflective mode of apprehension the Greeks . . . were made at home in the world. Their religion suffused and transformed the facts both of nature and of society, interpreting what would otherwise have been unintelligible by the idea of an activity which they could understand because it was one which they were constantly exercising themselves. Being thus supplied with a general explanation of the world, they could put aside the question of its origin and end, and devote themselves freely and fully to the art of living, unhampered by scruple, and doubts as to the nature of life.'

' . . . they were not conscious of a spiritual relation to God, of sin as an alienation from the divine power and repentance as the means of restoration to grace. The pangs of conscience, the fears

and hopes, the triumph and despair of the soul which were the preoccupations of the Puritan, were phenomena unknown to the ancient Greek. He lived and acted undisturbed by scrupulous introspection; and the function of his religion was rather to quiet the conscience by ritual than to excite it by admonition and reproof.'[1]

Professor Whitehead has defined religion as 'what the individual does with his own solitariness'. The Greek did not feel solitary. He was at home in the world. As Worringer has said: 'With the coming of Classical man the absolute dualism of man and the outer world ceases to exist, and consequently also the absolute transcendentalism of religion and art. The divine is stripped of its other-worldliness; is made worldly, is absorbed into mundane activity. For Classical man, the divine no longer exists as an exterior world, is no longer a transcendental idea but exists for him in the world, is embodied in the world'.[2] The process of thought has developed so far that the correlate of art is no longer religion, but science or philosophy or simply *humanism*; and as such Greek art properly belongs to a later stage of our enquiry.

CHRISTIANITY

We come finally to Christianity, which is an extremely difficult religion to generalize about. Semitic in origin, it is quite ready, even from the beginning, to accommodate the notion of immanence, and in some of its phases has leanings towards pantheism. As I have already suggested, it is modified according to its material environment. But twice in its history its relation to art has been a decisive factor in its disruption—once specifically in the Iconoclastic Controversy, and then less definitely at the Reformation. At both crises the resulting schism had a territorial and even a climatic basis, proving once again the incapacity of dogmas to surmount natural barriers.

From the beginnings of Christianity, there were two traditions of doctrines about the use of art—the Syrian and the Roman.

There is no doubt that at first Roman Christianity carried on the Semitic tradition and shunned any representation of holy

[1] *The Greek View of Life* (London, 17th edn., 1932), pp. 65-6.
[2] *Form in Gothic*, p. 28

persons. In the second century Clement of Alexandria expresses the strict view when he says: 'It has been plainly forbidden us to practise deceptive art; for the prophet says, "Thou shalt not make the likeness of anything that is in heaven, or in the earth beneath".' But that strict injunction was departed from to the extent of allowing a symbolic art, and in the first two centuries pictorial representations of the dove, the fish, the ship, the anchor, the lyre, the fisherman and the shepherd were used. For the rest of their decoration, the early Christians took over motives from Pagan— that is to say, debased Hellenic—art: Cupids with garlands, birds, grape-vines, flowers and all kinds of purely ornamental motives, the familiar art of the catacombs. Though the artists who carried out the decoration of the Roman catacombs are reputed to have come from the East, the early Christian art of Syria and Asia Minor seems to have been more original and more realistic. The general iconography of Christianity (the traditional modes of depicting Christ and the Apostles) can be proved to have been of Eastern origin. But these are large and difficult questions that do not really concern us. What is certain is that the Church in Rome gradually modified its policy, and by the fifth century the depiction of Christ, and a fortiori of the Apostles and saints, was permitted. Certain sects, the Nestorians in particular, remained unconvinced, and with the rise of Mohammedanism the Semitic tradition was given a new life which was not without its repercussions on Christianity. And when the great iconoclastic controversy finally came to a head in the eighth century, there is no doubt that the iconoclasts derived much of their doctrine from Eastern heresies such a Monophysitism.[1]

THE ICONOCLASTIC CONTROVERSY

We cannot follow the course of that controversy in detail, but some of its general features are very important. What was really happening during these first centuries of the Christian religion was but a repetition of a development that had taken place before in the world's history—notably in Egypt. On the one side there

[1] 'Iconoclasm was an Asiatic movement, supported by Asiatic emperors, Asiatic bishops and the Asiatic army.' Edward James Martin, D.D.: *A History of the Iconoclastic Controversy* (London, 1930), p. 34n.

evolved an official dogmatic conception of art, which would keep art esoteric and mainly symbolic; on the other side there evolved a vulgar and realistic conception of art, an art for the instruction and superstitious enjoyment of the people. But at this particular crisis of Christianity it was not a clear-cut issue between the priesthood and the people; for on one side was the priesthood supported by all the might and authority of the Eastern emperors; on the other side were the monasteries in close touch with the common people.

No doubt the iconoclastic controversy was not merely an abstract theological issue. Dr. Martin, in the book already referred to, says that it is 'a nice historical riddle' to define the motives and aims of the Emperor Leo, who initiated the reform. 'That Leo's motives were partly religious seems indisputable. The Asiatic environment in which he lived so long was . . . permeated with Iconoclastic ideas. All the traditions of the Christian Emperors involved them in theology. The connection of Church and State in Constantinople was of such a character that the Emperor was by his office a church official. . . . At the same time Leo's motive cannot have been purely religious. . . . A political and social aim is to be sought also . . . Leo's political ideal seems to have been simply to make use of his religious point of view to support his general scheme of purifying and raising the low tone of society. It was not the preliminary plan of Leo but the reactions that met it that moulded the form and the theology of Iconoclasm.' The images came into question, as we have seen modern art come into question, as part of a general change of cultural anarchy— Kulturbolschevismus. But it was anarchy from a party point of view—in this case the imperial party. When it came to the point, the Emperors discovered that the images represented not so much the decadence of one form of religion, as the strong nascent spirit of a new religion—that popular Christianity which was finally to triumph over the whole of the western world.[1]

[1] Cf. Victor Lasareff: 'New Light on the Problem of the Pisan School, *Burlington Magazine*, February, 1936. The author distinguishes between the two opposing artistic traditions in the east—'the metropolitan Constantinople tradition imbued with the spirit of Hellenism, and the Eastern Christian tradition which was distinguished by a peculiar expressiveness, and was closely connected with the popular sources, principally located in the provinces and

ART AND RELIGION

The iconoclastic view is surely very easy to understand. Apart from the Old Testament injunctions against idolatry, the whole teaching of Christianity was imbued with the Semitic dislike of images and idols. But though the charge of crude idolatry was not without some justification, the case against images was given an altogether subtler and more theological character. The Iconoclasts regarded the images as drawing 'the spirit of man from the lofty adoration of God to the low and material adoration of the creature'. That is to say, in Dr. Martin's words, 'they conceived of idolatry as an attitude of mind which led a worshipper to substitute the created thing for its Creator'. But of course that lofty view was soon lost sight of in the bloody and embittered struggle which ensued.

The defence of images, as put forward by St. John of Damascus, for example, is elaborate and logical. Neglecting its purely theological aspects, the image is defended both as symbol and as a medium of instruction: a modest claim. But when the Council of Nicæa met in 787 to settle the question once and for all time, the actual formulation of the true doctrine was of extraordinary latitude:

'We therefore following the royal pathway and the divinely inspired traditions of the Catholic Church . . . define with all certitude and accuracy that, just as the figure of the precious and life-giving Cross, so also the venerable and holy images, as well in painting and mosaic as of other fit materials, should be set forth in the holy churches of God and on the sacred vessels and on the vestments and on hangings and in pictures both in houses and by the wayside, to wit, the figure of our Lord God and Saviour, Jesus Christ, of our spotless Lady, the Theotokos, of the honourable angels, of all saints, and of all pious people. For by so much more frequently as they are seen in artistic representation, by so much more readily are men lifted up to the memory of their prototypes and to a longing after them; and to these should be given due salutation and honourable reverence, not indeed the true worship of faith which pertains only to the divine nature, but to these as to the figure of the precious and life-giving Cross and to the book of

especially vigorous on Asiatic soil'—and proceeds to show how this second tradition spread to Europe through Pisa in the beginning of the thirteenth century and so influenced the whole development of Italian painting.

the Gospels, and to the other holy objects incense and lights may be offered according to ancient pious custom. For the honour which is paid to the image passes to that which the image represents, and he who reveres the image reveres in it the subject represented. For thus the teaching of our holy Fathers, that is the tradition of the Catholic Church . . . is strengthened. . . .'[1]

But though this formulation was accepted and a united doctrinal front thus obtained, actually in practice the East and the West were to go their own ways. 'It is probable', says Dr. Martin, 'that throughout the East the actual restoration of pictures was ineffectual.' Syro-Semitic Christianity was henceforth to fight a losing battle, but only from the point of view of an orthodox Christianity. From its own point of view it was remaining faithful to the profounder traditions of its civilization—traditions based, as I have suggested, on cruder and more elemental because material facts.

The theological results of the controversy do not concern us here. In the East the art of the Church, doctrinally forced to run counter to native instincts, became formal and stereotyped. 'And so there became established the featureless conventional face of the eikons.' At the same time the dualism between religious and profane art which we have already noted was accentuated, and henceforth the two types of art developed independently of each other. Outside the official images, the Eastern Church cultivated an art of paganism, a cult of Hellenic motives, of Alexandrian affectations. Plato, Aristotle, Plutarch, Sophocles, joined the blessed company of the saints and apostles; Cupid and Psyche hovered about the scenes of the Passion. But side by side with this official art there was the popular art, still supported by the monasteries, rejecting all commerce with paganism, fanatical, realistic and superstitious, deriving from the realistic tradition of Syrian monasticism. It still appeals to us, as it did to the people of that time, by its freedom, its dramatic force and its humanism.[2]

I have said that the iconoclastic controversy was settled once and for all by the Council of Nicæa, but actually it was to break out again in the ninth century. No new principles were involved, and the iconoclasts failed completely to achieve their objects

[1] Martin, *op. cit.*, pp. 103–4.
[2] Cf. Louis Bréhier: *L'art byzantin* (Paris, 1924), pp. 32–62.

The movement hardly touched the Western world, but there was an outbreak in the Frankish Empire during the reign of Charles the Great and there was the affair of Claudius of Turin in the ninth century—but these were isolated incidents in the development of Christianity and had nothing to do with the next great movement against art instigated by Christians—the Reformation and more particularly Puritanism.

CHRISTIAN ART IN THE NORTH

As Christianity spread northward from its Mediterranean cradle, it carried with it its two main artistic elements: the symbolism of its official aspect and the realism of its popular aspect. The former element penetrated first and farthest; Syrian motives were planted in the Ultima Thule of that world—in Northumbria and the Hebrides. Meanwhile the popular element was acquiring many of the features of pagan art—the naturalism and grace of late Hellenic art. When they reached the north these elements, as well as the spiritual doctrines they represented, had, like Buddhism in China, to contend with the *genius loci*. And that *genius loci* was something very different from the background against which Christianity had hitherto developed. There was darkness instead of light, cold instead of warmth, gloom instead of gladness; and there was an indigenous art of corresponding character. This art, which we can most conveniently call Celtic, was a direct survival of the neolithic art we have already mentioned. It was an art that renounced naturalism, an art tending toward abstraction and purely geometrical ornament We know very little of the religious cult of this time, but we can assume, on what evidence there is, that it differed very little in kind from the religion of primitive man. 'It was far removed from devotional reverence and submission to the deity: the cult exhausted itself in fear-laden incantations and a wealth of sacrifices for the appeasement of wayward, supernatural powers,' suggests Worringer. And such a religious spirit would account for the awesome, agitated character of Northern art.

I do not wish to exaggerate the importance of the climatic factor, but the fact remains that whenever an ideological move-

ment—whether merely stylistic or profoundly religious and spiritual—is transplanted into a region of different climatic and material conditions, that movement is completely transformed. It adapts itself to the prevailing ethos—that emanation of the soil and weather which is the characteristic spirit of a community. And it is precisely in the two greatest religious disseminations—Buddhism in China and Christianity in Europe—that the process can be most clearly observed.

The northern trend of Christianity led to the introversion of Christianity. From a religion external, ritualistic and hieratic, it gradually developed into a religion of individual belief—always introspective, sometimes morbid and fanatical. That process is one which involves the gradual disuse of objective aids to worship.[1] In its great triumphant and proselytizing period—say from the tenth to the thirteenth centuries—every means was valuable for the visual instruction and the awesome enthralment of peoples emerging from barbarism; and during this time the Church was still largely governed from the South; its architects and artists were still at school in the East. But slowly the image was giving way to the idea: What is the Gothic cathedral, when once it had become conscious of its individuality and its new direction, but the representation in stone of a vague instinct and aspiration, which we can best describe by the abstract concept of transcendentalism? It is true that during the whole of the Gothic period this great and pure abstraction was to be hung like a Christmas tree with bright statues and paintings and pictorial windows; but there is a clear division, indeed often a strident opposition, between these two types of art—the architecture with its esoteric significance only vaguely apprehended by the people, and the minor arts which were also the popular arts, and in practice often the objects of a superstitious cult. But whether with Professor Whitehead we are to regard it as following a normal historical process of development from ritual through emotion and belief to rationality; or whether we are merely to regard it as conforming to the *genius loci*, the climatically determined temperament of northern man, Christianity was destined to divide, and in its northern division

[1] The extent to which this development had taken place in the Church *before* the Reformation is well brought out by Coulton, *op. cit.*, Chap. XVI.

largely to discard its æsthetic elements. After the Reformation the art of Northern Europe is no longer specifically Christian art. Protestantism, if not defiantly opposed to all manifestations of sensuous values, was ever to be suspicious of them.[1]

The course of development was very different in the South of Europe; there the opposition was not simply one between Christianity and art, but rather between two conceptions of art, one subordinate to religion, the other free. The Renaissance is not simply a rebirth of art; art was never stronger or more significant than in the centuries immediately preceding the Renaissance. The Renaissance is rather the paganization, the secularization of an art too vital any longer to submit to religious control. Just as in philosophy the same period shows the slow emancipation of reason from the control of supernatural dogma, so art is emancipated from ecclesiastical control. It may still be used to express an individual religious sentiment, but that will not be its exclusive function. The whole realm of nature is thrown open to the artist, and there he may wander free to select and idealize and portray what he will. We must not conclude that such freedom will be altogether good for him; we may, indeed, when we come to investigate that question in the next chapter, discover that it was in the end altogether bad for him.

[1] A late example from the history of our own art may be given. In 1773 Sir Joshua Reynolds and Benjamin West tried in vain to carry through a scheme for the decoration of St. Paul's by pictures, but were defeated by the then Bishop of London, Dr. Terrick. It was no doubt this experience which led Reynolds to make the following observation: 'It is a circumstance to be regretted, by painters at least, that the protestant countries have thought proper to exclude pictures from their churches: how far this circumstance may be the cause that no protestant country has ever produced a history-painter may be worthy of consideration'. Reynolds' observation has some bearing on the general problem. Faced with a phenomenon such as the predominance of portrait painting in England in the eighteenth century, the economic determinist would be prepared to explain it as a direct response to the demands of the wealthy classes of the time; but this is only half the truth. Those same classes controlled the Church and could have used their artists for religious or historical themes in the grand manner but for an inhibition of a purely ideological nature. That the ideology of puritanism is in its turn determined by economic circumstances may be true enough; my wish at the moment is, however, to point out the superficiality of any too direct equation between the art and the economics of a period.

Chapter Four

SECULAR ART

All mythology masters and dominates and shapes the forces of nature in and through the imagination; hence it disappears as soon as man gains mastery over the forces of nature. What becomes of the Goddess Fame side by side with Printing House Square?

KARL MARX, *Critique of Political Economy*

Most historians of the Renaissance, perhaps following Burckhardt's lead, have seen that decisive change in European culture as in some sense a passage from collective values to individualism. We have already had reason to question the reality of any collective notion of art. It is true that in the Middle Ages many phases of thought and feeling take on a collective aspect, being controlled by the central authority of a universal church. It is equally true that under such a dispensation individual values are at a discount, and a work of art is valued primarily for what it expresses, and not for the manner of expression. But the survival value of the work of art—the qualities in it which survive the ideas and aspirations of a particular age to appeal to the æsthetic faculties of succeeding ages—these are to be regarded as primarily the creation of individuals endowed with exceptional skill or sensibility. The Renaissance, therefore, did not bring about a fundamental change in the nature of art; it merely altered the conditions under which the artist worked; freeing him from disciplines and inhibitions and allowing him a specious freedom of action. I say a *specious* freedom, because in the outcome the artist discovered that he had merely exchanged one kind of dependence for another; he might henceforth be free to express himself, but only on condition that the 'self' expressed was a marketable commodity—a form of economic servitude which is still in force, and which has proved no less vile than the spiritual servitude of the preceding epoch.

65

SECULAR ART

THE ARTIST AS INDIVIDUAL

Worringer has already proposed an amendment of Burckhardt's view which puts the most favourable construction possible on the change; for the word 'individual' we should substitute 'personality'. This should be done at least for the Southern Renaissance, where the development does not suggest a 'crowd mechanically divided up into innumerable, incoherent, individual parts but a vast social organism, gradually becoming conscious of its individual parts and developing its compact mass into a thousand delicate individual organs, each one of which lived in a smaller, more subtle way the life which held the whole organism together.' Whether the Northern Renaissance, which we tend to identify with the Reformation, was of an essentially distinct nature, is a question we will discuss presently. Certainly, however, in Italy the process was a positive one in the direction of increasing self-assertion, self-affirmation, self-control.

We return to Professor Whitehead's phrase; for the process was equally an increasing awareness, on the part of the individual, of his solitariness—of his differentiation from the crowd. But in the South such was the self-confidence of the individual in this situation that the resulting attitude is no longer essentially religious, but pagan. And by paganism, in this context, we do not imply even the half-divine order of an Olympia, but merely an unreflecting hedonism, not yet compelled by circumstances to rationalize its experience.

Such a transformation of sentiment as the Renaissance represents does not take place autonomously; it is not the free and disinterested expansion of a doctrine or an idea. It is rather the direct expression of economic processes. We have seen how the Iconoclastic Controversy, abstract enough to all appearances, was but a reflection of the conflicting power, wealth and interests of the imperial court on the one side and the monasteries on the other side. So in this new development the ideological changes merely register a shift in the possession of economic power. During the fourteenth and fifteenth centuries the Church committed the fatal mistake of relaxing its rules against usury; it allowed, that is to say, the growth of a system which divorced wealth from production

by making money, which had hitherto served merely as a medium of exchange, become in itself a commodity. That seems the essential factor in a complicated historical process in which war and technology played important parts. Whatever the details of the process of change, the final result is not to be mistaken; just as with the decline of the central imperial power the Church had gradually assumed a preponderating influence based on wide possessions and the effective control of wealth, so now there grew up men and corporative bodies wealthy in their own rights and as a result of their own efforts, and these forces soon found themselves in conflict with the Church. Here a republic challenged the authority of the Pope, and elsewhere a king dispossessed the wealthy monasteries, and those are the events which loom large in our history books. More significant, however, is the change of mood and temperament which affected people at large. I am not going to discuss the ways in which the economic changes brought about this change of heart. The actual process consisted, I believe, of an infinite series of small deflections and counter-deflections caused first by one force and then by another, the heart taking, as a result, the zig-zag course of a vessel tacking against the wind. As the historical process developed, it revealed itself as a disintegration, better still, as a differentiation. Granted that the homogeneity of the Middle Ages is to a great extent an effect of distance—of not being able to see in the mass the details which a closer inspection would reveal—yet nevertheless the fact remains that between the end of the classical civilization of Rome and the beginning of the Renaissance in Italy, the individual did not strive to express, or did not succeed in expressing, his own personality. He expressed, as an artist, his sensibility. But that sensibility was not used either to reveal a point of view personal to the artist, or to depict what was personal or idiosyncratic in others. But slowly all that changed. The artist declared himself, confessed his humanity, and celebrated the humanity of his fellow-men.

THE RISE OF PORTRAIT PAINTING

A striking clue to this development is found in the rise of portrait painting. Roman art, especially in its sculpture, had expired in a

high fever of realism—a portraiture of exact and even mordant skill. Though this desire for self-record did not entirely disappear in the Early Christian and Byzantine periods—there are certain etched goldleaf medallions, for example, of startling realism, as well as certain portrait busts and statues of the later emperors—nevertheless, the face in general was hidden behind the mask, and remained there until the Renaissance once more revealed it.

Sometimes in a mediæval work of art—in the corner of a stained-glass window, in the margin of a manuscript—we may discern a tiny figure which on inspection proves to be a summary portrait of the artist, or more likely of the donor of the work to the Church. In the fourteenth century this figure is gradually obtruded. It increases in size and relative importance, until, by the time we reach the middle of the fifteenth century, the donor may rank equal with the figures of the Holy Legend. Then, by the time we reach the sixteenth century, the donor and the artist have, so to speak, detached themselves from the legend, and a man is portrayed in his own right, separately and distinctly. For more than a century the whole aim of art seems to be to develop the psychological expressiveness, the verisimilitude and the actuality, of the representation of the human personality. In that aim the effort of Raphael culminated, and before and after Raphael a whole host of painters and sculptors were animated by that same will.

SELF-EXPRESSION

Next to the personality, the artist tried to depict his personal vision or fantasy. No longer hesitating to depict the super-natural figures and scenes with earthly realism, the artists vied with each other in giving their subjects every conceivable accent of originality and extravagance, desiring always to exhibit their own skill and imagination. In their search for fantasy they deserted the sacred legends and turned to the rich field of profane mythology, even mingling the two strains, as, less consciously, the early Christians had done. Finally, they dispensed with legend altogether, and resorted to the final phase of introspection—the expression of their individual vision. When the painter turned from

the telling of a story or the portrayal of a personality to the painting of inanimate subjects—landscapes and still-lifes—he was taking a step of peculiar significance. He was no longer saying 'I paint this subject because I think the incident or the person will interest you,' but rather 'I paint this scene or these objects because I think you will be interested in how well I paint them'. An artist like Giotto or Raphael had always been valued for his miraculous skill in rendering nature, but there had always been the saving element which we call the human interest. The artist was now to paint pictures without this human interest, and though the ignorant might still admire the result for its verisimilitude, the public whom the painter was really addressing were asked to admire the personality expressed in a harmony of colours and a coherence of form. The more the artists developed this tendency, the more they separated themselves from the understanding and appreciation of the common people.

We have now no lack of evidence, and we can distinguish in this period certain relations between art and society whose existence we have had reason to suspect in all periods. On the one side there is the complex mass which we call society or the people, and their demand is for naturalism or realism—for a picture that tells a story. On the other side is the artist, an individual or a member of a restricted élite, and his demand is to express himself—his feelings or his thoughts. We thus have set up a tension or opposition between the artist and society which is capable of explaining all the alternations of the history of art since the Middle Ages.

THE ART OF THE ÉLITE

Without following a sociologist like Pareto into the detail of his long and elaborate analysis of society, we may accept as true for the whole of the modern period his conception of a relatively small compact body which is subject to a process of 'circulation'. Outside idealistic communities with no historical continuity, civilized society has always shown this division into a comparatively small and closed governing class on the one hand, and on the other hand a large and amorphous mass of 'common people'—from which, nevertheless, a new élite in due course arises to displace a govern-

ing class grown decadent and effete. Such, at any rate, is the typical formula for European societies from the Renaissance onwards (and I do not mean to imply that it is not the typical formula before the Renaissance). Corresponding to this formula we have a similar division of art, and perhaps a similar process of circulation. The élite accumulates power and wealth and leisure. It demands outward symbols of its position, and above all those which reflect its pomp and glory. The art of architecture especially is in requisition, and most of the other arts follow in its wake. Schools and academies are established and there grows up what is variously known as a tradition, or taste. That is to say, a type of art guaranteed to appeal to the refined sensibilities of an exclusive class. The 'taste' of a period does not control or determine the art of a period, any more than the religion of a period does. It is a parallel development, or rather, in the sense I have already explained, a dialectical development within the synthesis we call the culture of a period. The artist creates his work within the limitations of the particular tradition into which he is born, but the conditions of his 'greatness' or 'genius' or whatever the word is by which we denote his exceptional character, is that he transcends the tradition in some respect, and thereby modifies it. So the taste of a period is moulded and progresses by infinitely small acts and experiments. The more closed and exclusive the group within which this process is taking place, the more refined and esoteric the product becomes, until its decadent character can no longer be disguised. By that time the group itself is probably ready to disintegrate, and the art and its social foundations perish together, to be replaced by a new élite springing from the general mass of the people, and bringing with it a crude but virile art—an art which will in its turn submit to the process of refinement.

POPULAR ART

The popular art, like the art of the élite, is there all the time, and just as it existed in other well-defined periods, like the Egyptian and the early Christian, so it existed in the Middle Ages and the Renaissance, and may still be found to-day, often where it is least suspected (in aeroplanes and motor-cars, in films and in sports

accessories). Such art is always diffused, appealing to a wide undifferentiated public, and generally not recognized or acknowledged as art *at the time of its creation*. But certain theorists, looking back on the history of art, and seeing the inevitable rise of such types of art in any given period, are apt to make a qualitative judgment, and say that what is popular is therefore best. Herein lies a definite danger. A certain type of art is popular at any given time, and perhaps there are certain characteristics of such popular art which are universal and permanent—it is generally realistic, for example. But it is illogical, and false to the very nature of the dialectical process of history, to take that further step which demands that the art of a particular period *should* be popular. The typical art of a period is the art of the élite, and it is contradictory to assert that the art of an élite can or should have the characteristics of popular art. Such a demand can only be made for that hypothetical state of society, the classless society, which has no élite.

Incidentally it is to be observed that the classless state, as conceived by Marx and Engels, and as most explicitly defined by Lenin in his *State and Revolution*, by no means involves the abolition of élites. Élites are a reflection of a natural differentiation in the talents and abilities of men, and to attempt to suppress their manifestations in art or any other creative medium would be to go contrary to the unalterable facts of our human nature. The élite becomes a caste or class when it adds authority to expression, substitutes power for persuasion, and generally forsakes the æsthetic or moral basis of its activity.

Even granted classless society, it is still necessary to ask whether popular art as it has been known in the past, and as it is known to-day, can possibly satisfy all the requirements of a full æsthetic sensibility. That we must doubt, and for the following reasons.

The artist, the individual endowed with exceptional sensibilities and exceptional faculties of apprehension, stands in psychological opposition to the crowd—to the people, that is to say, in all their aspects of normality and mass action. That very acuteness of perception which distinguishes the artist is purchased at the price of maladaption, of nonconformity and revolt. I do not wish, for the moment, to examine the psychology of the artist, but we have only

to look at our comic papers, indeed at the whole literature and iconography of the artist as a type, to see him universally branded as a freak. Behind all this popular derision and contempt is a recognition of the truth which Plato recognized on a sublimer plane—namely, that the artist is an eccentric element in any well-ordered or egalitarian community. He is an exception, and because he is an exception he becomes in some sense a parasite—but a parasite, not of the people, but of the élite whom he can flatter and amuse, and who will, in return, give him the means of subsistence. Nowhere has this process been more clearly demonstrated than in Soviet Russia, where the artist is dependent for his very existence on the approval of a political minority.

The cynic and the philistine can leave it at that, failing to recognize that the artist's exceptional faculties give him more than manual dexterity, more than sensuous refinement, that 'more' which is an intuition of the nature of reality, and justifies us in regarding art as an indispensable mode of knowledge. There are these two aspects to every artist's work: its technical externals or craftsmanship and its inherent truth or expressiveness. Both the dilettante at one extreme and the uneducated mass of people at the other extreme concentrate on the externals—the one on the subtleties and refinements of technique, the other on the blatant display of skill, by which is always meant the creation of an illusion of reality. But the artist, in the degree of his greatness, has to avoid these temptations and the flattery or popularity which they bring. 'The artist', as Cézanne was to realize, 'can only appeal to an extremely restricted number of people.'[1] In a letter to his mother this great painter shows how clearly he realized the sacrifice required of him. He was then thirty-five years old, and still completely unrecognized. 'I am beginning to find myself stronger than any of those around me, and you know that the good opinion I hold of myself has not come to me without good reason. I must go on working, but not in order to attain a finished perfection, which is so much sought after by imbeciles. And this quality which is commonly so much admired is nothing but the accomplishment of a craftsman, and makes any work produced in that way inartistic and vulgar. I must not try to finish anything

[1] Letter to Bernard quoted by Gerstle Mack: *Paul Cézanne* (London, 1935).

except for the pleasure of making it truer and wiser.' And again, late in his life, he indicates the essential quality which the artist must possess to save him from vulgarity. 'It is only the initial force,' he writes, '*id est* temperament, that can carry one to the goal one is seeking.'[1] And by temperament he means, of course, those characteristics of heightened sensibility, of imaginative apprehension and other allied faculties which together constitute the uniqueness of the artist.

THE ARTIST'S DILEMMA

If the artist were condemned to isolation, he would be stultified. His faith is that the extremely restricted number of people to whom alone he can hope to appeal directly will in their turn influence a wider circle of people, and so by degrees and in the course of time his truth and wisdom are assimilated by the people, and become a part of the culture of his period. Such indeed is the process of integration which the anthropologists speak of.

But even in his immediate task of appealing to a restricted number of people, the artist must select what we might call a mode of conveyance. His emotions and feelings are individual—always fundamentally the sensational awareness of a particular nervous organization. He can satisfy himself—express himself—entirely by these means, but if he is to reach outside himself he must operate within some more or less restricted communal emotional unity corresponding to the collective representations which are the natural possession of primitive peoples, and of peoples professing a universal religious unity. Self-consciousness has destroyed such collective spirituality in the modern world, with the result that the artist must seek a substitute, which may be a residue of religious superstition, but more probably some form of idealism. The history of art since the Renaissance is mainly a history of its dalliance with various forms of idealism.

Its first recourse was to that type of idealism which had been so fruitful in the past—the pagan idealism of Greece. That resuscitated idealism was to undergo many modifications between the fifteenth and the nineteenth centuries, but it remained the essen-

[1] *Op. cit.*, pp. 199 and 365.

tial basis of what we rightly call the classical tradition. But already in the eighteenth century we have the rise of an alternative ideal, at first not wholly dissociated from classicism, which we shall call moralism. And finally, in the nineteenth and twentieth centuries, we get a series of modifications and reversions most of which may be included within the concept of romanticism—even that extreme form of individualism which would reject all compromise with idealism, and depend for its appeal on the bare sensationalism of form and colour.

In all this process the artist is contending, not only with his own technical problem, which is to reconcile his æsthetic sensations with an external ideological motive, but with the no less acute problem of securing for himself a livelihood in a world which has reduced all labour to a cash basis. The work of art, that is to say, has become a commodity which the artist must sell in the open market, or perish. The conditions of his work are such that the price he must put on his commodity is one which only the rich can afford. That is to say, art becomes not merely a commodity, but more precisely a luxury product. The means to commission or purchase luxuries belong only to those individuals whose acquisitive instincts have triumphed in competition with their fellow-men, or exceptionally to those who have inherited the wealth of such individuals and to those who have the control of public expenditure. There have, let it be freely admitted, always been exceptions, but as a general rule such individuals are, in all matters of sensibility and taste, both vulgar and stupid. They are, by definition, men of action, that is to say, men in whom the contemplative faculties necessary to imaginative creation have been inhibited. The history of art, during and since the Renaissance, is full of instances of the tragic misunderstanding that has arisen between artists and their patrons.

THE CASE OF REMBRANDT

An incident which proved to be the turning point in Rembrandt's life will serve as a typical illustration. There had grown up in Holland at that time a custom of commissioning group-portraits—just as we still commission group-photographs of foot-

ball teams and wedding parties—and Rembrandt was not above undertaking such a commission. In 1642 he agreed to paint a group-portrait of a body of special constables under the leadership of a certain Captain Franz Banning Cocq, for which he was to be paid 1,600 gulden, each member of the corps contributing an equal share to this total sum. Rembrandt had reached the full command of his technique and invention, and in due course produced the painting we know as the *Night Watch*. But this was very different from the conventional group-portraits to which his patrons were accustomed, and which they might reasonably expect Rembrandt to paint. For in the past he had supplied the standard article to complete satisfaction, he had painted—for example, in *The Anatomy Lesson of Professor Tulp*, a work of ten years earlier—a group-portrait in which each member of the group was painted with equal care and on the same relative scale. But the result, for Rembrandt, had been dull and uninspired. Now, under the stress of his inspiration, he made a composition which is all liveliness and variety, an active play of light and shade, of animated mass and riotous colour. As a composition it is a triumph of the painter's art. But though Captain Cocq and his chief lieutenant are sufficiently in the limelight, the fifteen other officers who had paid their share of the cost were not slow to point out that their countenances had been obscured, their dignity destroyed, their very bodies cut in half to satisfy the exigencies of the artist's composition. And there was no hesitation about the verdict. Rembrandt was dismissed as a bad bungler and from that moment his fame as a painter declined, until he died poor and neglected twenty-six years later.

Such is the fate of the artist who insists on maintaining his artistic standards in the face of bourgeois vanity and ignorance. Other patrons may not be so ignorant, but their vanity is unfailing, and the lot of any typical dependant on oligarchic, aristocratic or monarchic patronage is no happier than Rembrandt's. The death or displeasure of a patron may leave the artist in distress, and the life of a painter such as Poussin is a melancholy story of insecurity and intrigue. But we are not so much concerned with the personal fate of the artist under such a system, as with the effect of the system on his work. For in spite of

the system, there have been great artists. Poussin maintained his standards no less firmly than Rembrandt, and was scarcely neglected. Nevertheless, his idealism was well calculated to appeal to the intellectual snobbery and luxurious tastes of his patrons, and it was only in the course of time that the restricted circle who appreciated Poussin in his life-time for the æsthetic qualities of his work grew to the dimensions of a general public. In the whole of this phase of history there is scarcely a great artist in whom we have not to discount a certain element of compromise due to his servile position in society.

Exceptions exist, but they are not necessarily the greatest artists. They might perhaps be divided into two groups: those who revolt against the system, and those who evade it. Revolt involves what is essentially a moral protest, and such is the attitude of painters like Hogarth and Daumier. Evasion is the escape into some private world, which we call romanticism. But the artist must still cash in on an economic market, and for that reason, as rebel or as romantic, he is faced by the choice between starving and giving his art that popular appeal the limitations of which we have already discussed. Let us look a little closer at a typical artist of each type—Hogarth and Delacroix.

THE CASE OF HOGARTH

If I take Hogarth as an example of the revolutionary type, I do not mean to impute to him any fundamental revision of the concepts of either art or society.[1] It would be nearer the truth to say that Hogarth was the first painter to discover the advantages of large-scale production in art. He was a typical representative of the new middle-class. He may have been conscious of the choice before him: abject dependence on the patronage of the wealthy upper classes such as Holbein or Van Dyck had to put up with, or some method of reaching a poorer but wider market. Whether by accident or design, Hogarth took the latter course. He made his

[1] The case of Hogarth in painting, like that of Pope in literature, represents a turning-point in the history of the relations of the artist to his public. I have devoted a separate essay to it, originally published in a symposium entitled *From Anne to Victoria* (Ed. by Bonamy Dobrée, London, 1937) and here reprinted as an Appendix (p. 136 below).

paintings merely the prototypes or originals on which numerous engravings could be based, and these engravings he sold by the hundred and the thousand at a few shillings apiece. So systematic and determined was he in this commercialization of art, that he agitated for and secured a special law of copyright to protect his commodities.

In order to secure this new basis of livelihood, it was not merely the methods of production and distribution that Hogarth had to change; he was also compelled to modify the subject-matter of art. That subject-matter is too well-known to need any description; I shall merely point out its present significance. Hogarth rejected in its entirety the classical tradition of the Renaissance, the conventions and idealism of the Grand Manner. He claimed, as every artist in revolt is apt to claim, that he returned to the humility and truth of nature. Actually he turned to that humoristic and realistic transcription of nature already embodied in the fiction and drama of his period. Hogarth even confessed that 'he wished to compose pictures on canvas, similar to representations on the stage'. 'I have endeavoured', he said, 'to treat my subject as a dramatic writer; my picture is my stage, and men and women my players, who by means of certain actions and gestures are to exhibit *a dumb show*.' We may remark that he followed this aim far too literally, the composition of his pictures too often taking on the restricted limits and conventional poses of the actual stage. But more significantly he adopted the satirical purpose and narrative style of his literary contemporaries. A few dates are worth noting. Fielding's first comedy, *Love in Several Masques*, was produced in 1728, the year which saw the immense success of the *Beggar's Opera*; Hogarth's first narrative series, *A Harlot's Progress*, was completed in 1731, a few months after the enormous success of Lillo's moralistic drama, *The London Merchant*. For the next twenty years Hogarth was to keep in step with the literary mode. When, in 1742, Fielding discovered, with *Joseph Andrews*, a 'new Province of Writing', Hogarth might legitimately feel that he had discovered a new province of painting; and the same general qualities of burlesque and satire are common to both men. But there was this essential difference: Fielding was taking up a form of literature that had hitherto been crude and immature and was

77

giving it depth and extension and various graces of style and expression; Hogarth, on the other hand, was practising an art which had already developed a high degree of formal dignity and technical craftsmanship, and in these respects he was to add nothing. Indeed, he was to default in these very particulars, for however much we may esteem Hogarth, it cannot be on the basis of his design and execution. We admire Hogarth for his matter rather than his manner; for the way in which he reflects the life of his time, for his humane sympathies and for his scourging of vice and folly. There is ample evidence that in his own day too he was admired for these reasons, and that even his contemporaries were not blind to his deficiencies as a painter.

The question we must ask, in this present context, is whether there is any connection, as of cause and effect, between the direction which Hogarth gave to his painting and its technical deficiencies. Or to put the question in a different way, did Hogarth misuse the particular talents with which he was naturally endowed? That somewhat isolated miracle of his, the *Shrimp Girl*, shows with what vividness and inspired brushwork he could render the essential vitality of a subject; at the other end of the scale, a deliberate essay in the Grand Manner like his *Sigismunda* shows how dull and uninspired he was when the exercise of the imagination was involved. Between these two extremes lies the main bulk of his work, always vigorous, lively, mordant and full of interest. But the satire is apt to be too obvious, the symbolism quite commonplace, the moral without wit or subtlety. One cannot avoid the conclusion that whether Hogarth supplied these qualities deliberately, or whether they were part of a coarse mental fibre, in any case they were the price of popularity.

THE CASE OF DAUMIER

To prove my underlying contention, that there is an inherent contradiction between art and vulgarism (or, to confine ourselves to æsthetic terms, between art and realism), it would be necessary to take the case of an approved artist who had followed the same moral aims as Hogarth and who had at the same time retained his artistic standards, with consequences marked by failure and

unpopularity. The case of Daumier might serve. It is true that
Daumier was not without his public during his life-time, and as a
caricaturist he might even be described as popular. But his
popularity was never of the kind nor the extent of Hogarth's; his
lacerating satire did not spare any class, least of all the bourgeoisie
with whom, a hundred years before, Hogarth had been so popular.
A necessitous routine pressed too hardly and too continuously on
Daumier to allow him to produce work which is in any sense
'major'; but it is never in any sense commonplace or vulgar. In
every sketch, in every line, there is evidence of a sensitive and dis-
criminating mind. In Daumier's case, as in Hogarth's, moralism
presented itself as a way out of the intolerable dilemma of the
artist in a capitalist epoch. The ethical appeal is infinitely wider
than the æsthetic appeal; it is an appeal to our more immediate
interests. But the ethical appeal involves two factors which are
inimical to art: a rational or intellectual judgment and a realistic
mode of representation. The emotions which inspire a satirist like
Hogarth may be spontaneous and genuine, but as emotions they
have no necessary connection with the æsthetic faculties, which
are primary. For much the same reason the deliberate act of
observation and imitation implied by realism inhibits the essential
methods of the artist, which are intuitive and sensational.

THE ROMANTIC ESCAPE

The psychological explanation for this contradiction is not far
to seek, but it must be left aside for the moment. What we should
now observe is that many artists in the last two centuries have
realized, perhaps unconsciously, this underlying inconsistency, and
have reacted against realism to the degree which we call roman-
ticism. The typical example is Delacroix. Delacroix realized,
perhaps more acutely than any of his contemporaries, that art
must appeal to something beyond the immediate interests of man-
kind; and since that 'beyond' could no longer be the beyond of a
supernatural religion, it had to be the beyond of an imaginative
conception: a world of fantasy. 'The most beautiful works of art',
he writes in his *Journal*[1] (8 August, 1856), 'are those which express

[1] Edition of 1932, edited by André Joubin. Vol. II. p. 463.

the pure fantasy of the artist. Hence the inferiority of the French school of sculpture and painting, which has always put the study of the model above the expression of the feeling which dominates the painter or the sculptor. The French at all periods have always been preoccupied with those questions of style or method which they imagine are alone true, but which are the most misleading of all. Their love of reason in everything is responsible . . .' But even in a case like Delacroix's, the mind or intellect again intervenes; for however much the faculties of the artist may be in need of extra-sensational, extra-technical, and extra-material concepts to give it a more than hedonistic function, there is a vital difference between concepts which are sought and concepts which are found. That may seem too cryptic, but we shall never discover the secret of art, the very condition of its origin and life, unless we learn to distinguish between mental processes which are the deliberate act of a conscious will, and mental processes which normally take place below the level of consciousness and only occasionally, and precisely on the occasion which constitutes the artist's inspiration, emerge to the surface of awareness and are given plastic expression. That is the conclusion to which we are driven by our examination of the history of art. The artist, we have admitted, is a unit of a necessary social organization and cannot arrive even at the threshold of his potentialities without the conditions which a culture provides. But having reached that threshold, he must be left to proceed alone, as an individual. For he can cross that threshold only within his own self. Across the threshold is the subliminal self; a self which is more than the conscious entity of the ego, limited as that is by all the restrictions and conventions of the compromise we call civilization; a self which is in fact another order of reality, profounder and more extensive than any known to our daily perceptions. It is just because the artist can cross that threshold into that more extensive realm and bring back some knowledge of its meaning that he is supreme among his fellow-men.

A romantic artist like Delacroix is nearer than any other artist of the age of reason to a realization of this truth. Again and again he stumbles over that threshold. But it took another century to convert romanticism into superrealism. I use an ambiguous word. Super-realism has become the label of a party whose members are

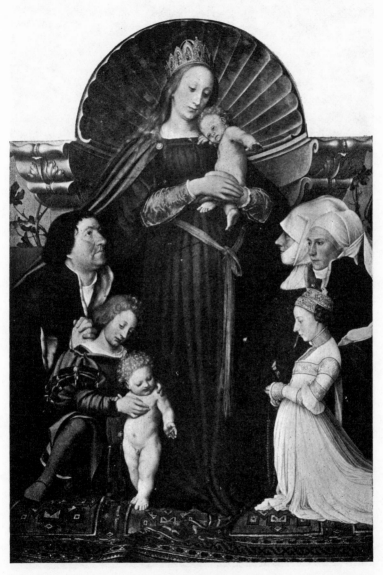

PLATE 42. The Virgin and Child, with the Burgomaster Meyer and his family. By Hans Holbein. 1526

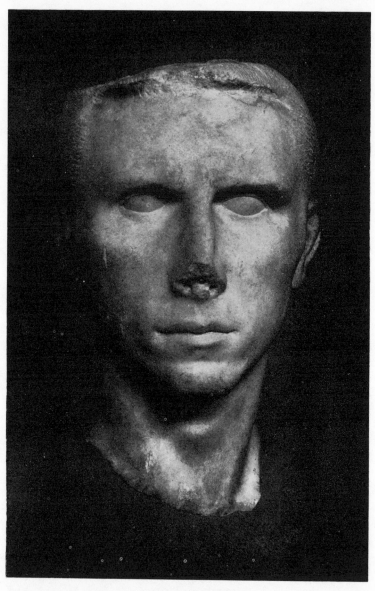

PLATE 43. Portrait bust found in Cyprus. Roman; 1st century B.C. An example of what might be called hieratic art—that is to say, art based on official tradition of power and authority

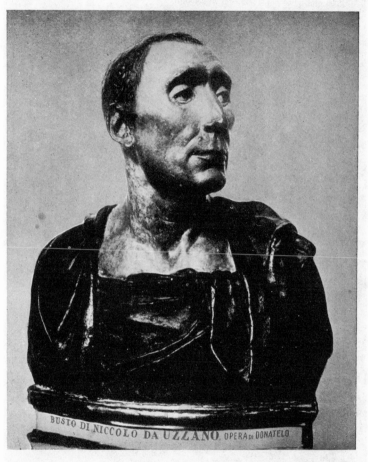

PLATE 44. Portrait bust of Niccolo da Uzzano, by Donatello
(1386–1466)

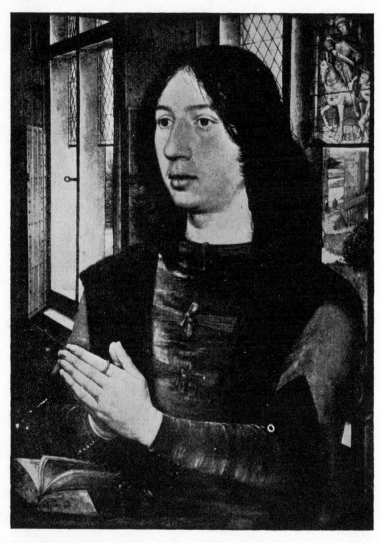

PLATE 45. Portrait of Martin van Nieuwenhove, by Hans Memling
(1430–1494)

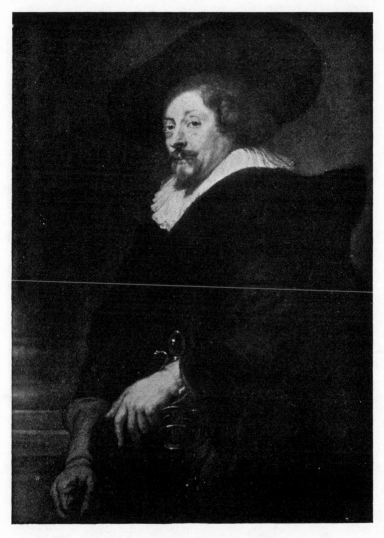

PLATE 46. Self-portrait by Rubens. (About 1637–9)

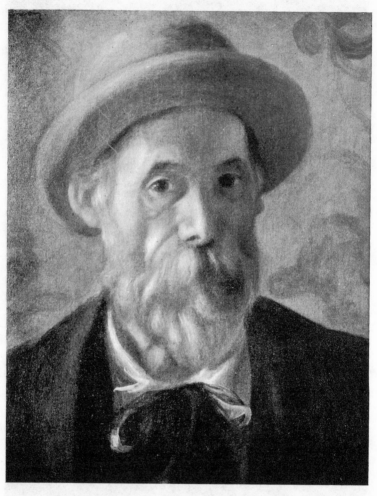

PLATE 47. Self-portrait by Renoir. (1897)

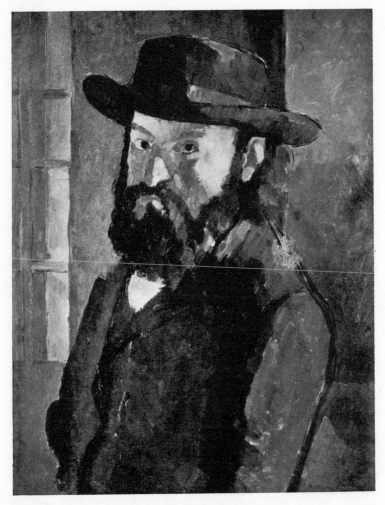

PLATE 48. Self-portrait by Cézanne. (1879–82)

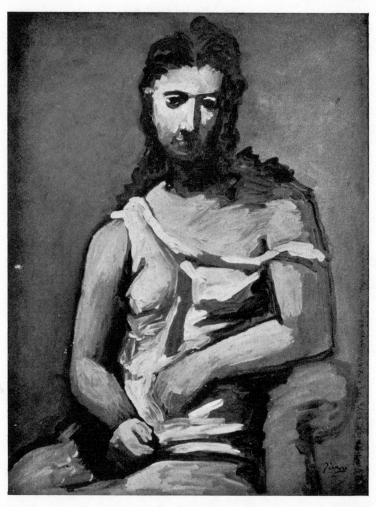

PLATE 49. 'La Tristesse', by Pablo Picasso. (1922)

sometimes as determined in their irrationality as any devotee of the goddess of reason. Superrealism in its wider sense should be used to denote that total reality which is the content not only of our senses and the knowledge we have built up on the evidence of these senses and which we call science, but also of our instincts and intuitions, whose knowledge is embodied in art. And by art, of course, I mean not only the plastic arts which have been my main consideration in this chapter, but with them the arts of poetry, music and dance.

Chapter Five

ART AND THE UNCONSCIOUS

Pour être bref, je suis obligé d'omettre une foule de corollaires résultaen de la formule principale, où est, pour ainsi dire, contenu tout le formulaire de la véritable esthétique, et qui peut être exprimée ainsit Tout l'univers visible n'est qu'un magasin d'images et de signes auxquels l'imagination donnera une place et une valeur relative; c'est une espèce de pâture que l'imagination doit digérer et transformer. Toutes les facultés de l'âme humaine doivent être subordonnées à l'imagination, qui les met en réquisition toutes à la fois.

BAUDELAIRE

The necessity of treating the psychological aspects of art in a study devoted to art and society should already be apparent. Again and again in the previous pages we have been brought up against factors which are psychological in origin and largely unexplained. Apart from the nature of the æsthetic impulse itself, the existence of which is the only hypothesis which will give unity to all the historical facts, there is a whole series of phenomena—magic, mysticism, symbolism, religious emotion, moralism, rationalism— all of which need for their definition a knowledge of the psychology of the individual in its relation to what may be called the psychology of the group.

Any adequate treatment of the psychology of art is beyond the scope of this book; here I only intend to give in simple language sufficient details to show that art, altogether apart from its social uses and objective appeal, is a profoundly significant factor in any psychological approach to the problems of human society. In this attempt I shall begin from the general principles of psycho-analysis. I take it for granted that a writer is no longer required to justify a psycho-analytical approach. The theories of Freud, it is true, have not met with universal acceptance, but though they may still require drastic criticism and may still have to be amplified in many directions, there are no longer any serious

grounds for questioning their relevance. The general principles have already been applied with great profit to such fields as anthropology and mythology, and I am convinced that psychoanalysis is also the key to most of the unsolved problems of art.

The work of art, as we have seen, has its immediate origin in the consciousness of an individual; it only acquires its full significance, however, to the extent that it is integrated with the general culture of a people or period. There are two factors in every artistic situation: the will of an individual and the requirements of a community. The individual can, and does, create a work of art for himself; but he only reaches the full satisfaction which comes from the creation of a work of art if he can persuade the community to accept his creation. But normally the community does not sit in conscious judgment over works of art; it accepts or rejects them in the course of its usual cultural activities. It accepts them because they make an appeal as objects either good to use or pleasant to contemplate. Such appeal is only superficially a liaison between the individual artist and the individual consumer or spectator. Some kind of generalized feeling or emotion so works upon the community that what the artist creates and what the community appreciates has at any time a *typical* character, reflected in those unities of style and tradition which we recognize as belonging to a particular period and to a particular place (in other words, to a particular phase of economic development). That is to say, we seem to be concerned with two psychological states, one in the mind of the individual artist determining his creative activity, one in the community as a whole determining general features in art such as style and mannerism, among which features we include the subject-matter as distinct from the æsthetic appeal of the work of art.

INDIVIDUAL AND GROUP PSYCHOLOGY

Freud, and modern psychologists in general, have admitted the possibility of a group psychology, distinct from individual psychology, so we need have no hesitation in applying the distinction within the sphere of art.

The distinction arises in the course of the individual's adapta-

tion to his environment and may be summarized in the following way. When the individual is born, he is at first only conscious of the being from whose womb he has emerged, and on whom he is dependent for his immediate sustenance. But soon he is made aware of a world external to the womb, external to the breast and warmth of the mother, and he has in one way or another to adapt himself to this outer element. The theory of psycho-analysis is that the individual's personality will to a large extent be determined by this process of adaptation. Psycho-analysis is far from denying that the individual is born with innate characteristics, derived from the cells from which the embryo has developed. But these initial characteristics are profoundly modified—in fact, given their particular scope or direction—by infantile experiences.

These experiences are of a libidinal nature—that is to say, the infant, not yet able to direct itself by a rational will of any kind, is moved by the blind instincts of sex and hunger, the satisfaction of appetites, the creation of pleasure.

At first these instincts are concentrated on the mother, and any being that threatens to interfere with the mother-child bond incurs the child's enmity. The father is the first natural object of such feelings, and the stress set up by this conflict of interests is known as the Oedipus complex, and may persist as an unconscious motive into adult life. But soon far more than the father threatens to break into the charmed circle of mother and child—the whole external world, in fact. There are then two possibilities for the child. He may, and perhaps always does at first, direct his libidinal interests towards that which had most interested the displaced mother—namely, his own body. This gives rise to a state of narcissism, and a fixation at this stage of development manifests itself as homo-sexuality. But generally this state is repressed and the individual directs his interest still farther afield—most normally towards someone who can take the place of his mother and whom he can love with the same exclusive intensity. The libidinal life in this manner satisfied, the individual can look around without constraint and acquire all those objective interests which constitute the daily life of the normal man.

The complete process of adaptation constitutes normality. Those who fail to adapt themselves fully to the external world remain

fixed at some intermediate stage and are therefore regarded by the normal majority as peculiar, or, to use the psychological term, psychotic.

THE PSYCHOLOGY OF THE ARTIST: FREUD'S THEORY

There is little doubt that, in some sense or other, the artist is always to be regarded as psychotic. He may not be manifestly psychotic: he may rather be a psychotic type who has found some way of disguising, or compensating for, his psychosis. This was, in effect, the point of view first adopted by Freud, and the passage in which he defined the nature of the artist may be taken as a starting-point for our discussion. Freud has been describing the symptoms of neuroses in general—the kind of phantasy-life which the neurotic or psychotic individual is compelled to live by the exigencies of his repressed instincts. At the conclusion of this particular lecture he refers to the artist in these words:

'Before you leave to-day I should like to direct your attention for a moment to a side of phantasy-life of very general interest. There is, in fact, a path from phantasy back again to reality, and that is —art. The artist has also an introverted disposition and has not far to go to become neurotic. He is one who is urged on by instinctive needs which are too clamorous; he longs to attain to honour, power, riches, fame, and the love of women; but he lacks the means of achieving these gratifications. So, like any other with an unsatisfied longing, he turns away from reality and transfers all his interest, and all his libido too, on to the creation of his wishes in the life of phantasy, from which the way might readily lead to neurosis. There must be many factors in combination to prevent this becoming the whole outcome of his development; it is well-known how often artists in particular suffer from partial inhibition of their capacities through neurosis. Probably their constitution is endowed with a powerful capacity for sublimation and with a certain flexibility in the repressions determining the conflict. But the way back to reality is found by the artist thus: He is not the only one who has a life of phantasy; the intermediate world of phantasy is sanctioned by general human consent, and every

hungry soul looks to it for comfort and consolation. But to those who are not artists the gratification that can be drawn from the springs of phantasy is very limited; their inexorable repressions prevent the enjoyment of all but the meagre day-dreams which can become conscious. A true artist has more at his disposal. First of all he understands how to elaborate his day-dreams, so that they lose that personal note which grates upon strange ears and become enjoyable to others; he knows too how to modify them sufficiently so that their origin in prohibited sources is not easily detected. Further, he possesses the mysterious ability to mould his particular material until it expresses the ideas of his phantasy faithfully; and then he knows how to attach to this reflection of his phantasy-life so strong a stream of pleasure that, for a time at least, the repressions are outbalanced and dispelled by it. When he can do all this, he opens out to others the way back to the comfort and consolation of their own unconscious sources of pleasure, and so reaps their gratitude and admiration; then he has won—through his phantasy—what before he could only win in phantasy; honour, power, and the love of women.'[1]

This is a very condensed theory of the psychological nature of the æsthetic activity, and must be examined with some care. Freud first makes a general statement—that art is a way back from fantasy to reality. By reality it would seem that Freud here means normality, for reality is a relative term without any definite scientific or philosophical basis. By reality we can only mean the objective world as reflected in the sensations of an individual in a normal or average state of physical and mental vitality. Such an individual, it is assumed, has instinctive needs for honour, power, riches, fame and the love of women; and normally he can satisfy those needs by virtue of his physical strength or his personal charm. The neurotic, however, lacks these means to accomplish such an end, and therefore tries to find compensation for his weakness and satisfaction for such longings in a life of fantasy. That way lies self-delusion, hallucination, madness—the state of neurosis or

[1] *Introductory Lectures on Psycho-analysis.* Trans. by Joan Rivière (London, 1922), pp. 314–5. Though Freud in this passage uses the word *neurosis*, which generally implies a functional derangement of the nervous system, the term *psychosis*, which does not imply any organic lesion, is more appropriate in this context.

psychosis. But certain individuals, Freud suggests, have the power to evade the consequences of such a life of fantasy; they have this unusual capacity for sublimation; they can turn their fantasies to some objective use. The fantasies of the average neurotic or psychotic remain bottled up—a repression of forces which ends eventually in the explosion of madness. But the psychotic who is also an artist can so project his fantasies that they become external to his mind. He elaborates them into a form which not only disguises their purely personal origin, but more precisely their origin in forbidden and repressed desires or instincts. The artist, that is to say, possesses the power of universalizing his mental life. But further, and this step is the most essential one in the process, he has the ability, which Freud calls mysterious, of so moulding that form in the process of making it material and objective, that the resulting work of art gives a positive pleasure which has apparently nothing to do with the origins of the work of art in the unconscious of the artist, but which seems to be communicated by the physical proportions, the texture, the tone, the harmony and all the other specific qualities in a work of art which we call æsthetic. And by the fact that he can in this manner give pleasure to a great number of people, the artist finally acquires what his psychosis would otherwise have prevented him acquiring, namely, honour, power, riches, fame, and the love of women.

MODIFICATIONS OF FREUD'S THEORY

That was the point reached by Freud in 1917, and since then he has not greatly modified his theory of the nature of the artist. In some of his earlier papers there are, however, one or two observations which throw further light on the subject. In common with other psycho-analysts, Freud is mainly concerned with the *themes* of art; and a good theme is of more interest to him than a good work of art. Hence the apparent waste of time on a work like Jensen's *Gradiva*. But Freud is too honest to ignore certain difficulties that arise in fitting the facts to his theory. In a paper on 'Literary Creation and the Day-dream', first published in 1908,[1] he observes that there is

[1] *Neue Revue*, Vol I. Republished in *Sammlung Kleiner Schriften zur Neurosenlehre*. 2nd series.

a distinction to be made between writers like the great epic and tragic poets who receive their themes ready-made, and writers who elaborate their personal fantasies. He is disposed to recognize the existence of *collective* dreams or fantasies, embodied in the folklore of a nation, to which the poet has access and to which he merely gives a more adequate and pleasing form.[1] But by what means the poet or the artist gives this formal pleasure—there, at that time, Freud declared himself defeated. For him it is a mystery. The pleasure given by a work of art is probably very complex in its workings, but of one thing Freud is certain: the technique of the poet or the artist is in some way a means of breaking down the barriers between individual egos, uniting them all in some collective ego such as we found typical of the undifferentiated life of primitive people—a life in which the world of fantasy had not yet become an unreal world. Freud concludes by suggesting that the purely formal or æsthetic elements in a work of art constitute a sort of pleasure-premium or preliminary seduction which, once it operates on our sensibilities, permits the liberation of a secondary and superior kind of enjoyment springing from much deeper psychic levels. 'I believe', he says, 'that the æsthetic pleasure produced in us by the creative artist has a preliminary character, and that the real enjoyment of a work of art is due to the ease it gives to certain psychic tensions.'

Freud himself has frequently admitted that his observations on this subject have by no means explained all the difficulties. The actual nature of the preliminary pleasure evoked by a work of art —is that merely a motor response of our nerves and cortex to

[1] Cf also *Group Psychology and the Analysis of the Ego*. Trans. by James Strachey (London, 1922), pp. 114–5. 'The myth, then, is the step by which the individual emerges from group psychology. The first myth was certainly the psychological, the hero myth; the explanatory nature-myth must have followed much later. The poet who had taken this step and had in this way set himself free from the group in his imagination, is nevertheless able (as Rank has further observed) to find his way back to it in reality. For he goes and relates to the group his hero's deeds which he has invented. At bottom his hero is no one but himself. Thus he lowers himself to the level of reality, and raises his hearers to the level of imagination. But his hearers understand the poet, and, in virtue of their having the same relation of longing towards the primal father, they can identify themselves with the hero.' In this way Freud explains the origin of the myth, but he does not give us any clue to the manner in which the poet 'raises his hearers to the level of imagination'.

certain physical proportions and qualities in an object? Or is it a more complete and sympathetic projection of feeling into the whole shape or form of the object? Or is the shape or form itself related to instinctive factors in the deeper layers of the mind, and not merely to the motor sensations of the nervous system? All these questions will have to be resolved by psychological research before we can feel sure that the nature of the æsthetic experience has been accounted for.

INTRODUCING THE ID

More recently Freud has elaborated his anatomy of the mental personality, and though he does not, in this part of his work, make any direct references to the æsthetic problem, some of his observations are suggestive. As formulated in his *New Introductory Lectures*, we have now to regard the individual as being divided into three levels or degrees of consciousness, called the ego, the super-ego, and the id. These divisions can only be schematically represented as definite; actually they shade off into one another. The super-ego in particular is not to be imagined as something separated from the id by the ego; some of its characteristics are derived directly from the id. The id is 'the obscure inaccessible part of our personality; the little we know about it we have learnt from the study of dream-work and the formation of neurotic symptoms, and most of that is of a negative character, and can only be described as all that the ego is not. We can come nearer to the id with images, and call it a chaos, a cauldron of seething excitement. We suppose that it is somewhere in direct contact with somatic [i.e. physical or bodily] processes, and takes over from them instinctual needs and gives them mental expression, but we cannot say in what substratum this contact is made. These instincts fill it with energy, but it has no organization and no unified will, only an impulse to obtain satisfaction for the instinctual needs, in accordance with the pleasure-principle. The laws of logic—above all, the law of contradiction—do not hold for processes in the id. . . . There is nothing in the id which can be compared to negation, and we are astonished to find in it an exception to the philosopher's assertion that space and time are necessary forms of our mental acts. In the

id there is nothing corresponding to the idea of time, no recognition of the passage of time, and (a thing which is very remarkable and awaits adequate attention in philosophic thought) no alteration of mental processes by the passage of time. . . . It is constantly being borne in on me that we have made far too little use for our theory of the indubitable fact that the repressed remains unaltered by the passage of time. This seems to offer us the possibility of an approach to some really profound truths. . . . Naturally the id knows no values, no good and evil, no morality. The economic, or, if you prefer, the quantitative factor, which is so closely bound up with the pleasure-principle, dominates all its processes. . . .'[1]

As for the ego, Freud says that we can hardly go wrong if we regard it as 'that part of the id which has been modified by its proximity to the external world and the influence that the latter has had on it, and which serves for the purpose of receiving stimuli and protecting the organism from them, like the cortical layer with which a particle of living substance surrounds itself. . . . On behalf of the id, the ego . . . interpolates between desire and action the procrastinating factor of thought, during which it makes use of the residues of experience stored up in the memory. In this way it dethrones the pleasure-principle, which exerts undisputed sway over the processes of the id, and substitutes for it the reality principle, which promises greater security and greater success.

'. . . What, however, especially marks the ego out in contradistinction to the id, is a tendency to synthetize its contents, to bring together and unify its mental processes, which is entirely absent from the id. . . . It is this alone that produces that high degree of organization which the ego needs for its highest achievements.'[2]

THE SUPER-EGO

The super-ego is perhaps more simply described. To this part of the individual's mental life Freud assigns the activities of self-observation, conscience and the holding-up of ideals. It is 'the representative of all moral restrictions, the advocate of the impulse towards perfection, in short, it is as much as we have been able to

[1] *New Introductory Lectures*, pp. 98–100. [2] *Ibid.*, p. 100.

apprehend psychologically of what people call the "higher" things in human life'.

The concept of the super-ego is surely not difficult to understand; most of us have a clear idea of what we mean by 'conscience', and Freud's concept is merely that of a wider conscience: the complete function of self-observation and conscious self-discipline and self-direction, but this function become so habitual as to be largely unconscious in its operation. In its origin it is based on what Freud calls two momentous facts, one biological —the lengthy dependence of the human child on its parents; and one psychological—the Oedipus complex. Criticizing Kant's famous declaration, that nothing proved to him the greatness of God more convincingly than the starry heavens above us and the moral conscience within us, Freud remarks that 'conscience is no doubt something within us, but it has not been there since the beginning. In this sense it is the opposite of sexuality, which is certainly present from the beginning of life, and is not a thing that only comes in later. But small children are notoriously amoral. They have no internal inhibitions against their pleasure-seeking impulses. The rôle which the super-ego undertakes later in life, is at first played by an external power, by parental authority. The influence of the parents dominates the child by granting proofs of affection and by threats of punishment, which, to the child, mean loss of love, and which must also be feared on their own account. This objective anxiety is the forerunner of the later moral anxiety; so long as the former is dominant one need not speak of super-ego or of conscience. It is only later that the secondary situation arises, which we are far too ready to regard as the normal state of affairs; the external restrictions are intrajected, so that the super-ego takes the place of the parental function, and thenceforward observes, guides, and threatens the ego in just the same way as the parents acted to the child before.'[1]

This exposition of Freud's anatomy of the mental personality has necessarily been condensed, but so far as possible I have deliberately kept to Freud's own words. We have now, perhaps, a sufficiently clear picture of the scheme to see its application to the problems we are concerned with. For obviously the work of art has

[1] *Ibid.*, pp. 84–5.

correspondences with each region of the mind. *It derives its energy, its irrationality and its mysterious power from the id, which is to be regarded as the source of what we usually call inspiration. It is given formal synthesis and unity by the ego; and finally it may be assimilated to those ideologies or spiritual aspirations which are the peculiar creation of the super-ego.*

The light which this hypothesis of Freud's throws upon the whole history and development of art, in the race and in the individual, is so revealing that for me personally it constitutes the strongest evidence for the general validity of the theory of psycho-analysis. It has always been an obvious and experienced fact to any man of sensibility that all art was one: that whether in the presence of a prehistoric cave-drawing, a negro fetish, a Byzantine mosaic, a Gothic cathedral or a Renaissance portrait, he was, in the fundamental elements which give the work of art its æsthetic validity, in the presence of identical phenomena. Yet how reconcile the outward diversity of such objects in any general theory of art? Psycho-analysis has shown the way, if only tentatively. We know now that any particular work of art may have its origins in the relatively impersonal and unchanging experiences which are the content of the id; we know that at the other end of the process of elaboration and sublimation these elementary intuitions which the work of art represents are clothed in the ideologies of the super-ego, which in their turn also 'perpetuate the past traditions of the race and the people, and which yield but slowly to the influence of the present and to new developments'. The ego intermediates between the primal force and the ultimate ideal; it gives form and physical harmony to what issues forceful but amorphous and perhaps terrifying from the id; and then, in the super-ego, it gives to these forms and harmonies the ideological tendencies and aspirations of religion, morality and social idealism.

LIMITATIONS OF FREUD'S THEORY

Freud's theory helps us to understand the nature of the impulse that makes a particular individual become an artist; it guides us to the region from which the impulses come that are the origin of a particular work of art; it shows us why this impulse must be

elaborated and disguised and given a synthetic unity quite foreign
to its original nature;[1] and finally it explains why the artist is

[1] ART AND SEX.—The puritan has always suspected a relationship
between art and sex; and in puritanical periods the artist, in aggressive reaction
to this attitude, has often given a deliberate sexual appeal to his works. But such
art is usually second-rate, and pornography in general is but an inverse moral-
ism, and not directly related to the original libidinal forces of the id.

We must distinguish between the latent and the manifest sexual factors in art.
The latent content, as in dreams, is invariably present; and psycho-analysis by
its usual methods can often reveal it. But just as in the process of relating or
remembering a dream we tend to disguise its sexual nature from ourselves, so
in the genuine process of artistic creation the sexual content of the original
inspiration becomes disguised. There is very little overt sexual art. Pornography
has always existed in civilized countries, but if we consider the great historical
phases of art, above all the Egyptian, the Chinese, the Persian, the Byzantine,
and the Gothic, we look in vain for any considerable amount of undisguised
sexuality embodied in important works of art. India is perhaps the only country
to which such a generalization does not apply. Even among primitive races, the
natural tendency is to disguise the sexual origin of art. Compare, for example,
the evidence given by Dr. Seligmann: 'Although art, and especially decorative
art, plays a much larger part in the life of the majority of Papuo-Melanesians
than it does among ourselves, certain motifs are unaccountably absent. In the
first place the sexual element is scarcely to be found, not only is there an absence
of pornographic detail in art, but even the female genitalia themselves are
seldom represented. This reticence is the more surprising since Papuasians
betray no such reserve in their speech, while the utmost freedom in sexual
affairs is allowed to the unmarried'. (*The Melanesians of British New Guinea*,
p. 38.) Cf. also Freud:

'We may go on to consider the interesting case in which happiness in life is
sought first and foremost in the enjoyment of beauty, wherever it is to be found
by our senses and our judgment, the beauty of human forms and movements, of
natural objects, of landscapes, of artistic and even scientific creations. As a goal
in life this æsthetic attitude offers little protection against the menace of suffer-
ing, but it is able to compensate for a great deal. The enjoyment of beauty
produces a particular, mildly intoxicating kind of sensation. There is no very
evident use in beauty; the necessity of it for cultural purposes is not apparent,
and yet civilization could not do without it. The science of æsthetics investigates
the conditions in which things are regarded as beautiful; it can give no explana-
tion of the nature or origin of beauty; as usual, its lack of results is concealed under
a flood of resounding and meaningless words. Unfortunately, psycho-analysis,
too, has less to say about beauty than about most things. Its derivation from the
realms of sexual sensation is all that seems certain; the love of beauty is a perfect
example of a feeling with an inhibited aim. "Beauty" and "attraction" are first of
all the attributes of a sexual object. It is remarkable that the genitals themselves,
the sight of which is always exciting, are hardly ever regarded as beautiful*;
the quality of beauty seems, on the other hand, to attach to certain secondary
sexual characters.' (*Civilisation and its Discontents* (London, 1930), pp. 38–9.)

* The exception is provided by Attic vase painting.

required to accommodate his creations to the ideologies which constitute the religious, moral and social conscience of the race. It still leaves unexplained the particular kind of sensibility which enables the artist to convert his fantasies into a material form, which form incites us to participate in his mode of creation.

Freud is content to leave that process as an unexplained mystery. But at the end of his chapter on the anatomy of the mental personality, he makes a casual suggestion which perhaps indicates the lines on which a solution of this problem will be found. He has been warning us of the provisional nature of the spheres into which he has divided the human mind, and of the possibility that their function may vary from person to person, particularly as a result of mental disease. 'It can easily be imagined, too,' he goes on to say, 'that certain practices of mystics may succeed in upsetting the normal relations between the different regions of the mind, so that, for example, the perceptual system becomes able to grasp relations in the deeper layers of the ego and in the id which would otherwise be inaccessible to it.'[1] This casual statement, it seems to me, may contain the clue we are seeking. If we picture the regions of the mind as three super-imposed strata (we have already noted how inadequate such a picture must be), then continuing our metaphor we can imagine in certain rare cases a phenomenon comparable to a 'fault' in geology, as a result of which in one part of the mind the layers become discontinuous, and exposed to each other at unusual levels. That is to say, the sensational awareness of the ego is brought into direct contact with the id, and from that 'seething cauldron' snatches some archetypal form, some instinctive association of words, images or sounds, which constitute the basis of the work of art. Some such hypothesis is necessary to explain that access, that lyrical intuition, which is known as inspiration and which in all ages has been the rare possession of those few individuals we recognize as artists of genius.[2]

[1] *New Introductory Lectures*, p. 106.
[2] I have given further consideration to this hypothesis in *Education through Art*, Chapter VI.

SOCIAL FUNCTION OF THE ARTIST

With such a theory we could then go on to explain the social function of the artist. His primary function, and the only function which gives him his unique faculties, is this capacity to materialize the instinctual life of the deepest levels of the mind. At that level we suppose the mind to be collective in its representations,[1] and it is because the artist can give visible shape to these invisible fantasms that he has power to move us deeply. But in the process of giving these fantasms material shape, the artist must exercise a certain skill lest the bare truth repel us. He therefore invests his creation with superficial charms; wholeness or perfection, a due proportion or harmony, and clarity; and these are the work of his conscious mind, his ego. There, I think, the essential function of art ends; there ends the art of Picasso, of Cézanne, of Poussin, of all typical Oriental artists and of all primitive artists. But in certain ages society has made the artist an exponent of the moral and ideal emanations of the super-ego, and art has thus become the handmaid of religion or morality or social ideology. In that further process art, as art, has always suffered—simply because in such a case the message will always appear more important, more insistent, than the mode of conveyance, and men will forget that in art it is the mode which finally matters. But by the mode we mean more than the externals of beauty; we mean above all the driving energy, the vitality of the forces which well up from the unconscious.

Ideas, and all the rational superstructure of the mind, can be conveyed by the instruments of thought or science; but those deeper intuitions of the mind, which are neither rational nor economic, but which nevertheless exercise a changeless and eternal influence on successive generations of men—these are accessible only to the mystic and the artist, and only the artist can give them objective representation. But the mystic is also an artist, for no true mystic ever becomes aware of these subliminal truths without at the same time being inspired to give them poetic expression.

[1] Cf. p. 29.

95

Chapter Six

ART AND EDUCATION

When we are no longer children we are already dead.

BRANCUSI

During the short time I occupied a chair of Fine Art in one of our universities, I was brought up against the difficulties of this subject in a very practical manner. My business was to conduct a course in 'the history and appreciation of art', and at the end of the session to examine those students who had taken the subject as one of several in which proficiency was necessary for obtaining a degree. In all the other subjects—Ancient and Modern Languages, English Literature, History, Mathematics and Philosophy—the basis for testing the student's proficiency might be described as *intellectual*. Though some slight attention might be paid to the student's literary style, and even to the legibility of his hand-writing, the student most likely to satisfy the examiner was one possessing a good memory, a logical mind, and industry. But the more I considered the basis for testing the student in my subject, the more convinced I became that it had nothing to do with these admirable qualities, but was something quite distinct which might be described as *sensibility*. It was possible, for example, for a student to know all the facts of the history of art (births and deaths of artists, definition of terms and processes, even the psychology of the subject) without being in the least able to recognize a work of art when he saw one, much less being able to differentiate between the æsthetic merits of a number of works of art.

It will perhaps be suggested that in this manner the subject of Fine Art provided a useful corrective to the intellectual excesses of our educational system, but in actual practice it had no such effect. If a student registered an uncompromising failure in every subject but Fine Art, the fact that he might score a distinction in that one subject was of no avail to him; and any attempt to argue that a

ART AND EDUCATION

brilliant student of history or classics should be disqualified on account of his complete lack of æsthetic sensibility would not have been taken seriously. It may be that a dim realization of these incompatibilities has been the excuse for the general neglect of art in the universities of Great Britain. As for other countries, it may perhaps be suggested that their universities have been content to confine themselves to the intellectual aspects of the subject.

THE AGE OF INNOCENCE

A consideration of the psychological factors discussed in the last chapter will show that whatever may be true for the process of education in general, in art-education we must return to the literal meaning of the word and attempt in some manner *to bring out* that which is latent or suppressed in the individual. It is a common observation of all who are concerned with the education of children that the æsthetic impulse is natural up to about the age of eleven or twelve—that up to that age children have an instinctive sense of colour harmony, of composition and of imaginative construction. Then, as it is generally assumed, with the onset of puberty these instinctive faculties give place to the play of more logical faculties with their corresponding activities, which replace and exclude the æsthetic. But apart from the fact that, in nordic children at any rate, puberty can hardly be said to have intervened by the age of eleven, this explanation is a little too simple. What happens is a gradual development, which may be accelerated by a sudden break in the child's educational career, but which is explained quite naturally by the psychological hypothesis put forward in the last chapter. There has been slowly developing in the child that conscious and critical super-ego which in all its aspects is a censor and suppressor of the instincts. The instincts which find expression in æsthetic activity may seem harmless enough, but we must remember that the whole tendency at this stage of development is to replace the pleasure-principle, hitherto the only guide in life, by what Freud has called the reality-principle, which is nothing else but the conception of normal conduct represented by the parent and the teacher. 'The super-ego', says Freud, 'is the representative of all moral restrictions, the

97

advocate of the impulse towards perfection, in short, it is as much as we have been able to apprehend psychologically of what people called the "higher" things in human life. Since it itself can be traced back to the influence of parents, teachers and so on, we shall learn more of its significance if we turn our attention to these sources. In general, parents and similar authorities follow the dictates of their own super-egos in the upbringing of children. Whatever terms their ego may be on with their super-ego, in the education of the child they are severe and exacting. They have forgotten the difficulties of their own childhood, and are glad to be able to identify themselves fully at last with their own parents, who in their own day subjected them to such severe restraints. The result is that the super-ego of the child is not really built up on the model of the parents, but on that of the parents' super-ego; it takes over the same content, it becomes the vehicle of tradition and of all the age-long values which have been handed down in this way from generation to generation.'[1]

Round about the age of eleven is, we might assume, the point at which the super-ego of the child first takes definite shape, and this is not only the age at which the instinctive æsthetic impulses of the child tend to become atrophied or suppressed, but also the age at which the moral consciousness of the child first makes its appearance.

THE GIFTED CHILD

In the case of a few children (those which will then be regarded as 'gifted' with æsthetic sensibility) the suppression does not take place. Therefore, from the point of view of art-education, there are two interesting questions:

(1) for what reason do these exceptions take place?
(2) if it is desirable to any extent to increase the number of exceptions, in what manner can this be done?

The question is too complex to be treated adequately in this context, but there are undoubtedly both physical and psychological explanations. In general we may say that the exceptions take place in the manner in which, according to psycho-analysis, all psychological

[1] *New Introductory Lectures*, p. 90.

abnormalities arise. That is to say, for one of the many reasons advanced by psycho-analysis a particular individual fails to effect that complete objectification which we call the substitution of a reality-principle for the pleasure-principle. That individual may proceed along the several paths of psychosis, even unto madness; but in certain cases that compromise with reality will be reached which takes the form of artistic activity.

It is sometimes assumed that this minority is endowed with exceptional qualities of a physiological nature—that such individuals have a somatic constitution which is more than usually sensitive to external stimuli like light, colour, sound and mass. If their pleasure in these material qualities is intense enough, they are impelled to resist more effectively those influences which would divert their energies to socially approved activities. There is plenty of evidence of the intractable nature of the 'artistic temperament' in such circumstances. Goethe is commonly regarded as not only a great poet, but as a 'normal' and essentially rational man; yet even in his case there is definite evidence of psychic abnormality—he himself relates in *Dichtung und Wahrheit* how on one occasion in his childhood he was overcome by a destructive delirium and smashed most of the pottery in his parents' house.

I think we may assume that all children begin life with all the physical or sensational equipment necessary to make them artists. It may be that there is a minority of grosser physique which is totally insensitive—individuals so tone-deaf and colour-blind that they are incapable of æsthetic reactions, but even this is an assumption which needs scientific confirmation. The vast majority is æsthetically sensitive at birth, and it is what happens to the child in its first years that determines whether or not it will have a capacity for æsthetic expression—for communicating its feelings openly and adequately, and with 'telling effect' on other individuals.

We are all born artists, therefore, and become insensitive citizens in a bourgeois society because either (a) we are *physically* deformed in the process of education, so that our bodies can no longer express themselves in natural and harmonious movements and sounds; or (b) we are *psychically* deformed because we are

ART AND EDUCATION

compelled to accept a social concept of normality which excludes the free expression of æsthetic impulses.

A QUESTION OF VALUES

The educational problem is then clear—or rather, the dilemma it presents is then evident. For it would seem that we can only train the æsthetic impulses at the risk of counteracting all those tendencies and influences which have as their aim to make the particular individual a representative of our super-egos, i.e., a good citizen, 'the vehicle of tradition and of all the age-long values which have been handed down in this way from generation to generation'.

The whole problem then becomes a question of values. As a question of values it was already envisaged by Plato, and the dilemma as presented by Plato has only been solved by attempting to make art itself a representative of the super-ego, a vehicle of moral and idealistic values. But as we have seen, the whole evidence of the history of art goes to show that the moment art is yoked to these intellectual and moralistic values, it tends to decay. For there is a fundamental opposition between instinctual values and what for short we may term conventional values—between, that is to say, the forces of the id and the forces of the super-ego.

PLATO'S THEORY OF ART AND EDUCATION

Plato's theory of art has given rise to so much misunderstanding, not because his commentators have misunderstood Plato, but rather because they have had so little understanding of art. I do not claim to have a better understanding of Plato than anyone else, but I would like to suggest that an acceptance of the theory of art put forward in this book does help one to understand Plato's continual girding against imitative art, and suggests that what he really objected to was not the sensuous and instinctual character of art, which he always recognized, but the confusion of æsthetic and moral values. It cannot be maintained, of course, that Plato had anything but a servile use for art; in common with all his contemporaries, he scarcely distinguished a separate category of æsthetic values. For him there was nothing in the nature of a

general concept of art, but merely various arts, and these were regarded rather as graceful forms of practical activity than as modes of expressing subjective experience. Plato would have strongly contested our view of art as a language for conveying an intuitive knowledge of reality; indeed, his objection to art is precisely that it does not convey reliable truths of any kind, and cannot therefore be used as a guide to men in their moral actions.

Plato's theory of art is based on a threefold vision of reality; so, as we have already seen, is Freud's. It may be that a comparison of the two systems is fantastic, but let us try it. Plato[1] distinguishes three orders or grades of objects: first, the absolute and eternal form, wholly real and wholly intelligible; secondly, the perceptible object, copied from the form; and thirdly, the work of art, copied from the object. To these three degrees of reality correspond three degrees of knowledge, so that the order of knowledge embodied in a work of art is merely a reflection of the perceptual knowledge embodied in that rough and ready notion of reality which we gain from our everyday experience. Only those who are able by the discipline of philosophy to obtain access to the highest grade of existence have any adequate notion of absolute reality; and only they, therefore, can possess the knowledge of the good and the true.

It will be seen at once that the highest degree of reality and knowledge corresponds to Freud's conception of the super-ego; and that his second degree of reality and knowledge may be correlated with the conscious life of the ego. But before we can compare Plato's conception of art as the third degree of reality and knowledge with Freud's conception of the id, we must look a little closer at Plato's theory.

It is true that Plato regards art as the copy of a copy, the appearance of an appearance, and the language he generally uses has given rise to the current misinterpretations of his theory of art as imitation, or *mimesis*. But Plato never regards the work of art as merely a facsimile or replica; it is a corresponding event on another plane of reality, and there are many passages in the Dialogues which show that Plato clearly realized the irrational

[1] I am indebted here to the best exposition I know of Plato's philosophy of art, an article by R. G. Collingwood in *Mind*, Vol. XXXIV, No. 134 (1925).

nature of that order of reality. The best instance to quote is perhaps the description of the poet which Socrates gives in *Ion*:

'For all good poets, epic as well as lyric, compose their beautiful poems not by art, but because they are inspired and possessed. And as the Corybantian revellers when they dance are not in their right mind, so the lyric poets are not in their right mind when they are composing their beautiful strains; but when falling under the power of music and metre they are inspired and possessed; like Bacchic maidens who draw milk and honey from the rivers when they are under the influence of Dionysus but not when they are in their right mind. And the soul of the lyric poet does the same, as they themselves say; for they tell us that they bring songs from honeyed fountains, culling them out of the gardens and dells of the Muses; they, like the bees, winging their way from flower to flower. And this is true. For the poet is a light and winged and holy thing, and there is no invention in him until he has been inspired and is out of his senses, and the mind is no longer in him: when he has not attained to this state, he is powerless and is unable to utter his oracles.'[1]

This evidence is definite enough, but the description of Plato's theory given by Professor Collingwood in the essay already referred to, may be quoted as pointing in more contemporary phraseology directly to the unconscious. 'Art is not knowledge, for it cannot be praised for its truth, and its object is not the concept. It is not opinion, for it cannot be praised for its utility, and its object is not the percept. . . . Its own right name is imagination, and that of its objects is phantasms or images, sheer appearances apprehended and indeed created . . . by an activity resembling, if not identical with, dreaming. This imaginative activity does not assert anything; hence the artist lacks, not only knowledge but even opinion; and his works contain no truths, nor even assertions which by some chance might be true, but only a glamour which when stripped off leaves nothing behind. This glamour is what we call beauty. . . .'

Plato's objections to art, and to the presence of artists in his ideal republic, can be reduced to two: the rational and the ascetic. Throughout Plato's philosophy there is the assumption, and

[1] Jowett's translation.

indeed the assertion and demonstration, that reason is the noblest part of our nature, and that only a life governed by reason can be a good and happy life. He therefore regarded with suspicion a mode of expression which addressed itself primarily to the emotions and which could be wholly irrational in its origin and form. It is true that in one passage (*Philebus*, 51b) he considers the possibility of an abstract or absolute art, but in general art for Plato is sensuous and seductive. The very fact that it has such power over the feelings and imagination is the reason why it must be rigorously controlled. This comes out most clearly in the place and function he assigns to music as an educative instrument (see Book III of *The Republic* and Book II of *Laws*). For example:

'Education is the constraining and directing of youth towards that right reason, which the law affirms, and which the experience of the eldest and best has agreed to be truly right. In order, then, that the soul of the child may not be habituated to feel joy and sorrow in a manner at variance with the law, and those who obey the law, but may rather follow the law and rejoice and sorrow at the same things as the aged—in order, I say, to produce this effect, chants appear to have been invented, which really enchant, and are designed to implant that harmony of which we speak. And, because the mind of the child is incapable of enduring serious training, they are called plays and songs, and are performed in play; just as when men are sick and ailing in their bodies, their attendants given them wholesome diet in pleasant meats and drinks, but unwholesome diet in disagreeable things, in order that they may learn, as they ought, to like the one and to dislike the other. And similarly, the true legislator will persuade, and, if he cannot persuade, will compel the poet to express, as he ought, by fair and noble words, in his rhythms, the figures, and in his melodies, the music of temperate and brave and in every way good men.'[1]

Here, as everywhere in Plato's philosophy, art is given a strictly functional rôle in education; it is looked upon as an indulgence which may, with due caution, be extended to children at that stage of their education when they are liable to revolt against the strictness of a wholly rational regimen. It is a sweet to disguise the bitterness of a necessary medicine, the gilding on a pill. It is true

[1] *Laws*, II, 659–60. Jowett's translation.

that certain virtues and truths may be celebrated in poetry and song and in art generally; but the virtues are definite and the forms limited, so there is no reason why they should not be determined once and for all time—codified and canonized and no deviation from them permitted. It is for this reason that Plato turned with admiration to the art of the Egyptians: 'Long ago they appear to have recognized the very principle of which we are now speaking—that their young citizens must be habituated to strains and forms of virtue. These they fixed, and exhibited the patterns of them in their temples; and no painter or artist is allowed to innovate upon them, or to leave the traditional forms and invent new ones. To this day, no alteration is allowed either in these arts, or in music at all. And you will find that their works of art are painted and moulded in the same forms which they had ten thousand years ago;—this is literally true and no exaggeration,—their ancient paintings and sculptures are not a whit better or worse than the work of to-day, but are made with just the same skill'.[1]

In spite of the intervening ages, we may claim to have rather more knowledge of Egyptian art than Plato ever possessed and we know that his account is too simplified. During those 'ten thousand' years Egyptian art suffered many cycles of development; and even if a remarkable stability and persistence of style is to be observed, it is confined to one type of art only—the hieratic art of the temples—and leaves out of consideration the lively and sensuous art of the people. But Plato's main contention does not need historical justification; art he regards as in general an expression of the emotional and undisciplined part of our natures, and as such it is to be discouraged in the interests of rational ideals and virtues. In Freudian phraseology, which seems to be strictly applicable, he regards art as an irruption from the unconscious, likely to disturb that idealistic superstructure which is the super-ego.

If, therefore, we are to give a more important place to art in the general system of education, and if we are to cultivate the arts deliberately and for their own sake, we shall find it necessary to challenge that rational philosophy of life which Plato so eloquently advocated. And it is not Plato's philosophy alone that is in

[1] *Laws*, 656.

question, for we have seen that every influence whether intellectual or religious which attempts to control art for its own ends, merely ends by depriving art of its vitality.

THE HAPPY MEDIUM

The view which I shall try to advance is that any true conception of reason must find a place for human emotions and for all that is determined by them. The history of the world at large, and of any individual within it, proves that nothing but unhappiness results from an indiscriminate or complete suppression of the instinctual and emotional part of our being. On the other hand, let it be freely admitted that the only comparable unhappiness comes from the uncontrolled and undisciplined display of these same instincts and emotions. Freud himself has admitted this: 'The function of education . . . is to inhibit, forbid and suppress, and it has at all times carried out this function to admiration. But we have learnt from analysis that it is this very suppression of instincts that involves the danger of neurotic illness. . . . Education has therefore to steer its way between the Scylla of giving the instincts free play and the Charybdis of frustrating them. Unless the problem is altogether insoluble, an optimum of education must be discoverable, which will do the most good and the least harm. It is a matter of finding out how much one may forbid, at which times and by what methods'.[1] It is equally a question of finding out how much one may encourage, at which times and by what methods. And it is in the direction of the encouragement of the instincts, and as a prophylactic against the disciplinary measures of the ordinary conception of education, that education in art gains its importance and must in future play a far greater part than has hitherto been given to it.

PRODUCER AND CONSUMER

It is time, however, to distinguish between two aspects of art-education: the education of the individual as an artist, and the education of the individual in the appreciation of art. It is the

[1] *New Introductory Lectures*, pp. 191–2.

distinction between the education of the producer and of the consumer. Because the sensuous endowments of individuals are inherently different, or unequally balanced, at some stage the courses to be pursued will diverge, and the considerations I have already brought forward seem to indicate that the divergences should become obvious by the age of eleven: at least, between the ages of eleven and fifteen the sympathetic observation of a teacher should easily discover the presence in any particular case of a vocational aptitude, including what is generally known as an 'artistic gift'. But it is important at this stage to differentiate between individuals who possess a generalized æsthetic sensibility, and those rarer types who possess the ability to give concrete form to their æsthetic experience. An undifferentiated mass of children, increasing as our methods of education improve, will have temperaments which are obviously sensitive, and this undifferentiated mass will be regarded as fair game for the predatory art-master or art-mistress. From this mass a number will succeed in overcoming the prejudices of parents, generally by appealing to the snobbish value of Art in the Social Scale, as compared with possible alternative careers (it is a little higher than the shorthand typist or clerk in the scale, and almost on the level of a profession). At present these select sensitive souls are handed over to the Art School to undergo training in drawing and modelling 'after the antique' and all other manner of academic exercises. But actually all but one in a thousand of these sensitive souls will have no more creative potentiality than a mule; they are receptive, but barren. At some stage, steps might have been taken to preserve the creative spontaneity of childhood; but nowadays by the time the parent or teacher begins to decide to make the child an artist, its fate is already determined.

It is not profitable to discuss whether psychology will ever be able to control the development of the individual in early childhood to such an extent that a particular 'bent'—for example, the artistic bent—will be subject to conscious choice and direction. At present there is no question of such a possibility, and we are left with the alternative of making the best of the chances provided by heredity and accidental environment. A great advance will have been made when the choice of a vocation bears some relation to an accurate determination of the child's innate disposition or tem-

perament. What we need for the selection of pupils to be trained as painters and sculptors is some means of determining, in the first eleven years of a child's life, the presence or absence of what, to avoid the ambiguous word 'creative', we will call a plastic faculty. By a plastic faculty I mean an ability to transfer to impressionable materials like stone and clay and paint (and it is equally true of materials like words and notes) the intuitions of shape and form and colour which rise from the instinctive or unconscious level of the mind, and it is this faculty alone which distinguishes the vocational artist from any other fully developed man of feeling. Let us ignore for the moment the significance of those intuitions; it is sufficient to bear in mind that no great art—no art universally and instinctively recognized as such since the beginning of the world—has been without these special characteristics.

It might be that *when* we have discovered means to test an individual's possession of such a faculty, we should be threatened with an excess of painters and sculptors; the Republic of those days would then have to decide how many artists it wanted for its social economy, and according to that quota a certain proportion would be selected on a competitive basis and trained accordingly. But that again is a possibility we need not seriously entertain. The slogan, that 'the artist is not a special kind of man, but every man is a special kind of artist', has often been repeated, and expresses an essential truth; but it is unrealistic to ignore differences in sensuous constitution. The differences between a painter and a musician, between a poet and a sculptor, are absolute, and depend on a sensitiveness towards a particular medium which enables a special kind of man to become a special kind of artist. Every man will, we hope, if he is not inhibited or deformed by his education, be able to express himself as an artist of some sort; but only a special kind of man can become a poet, painter, sculptor or musician of the special kind we call 'great'.[1]

EDUCATING THE INSTINCTS

If ideally the number of those who are to be trained as painters, sculptors and 'creative' artists generally should be restricted, on

[1] Since writing this book, I have treated these questions in much greater detail in *Education Through Art* (Faber & Faber, 1943).

the other hand the number of those to be trained in the appreciation of the arts should be vastly increased; indeed, no person should be exempt from such training except those hopelessly disqualified by stupidity or mental atrophy. For common sense as well as psychology tells us that the æsthetic impulses which are the normal possession of children, and which children all over the world and throughout all time have possessed in striking uniformity, are merely dormant in so-called educated people. It should not, therefore, be beyond our skill to devise means of preserving those impulses a little nearer to the surface of consciousness, thus enabling the mind to develop to a far greater extent those emotional responses to beauty whose refining and ennobling influence is now confined to such a modest remnant of mankind. As I have argued elsewhere, and often, the distinction between the fine and applied arts is merely one of degree and attitude, and not one of kind. In any natural order of society, *all* social activities would be æsthetic. Rhythm and harmony would pervade all that we do and all that we make: in this sense every man would be an artist of some kind, and no art would be despised merely because it was mechanic or utilitarian.

It would be useless, however, if in considering this question we avoided the conflict of values involved. Nothing less than a transvaluation of all values is necessary. We must learn to discount to a large extent those social and intellectual values which have been the proud aim of the whole classical tradition. The bloody and embittered history of a world which for more than two thousand years has depended on the supremacy of ideological values of some sort is no recommendation of their efficacy in promoting human happiness. We might at least try the experiment of educating the instincts instead of suppressing them; the cost of a failure could not exceed what the world has already endured, and is now enduring.

THE PROCESS OF EDUCATION

It is still necessary to ask what is involved in the process of 'educating the instincts',[1] more particularly in the sphere of art.

[1] It may be as well to give a definition of instinct. 'An instinct differs from a stimulus in that it arises from sources of stimulation within the body, operates

THE PROCESS OF EDUCATION

We have seen that Freud has described the id as 'a chaos, a cauldron of seething excitement'. But the work of art is always, in some sense, orderly. It is true that we need not confine ourselves even in the classical conception of order to such values as symmetry, regular proportion and definite outline; the baroque style, which is a contradiction of all these qualities, is still art, and proves that order and coherence can be open, irregular and dynamic. Indeed, the only common denominator of all types of art is a certain intensity or vitality—what we have called 'the artist's hand-writing', but which, of course, to extend the metaphor, includes the larger unit of the page. That is to say, a 'work' of art implies a certain quantity as well as quality of work, and the intensity must be co-extensive with that quantity.

In apparent contradiction to his description of the id as chaotic, Freud, as we have seen, also says that 'in the id there is nothing corresponding to the idea of time, no recognition of the passage of time, and (a thing which is very remarkable and awaits adequate attention in philosophic thought) no alteration of mental processes by the passage of time. . . . It is constantly being borne in upon me that we have made far too little use for our theory of the indubitable fact that the repressed remains unaltered by the passage of time. This seems to offer us the possibility of an approach to some really profound truths'.[1] Possibly among these truths is some solution of the mystery of art. Remember that we have assumed that the particular somatic or sensuous organization of the artist enables him 'to grasp relations in the deeper layers of the ego and in the id which would otherwise be inaccessible.' If we consider that this region, this cauldron, into which the artist is able to peer is a region of timeless entities, then we seem to have some explanation of the source of the vital energy which is transmitted to the artist's creative impulse, and at least the suggestion

as a constant force and is such that the subject cannot escape from it by flight as he can from an external stimulus. An instinct may be described as having a source, an object and an aim. The source is a state of excitation within the body, and its aim is to remove that excitation; in the course of its path from its source to the attainment of its aim the instinct becomes operative mentally. We picture it as a certain sum of energy forcing its way in a certain direction.' Freud: *New Introductory Lectures*, p. 125.

[1] *Op. cit.*, p. 99.

of an explanation of the universal appeal of what the artist is inspired to express. For what is timeless is by the same token universal.

We imagine the artist, then, as dipping into a cauldron of time-less and intensely vital entities, and in some manner bringing to the surface one or more of these entities. The probability is that any such direct contact with the deeper layers of the mind would be too much for us; such art we should describe as uncanny, *unheimlich*. We might tolerate it in a few cases—in the extreme fantasies of Bosch, of El Greco, of Goya's 'mad' phase. But in general the artist has to tame the entities of his vision before he retails them to the visionless public. And this is the function of that part of the artist's mind which we call his ego. It is the ego which mediates between the artist's id and the external world—which makes him, so to speak, the conscious agent that he is. The ego, says Freud, 'is the sense-organ of the whole apparatus, receptive moreover, not only of excitations from without but also of such as proceed from the interior of the mind. One can hardly go wrong in regarding the ego as that part of the id which has been modified by its proximity to the external world and the influence that the latter has had on it. . . . In the fulfilment of this function, the ego has to observe the external world and preserve a true picture of it in the memory-traces left by its perceptions, and, by means of the reality-test, it has *to eliminate any element in this picture of the external world which is a contribution from internal sources of excitation*. On behalf of the id, the ego controls the paths of access to motility, but it interpolates between desire and action *the procrastinating factor of thought*, during which it makes use of the residues of experience stored up in the memory. In this way it dethrones the pleasure-principle, which exerts undisputed sway over the processes in the id, and substitutes for it the reality-principle, which promises greater security and greater success'.[1]

All this is true of the formation of the normal individual, but in the case of the artist there is an exception; *he* does not eliminate any element which is a contribution from internal sources of excitation; *his* purpose is precisely to introduce such elements, and by the introduction of forces from that deeper level of being which we

[1] Freud: *New Introductory Lectures*, pp. 100–1. My italics.

call the id, disturb the even and orderly surface of the conventional conception of reality. It is *his* desire to evade the procrastinating factor of thought and give to the world all the immediacy and vitality of his intuitions, his perceptions of the instinctual processes of his mind.

His only care must be to compromise; so to control the outflow of his instinctive energies that they do not unduly alarm or antagonize the normal individual. He does this by disguising his lawless images—by giving them form and proportion, and a clothing of symbol and myth which make them acceptable to the public at large. Thus the artistic process in general may be said to consist of two processes: the immediate and essential one which has always been known as inspiration, and which psychologically we describe as an access to the deeper layers of the unconscious; and a secondary process of elaboration, in which the essential perceptions and intuitions of the artist are woven into a fabric which can take its place in the organized life of conscious reality.

The symbol and the myth remain always on this simple, sensuous level: they are not, as they exist in legend and folklore, anything but creations of the imagination. It is only when a race acquires a conscience, a theology and a morality, that the symbol and the myth become perverted by the intellect—rationalized and petrified. Then art is dead. For we must, in these matters, remain as children, and education should have no other aim than to preserve within us some trace of the penetration and the delight of the innocent eye.

Chapter Seven

ART IN TRANSITION

Que les accidents de féerie scientifique et des mouvements de fraternité sociale soient chéris comme restitution progressive de la franchise première?

ARTHUR RIMBAUD

So far in this book we have been considering art and society from the historical point of view. It is true that we have maintained certain general principles about the nature of art which are relatively theoretical and *a priori*; that is to say, though based on the science of art and a deduction from the whole historical range of relevant material, the facts in question are relative to the æsthetic sensibility, and this we have assumed to be, if not a fixed and dependable quantity, at least a psychological faculty which, however much it may vary from person to person and from period to period, is the expression of a basic human need—the need to give outward plastic and sensuous expression to our inner intuitions and emotions. Perhaps it is our awareness of the permanency of this impulse which causes us to seek for types of art which we can regard as universal and therefore calculated to appeal to mankind as long as mankind exists. Karl Marx was puzzled to understand why Greek art should 'still constitute with us a source of æsthetic enjoyment and in certain respects prevail as the standard and model beyond attainment.' Actually there is no absolute historical justification for even this belief. For several hundred years the ideals of Greek art were regarded as immutable; but during these centuries the actual objects meant by the phrase 'Greek art' have varied considerably. From the beginning of the Renaissance until the seventeenth century, the general notion of Greek art must have been extremely vague, and there was probably no very clear distinction between the various types of Greek art or even between Greek art as such and Roman art. The

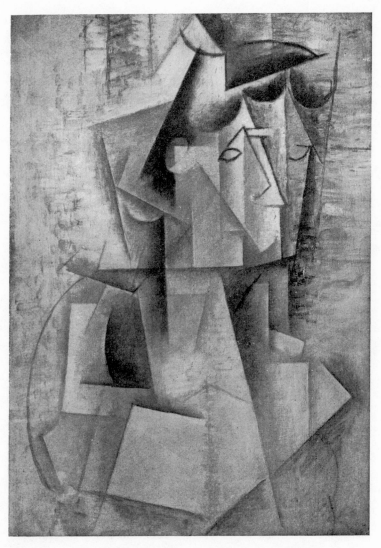

PLATE 50. 'L'Arlésienne', by Pablo Picasso. (1912)

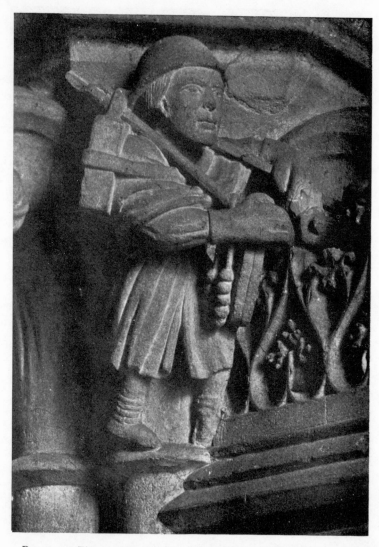

PLATE 51. Figure of a workman from Wells Cathedral. About 1220

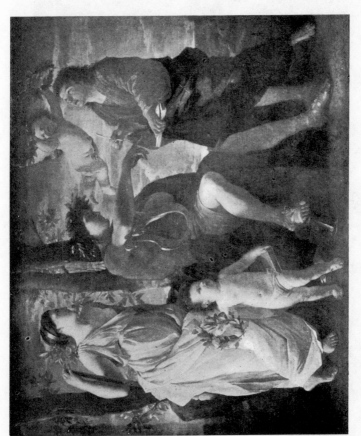

PLATE 52. 'L'inspiration du poète', by Poussin. 1636–8

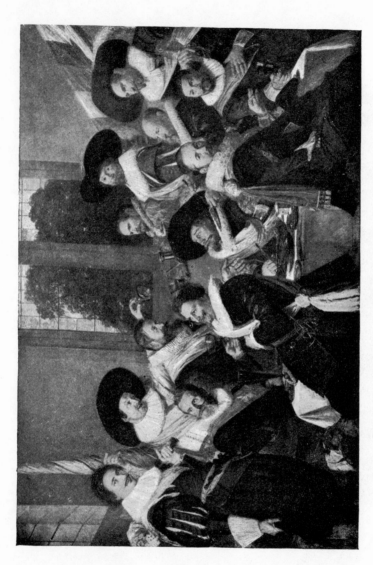

PLATE 53. Corps de St. Adraien, by Frans Hals. 1664

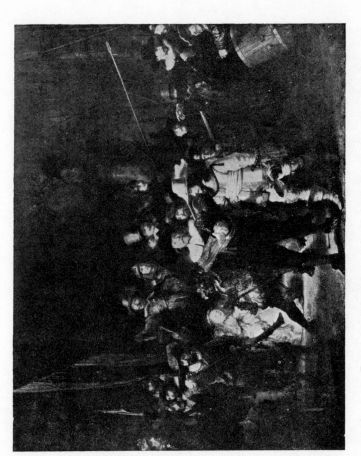

PLATE 54. The Night Watch, by Rembrandt. 1642

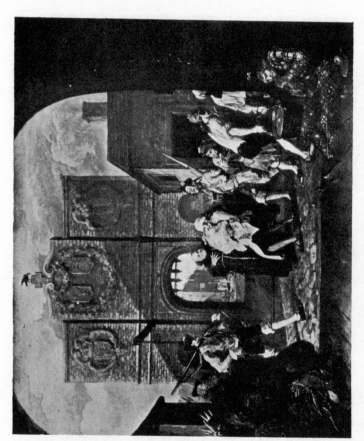

PLATE 55. 'Calais Gate', by Hogarth. 1748

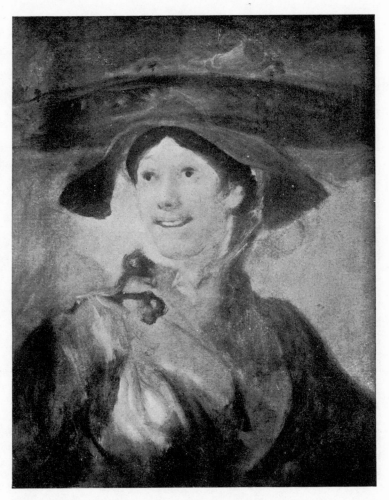

PLATE 56. 'The Shrimp Girl', by Hogarth

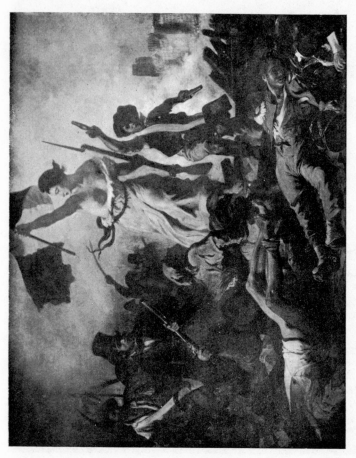

PLATE 57. 'Le 28 juillet—Liberté guidant le peuple', by Delacroix. 1830

systematic study of Greek art begins with the travels of Spon and Wheler in 1675-6, but it was not until the discovery of Pompeii in 1748 that sufficient material existed for the foundation of an historical method in the study of the history of Greek art. From that time our estimation of Greek art has varied with our increasing understanding. There may still exist people who would establish the peak of Greek art round about the year 400 B.C., but the general taste of the critic and the connoisseur has receded to the sixth and even earlier centuries. Though there is no denying the instability of æsthetic judgment, it is possible to maintain that from one point of view the modern taste is essentially right. For it involves a rejection of those purely intellectual standards of art which, as we have seen, have always been inimical to the very existence of art, and is based on an appreciation of those irrational and intuitive elements which we have now reason to believe to be the essential elements in art.

The question for the future, then, is whether we can preserve art in its essential nature whilst giving it a place in the pattern of our culture. We have seen that it is dangerous for a society to be too conscious about art; but it is nevertheless necessary for society to support the artist. Art must be regarded as a necessity like bread and water; but like bread and water, it must be accepted as a matter of course; it must be an integral part of our daily life, and must not be made a fuss of. It should be treated, not as a guest, not even as a paying guest, but as one of the family. I have already found support in Dr. Benedict's wise book, but I am tempted to add a final quotation describing the general process of integration which is the right and natural way in which a culture develops; it is all the more apt in that it takes art as an illustration:

'This integration of cultures is not in the least mystical. It is the same process by which a style in art comes into being and persists. Gothic architecture, beginning in what was hardly more than a preference for altitude and light, became, by the operation of some canon of taste that developed within its technique, the unique and homogeneous art of the thirteenth century. It discarded elements that were incongruous, modified others to its purposes, and invented others that accorded with its taste. When we describe its

process historically, we inevitably use animistic forms of expression as if there were choice and purpose in the growth of this great art-form. But this is due to the difficulty in our language-forms. *There was no conscious choice, and no purpose.* What was at first no more than a slight bias in local forms and techniques expressed itself more and more forcibly, integrated itself in more and more definite standards, and eventuated in Gothic art.

'What has happened in the great art-styles happens also in cultures as a whole. All the miscellaneous behaviour directed towards getting a living, mating, warring, and worshipping the gods, is made over into consistent patterns in accordance with unconscious canons of choice that develop within the culture. Some cultures, like some periods of art, fail of such integration, and about many others we know too little to understand the motives that actuate them. But cultures at every level of complexity, even the simplest, have achieved it. Such cultures are more or less successful attainments of integrated behaviour, and the marvel is that there can be so many of these possible configurations.'[1]

I have italicized what seems to me to be the consideration we are most likely to forget. The process of integration is instinctive, and it may be doubted whether a great civilization was ever consciously planned. It is an unconscious growth, and is killed by rationalization. At the present moment we have a civilization which has suffered such a fate. We are at the dead end of a process of rationalization, and by a supreme effort of consciousness we are trying to recognize the fact. Consequently we live in an age of transition, in which a whole way of life and thought is breaking down, never to recover, and if civilization is to continue we have to discover a new way of life. What I wish to discuss in this last section of my book is (*a*) the function of art in the present stage of transition, and (*b*) the place of art in the society of the future. Our aim is to establish a position from which we can survey the various existing social tendencies and select the one which would seem to offer the greatest promise of a civilization in which art would once more have its place and function.

[1] Ruth Benedict: *Patterns of Culture*, pp. 47–8. London, 1935.

AN AGE OF TRANSITION

There are many transitional movements in art to-day, and there is, of course, a body of artists opposed to movement of any kind. It would, however, simplify our discussion to divide all these various movements and monuments into three general groups, as follows:

I. Bourgeois Academic Art.
II. Revolutionary Art.
III. Functional Art.

The second group may be further subdivided into (1) expression-istic, (2) super-realist and (3) abstract or non-representational types. By so subdividing this middle group we may find it easier to pass from conceptions of one group to those of the others.

By bourgeois[1] academic art we mean art which has continued the general tradition of the Renaissance either as academic idealism (secular and religious), or as popular realism. It is the kind of art which every year covers the walls of the Royal Academy in England and of similar institutions in other countries. Occasionally competent in a technical sense, generally sentimental and always utterly insignificant, it is to be regarded as a commercial commodity which is neither aware of its fatuity nor yet ignorant of its fate. In the last hundred years it has suffered several severe blows. The first and the most mortal was the invention of photography, which has made such art altogether unnecessary as a method of re-cording natural facts and features. It cannot, of course, be claimed that the photograph gives an accurate interpretation of *reality*; nothing can be more arbitrary than a photograph, as most people know from the photographs they have had taken of themselves. Without in any sense becoming an idealist, it is therefore still possible for the painter to strive after some unique mode of rendering the objective reality of people and things; though from a psychological point of view it is open to doubt whether he can ever attain more than a subjective reaction. If such an objective reality existed, the more artists succeeded in their aim the more

[1] I apologize for using this word with its loose associations; but there is no English term to indicate the general standard of financial security under capitalism, the sense of a stake in the country, etc., and all the accompanying social and moral prejudices.

identical their work would become; but in fact there has never been the slightest tendency towards such uniformity of vision and expression. Once the subjectivity and relativity of the individual artist's vision are admitted, the avowed purpose of academic art becomes illusory; there seems no reason why the artist should limit himself in such an unimaginative way. There seems no reason, that is to say, why the artist should not take the whole range of internal perception as his legitimate province—which is, as we shall see, precisely the claim made by one school of modern artists.

A second blow, which was perhaps a consequence of the first, was a general defection of practically all artists and critics of intelligence. For good or for evil, the main stream of art since the middle of the nineteenth century has turned away from both realism and idealism, and has been concerned with the disinterested expression of æsthetic values. Admittedly, in the process, such art has ceased to be popular, and it may still be uncertain of its élite; but most artists of talent would now rather starve than compromise with the representational conventions of academic painting and sculpture.

A third blow perhaps affects more than academic bourgeois art: it is a general decline of what might be called the parlour conception of art. A painting or a piece of sculpture may still be used in a decorative way; but it is rarely collected for itself alone, with the implication that the more we have the better. It is acquired as part of a scheme of decoration, in which the picture, for example, is only one element, and actually an element which may be dispensed with altogether. In itself a sign of increased æsthetic sensibility, this tendency is fatal to the whole individualistic conception of the work of art, for if the picture is not collected for what it says (which gives it an illimitable scope) but for what it does—that is to say, for its decorative function—a saturation point is soon reached, at least in countries with a stagnant or a declining population. There may still be thousands of homes without an academy picture, and academicians may pluck up courage at the thought. But a still further blow awaits them which is sufficient to dash any nascent hopes. This is the increase in the methods and efficiency of processes of reproduction. Where an original academy picture

might hang, to-day there will more likely hang an excellent fac-simile of the year's *best* academy picture, acquired for a fraction of its cost. But worse: it has been discovered that certain types of 'modern' art (pictures by Van Gogh and Gauguin, for example), even though they may be unsatisfactory as representations of what we see, are very 'decorative', chiefly because they are bright in colour; and thousands of these reproductions are sold every year to people who were formerly potential purchasers of canvases from the Academy or the local art show.

Some of these tendencies affect the revolutionary artist no less than the academic artist, but the difference is, first that the revolu-tionary artist is in the minority, and may be supplying what is comparatively speaking an article with a certain scarcity value; secondly, and more significantly, he is probably himself in revolt against the individualistic basis of the art market, and prepared for the sacrifices involved in the transition to some other basis. He would not be human if he did not want people to buy his pictures, and no doubt the liaison between patron and artist has its senti-mental value. But actually the artist would prefer to get on with what he would call his work without having to worry about the financial economy of his existence. He would like to be a member of a corporative body which guaranteed him his means of sub-sistence; he would like to be regarded as just as necessary to the general economy of a country as the destructive or defensive personnel of the army and the police force. He might deserve, but would not claim, exceptional treatment; he would only insist on being recognized as one of the essential elements in the structure of an autonomous society.

At present, deprived of the solid support of his former patrons, his revolt takes one or other of the three paths already indicated. Let us examine them in turn.

EXPRESSIONISM

'Expressionism', though it is a familiar word in other countries, has not been used much in English art criticism; it is, however, a fundamentally necessary word, like 'idealism' and 'realism', and not a word of secondary implications like 'impressionism'. It

denotes one of the basic modes of perceiving and representing the world around us. There are, in fact, only these three basic modes—realism, idealism and expressionism, though, as we shall see in a moment, there is a fourth mode which claims to supersede realism. The realistic mode needs no explanation; it is, in the plastic arts, the effort to represent the world exactly as it is presented to our senses, without attenuation, without omission, without falsity of any kind. That the effort is not so simple as it sounds is shown by a movement like Impressionism, which questioned the scientific basis of normal or conventional vision, and tried to be even more exact in its rendering of nature.

Idealism starts from a basis of realistic vision, but deliberately selects and rejects from the plethora of percepts. According to Reynolds' classic definition, 'there are excellences in the art of Painting beyond what is commonly called the imitation of Nature. . . . All the arts receive their perfection from an ideal beauty, superior to what is to be found in individual nature'. The artist's eye, he says in this same Third Discourse, 'being enabled to distinguish the accidental deficiencies, excrescences, and deformities of things, from their general figures, he makes out an abstract idea of their forms more perfect than any one original.'

Idealism, it will be seen, has an intellectual basis; it is this intellectual dignity which, Reynolds felt, alone distinguishes the artist from the mere mechanic. Realism, we may say, is based on the senses; it records, as truthfully as possible, what the senses perceive. But there is still another division of man's conscious ego which we call the emotions, and it is precisely to the emotions that the third fundamental type of art corresponds. Expressionism is that type of art which strives to depict, not the objective facts of nature, nor any abstract notion based on those facts, but the subjective feelings of the artist. It is, by definition, individualistic, and it is by no means a specifically modern phenomenon of art. To some extent it is more typical of Northern races, because Northern races tend to be more introspective. On the other hand, a purely Mediterranean artist like El Greco is an expressionist, and no art is more expressionistic than the mystical types discussed in Chapter II, which are widely distributed over the world. There is much expressionistic art in Spain (a sculptor like Montanez, for

example), and it is not difficult to find examples in Italy. If we call the Northern examples typical (and Grünewald's Isenheim altar-piece at Colmar is always quoted as the type-piece), it is perhaps merely because they are nearest in the sympathetic nature of the feelings expressed.

Modern expressionism has developed into a distinct movement, and Van Gogh as much as any other individual is to be regarded as its founder, though actually the Norwegian painter Edvard Munch has been the most conscious and influential exponent of the style, giving birth to that prolific German school now so much in disfavour, which includes such powerful artists as Emil Nolde, Carl Hofer and Karl Schmidt-Rottluff. But even France has its expressionists (Georges Rouault and Marcel Gromaire) and express-ionism is the prevailing school in Belgium (Constant Permeke, Gustave de Smet, Fritz Van den Berghe and Floris Jespers).

Expressionism lives up to its name; that is to say, it expresses the emotions of the artist at any cost—the cost being usually an exag-geration or distortion of natural appearances which borders on the grotesque. Caricature is a department of expressionism, and one which most people find no difficulty in appreciating. But when caricature is carried to the pitch and organization of a composition in oils, or a piece of sculpture, then people begin to revolt. The artist is no longer 'appealing' to them—he is not flattering their vanities nor satisfying their super-egoistic idealism in any way. He is openly in revolt against the conventions of the normal concep-tion of reality and is endeavouring to create a vision of reality more strictly in accordance with his own emotional reactions to experience.

SUPERREALISM

As we have already hinted, and as the psychologist would not be slow to point out, the expressionist's notion of reality is confined to the conscious level of experience, and even inclines to a certain kind of idealism (for why should the realism of the emotions be any more 'real' than the realism of the intellect?). Any division of the total human personality is arbitrary, and any form of art based on a selected part of this total personality is equally arbitrary, and

therefore an idealistic preference. If reality is to be our aim, then we must include all aspects of human experience, not excluding those elements of sub-conscious life which are revealed in dreams, day-dreams, trances and hallucinations. Such is the quite logical claim of surrealism or superrealism, a movement in art not confined to painting and sculpture, but including poetry and prose, even philosophy and politics.

The superrealist is profoundly conscious of that lack of organic connection between art and society which is characteristic of the modern world. He sees that fundamentally the fault lies in the economic structure of society, and he believes that no satisfactory basis for art can be found within the existing form of society. He is therefore revolutionary, but not merely a revolutionary in matters of art. He begins with a revolutionary attitude in philosophy, with (to be precise) that revolutionary conception for which Marx was responsible, and which may perhaps be summarized in two propositions: (1) that no theory is valid that does not envisage a practical activity based on that theory, and (2) that the object of philosophy is not to interpret the world, but to transform it. Beginning from such a standpoint, the superrealist is naturally a Marxian socialist, and generally claims that he is a more consistent communist than many who submit to all manner of compromise with the æsthetic culture and moral conventions of this last phase of capitalist civilization. Surréalisme, in the form expounded by the animator of the movement, André Breton, has been profoundly influenced by the dialectical materialism of Marx. In particular it takes over from Marx that 'logic of totality' which Marx in his turn had taken over from Hegel, at the same time freeing the Hegelian dialectic from its inherent mysticism. But just as for Hegel and Marx the social system constitutes a whole, and none of its separate parts—its political economy, its religion, its art—can be properly understood in isolation, so art itself is not to be regarded as a reflection of one part of our mental experience—that part which we call 'conscious'—but is to be regarded as a synthesis of all aspects of our existence, even (indeed, especially) the most contradictory. 'I believe,' declared Breton in the First Manifesto of 1924, 'in the future transmutation of those two seemingly contradictory states, dream and reality, into a sort of absolute reality, a

super-reality, so to speak.' And then, more specifically in the Second Manifesto:

'While surrealism undertakes particularly the critical investigation of the notions of reality and unreality, of reason and unreason, of reflection and impulse, of knowing and "fatal" ignorance, of utility and uselessness, there is nevertheless between it and Historical Materialism this similarity in tendency, that it sets out from the "colossal abortion" of the Hegelian system. I do not see how limits, those for instance of the economic framework, can be assigned to the exercise of a thought which is definitely adapted to negation and the negation of negation. How allow that the dialectical method is only to be applied validly to solving social problems? It is the whole of surrealism's ambition to supply it with nowise conflicting possibilities of application in the most immediate conscious domain. I really cannot see, *pace* a few muddle-headed revolutionaries, why we should abstain from taking up the problems of love, of dreaming, of madness, of art and religion, so long as we consider these problems from the same angle as they, and we too, consider Revolution. And I have no hesitation in saying that nothing systematic has been done in this direction before surrealism, and for us also at the point where we found it, "the dialectical method in its Hegelian form could not be put into application." For us also it was imperative to have done with idealism proper, and our coining of the word "surrealism" is enough to show that this was so. . . .'[1]

This passage shows that surrealism possesses that second characteristic of the Marxian dialectic—its capacity to pass from the static to the dynamic, from a system of logic to a mode of action. When we use phrases like the totality of a social system, the integral pattern of culture, we are apt to deceive ourselves and to falsify our logic by imagining an abstract stable structure. But in its concrete reality this body is a bundle of co-ordinated activities—limbs, muscles, cells—all of which are in movement, and not one of which can move without affecting immediately or somewhere in a line of successive movements, the rest. The notion of an art, then, divorced from the general process of social development, is an

[1] Trans. by David Gascoyne: *What is Surrealism?* By André Breton, pp. 72–3. London (Faber & Faber), 1936.

illusion; and since the artist cannot escape the transformation of life which is always in progress, he had better take stock of his position and play his part in the process. If he believes in the reality and the importance of the artistic activity in itself, he must see that that activity is integrated with the other social activities which constitute the active totality of social development.

There can be no doubt as to the direction which these activities should take. That liberation of the mind which surrealism requires as the primary condition of its revolutionary activity demands, as Breton has made sufficiently clear, the liberation of man, 'which implies that we must struggle against our fetters with all the energy of despair; that to-day more than ever before the surrealists entirely rely for the bringing about of the liberation of man upon the proletarian Revolution.'

Liberation in itself is not an end; we must still ask what is the final purpose of surrealism. Again André Breton may be allowed to speak:

'A certain immediate ambiguity contained in the word surrealism, is capable of leading one to suppose that it designates I know not what transcendental attitude, while on the contrary it expresses—and always has expressed for us—a desire to deepen the foundations of the real, to bring about an ever clearer and at the same time ever more passionate consciousness of the world perceived by the senses. The whole evolution of surrealism, from its origins to the present day . . . shows that our unceasing wish, growing more and more urgent from day to day, has been at all costs to avoid considering a system of thought as a refuge, to pursue our investigations with eyes wide open to their outside consequences, and to assure ourselves that the results of these investigations would be capable of facing the *breath of the street*. At the limits . . . we have attempted to present interior reality and exterior reality as two elements in process of unification, of finally becoming *one*. This final unification is the supreme aim of surrealism: interior reality and exterior reality being, in the present form of society, in contradiction (and in this contradiction we see the very cause of man's unhappiness, but also the source of his movement) we have assigned to ourselves the task of confronting

these two realities with one another on every possible occasion, of refusing to allow the pre-eminence of the one over the other, yet not of acting on the one and on the other *both at once*, for that would be to suppose that they are less apart from one another than they are (and I believe that those who pretend they are acting on both simultaneously are either deceiving us or are a prey to a disquieting illusion), of acting on these two realities not both at once, then, but one after the other, in a systematic manner, allowing us to observe their reciprocal attraction and interpenetration and to give to this interplay of forces all the extension necessary for the trend of these two adjoining realities to become one and the same thing.'[1]

It should at once be obvious that much in the theory of surrealism corresponds to the basic realities of art as revealed by our historical survey of its development. Perhaps for the first time in history the artist has become conscious of the springs of his inspiration, is in conscious control[2] of such inspiration, and able to direct it to the specific course of art, which is the deepening of our sense of the total reality of existence, and, in a genetic sense, the further development of human consciousness. Hitherto the artist has been at the mercy of those conventions of naturalism, moralism and idealism which prevent and restrict the free operation of the unconscious forces of life, *on which alone the vitality of art depends*. At times the artist has thrown off these fetters and has allowed what has been called the imagination to transform reality, and though such art has been dismissed as 'romantic' by the intellectual prejudices of those interested in a static condition of normality, nevertheless such art, as typified above all in the art of Shakespeare, has never been deprived of its vitality, and philosophers of the perspicacity of Plato have been compelled to recognize precisely in its irrationality the distinguishing quality of all such art. Nevertheless, as Breton makes so clear in the passage already quoted, art is not merely irrationality; it is rather the interpenetration of reason and unreason, a dialectical counterplay, a logical progression whose end is a transformed world, a land of fantasy,

[1] Trans. by David Gascoyne: *What is Surrealism?* By André Breton, pp. 49–50.
[2] The paradox of such 'conscious' control being that its aim is to circumvent the intellect, the normal instrument of conscious control.

but with this qualification: 'the admirable thing about the fantastic is that it is no longer fantastic: there is only the real.'

It would be possible to show how closely the romantic theory of poetry, as elaborated by a great critic like Coleridge, or even by an honest Victorian like A. C. Bradley, corresponds to the theory of surrealism, but that task may perhaps be left to future epigoni.[1] We must now turn to the only movement in modern art which at all directly challenges surrealism. This is the movement variously known as abstractionism, constructivism, or non-representational art.

AN ART OF PURE FORM

It was inevitable that once the arts of painting and sculpture deserted the aim established during the Renaissance of giving an exact representation of the natural appearances of the external world, there would be no halting short of an art of pure form. Some artists would aim at presenting the subjective reality of their own emotions or feelings, and thus give rise to that type of art I have already described as expressionism. But other artists would prefer to find the subjective reality, not in their own wayward moods, but in their sensational awareness of the concrete elements of their art—namely, forms and colours. That, it might seem, was a safer anchorage. The difficulty, which only a few have even been aware of, was to avoid the merely decorative result. To arrange form and colour into an attractive pattern undoubtedly requires the exercise of a refined æsthetic sensibility, but once the result was achieved it could not stand comparison, in all that art has meant to humanity, with the highest products of representational art. For these, in addition to a decorative appeal fully as strong as that of any abstract composition, had given the extra values of psychological interest or idealistic fancy.

The more profound of the abstract artists did not need to be told that 'decoration is not enough'. Their intuitions, if not their critical intelligences, made them aware of elements in their work which were more than a pleasant titillation of the senses. They knew that these elements had always been present in art, even in

[1] Meanwhile I have made the attempt myself in an introduction contributed to a volume entitled *Surrealism* (Faber & Faber, London, 1936).

representational art, and were the essential elements in the arts of architecture and music. Now though any amount of what we will call cosmic jargon has immemorially been permitted in the criticism and exposition of these latter arts, it somehow seemed foreign to the arts of sculpture and painting. But there is nothing in the nature of the elements concerned to prevent an analogous approach to abstract editions of these once representational arts.

The claim, therefore, of the abstract artist is that the forms he creates are of more than decorative significance in that they repeat in their appropriate materials and on their appropriate scale certain proportions and rhythms which are inherent in the structure of the universe, and which govern organic growth, including the growth of the human body. Attuned to these rhythms and proportions, the abstract artist can create microcosms which reflect the macrocosm—he can hold the world, if not in a grain of sand, then in a block of stone or a pattern of colours. He has no need of natural appearances—of the accidental forms created in the stress of the world's evolution—because he has access to the archetypal forms which underlie all the casual variations presented by the natural world.

I do not doubt myself that the abstract artist is sincere in this claim, and that he does achieve, with all due allowance for human fallibility, what he attempts. The only point in doubt is the social relevance of his activity.

Many of the critics of abstract art, especially the surrealists, dismiss it as the most evident byzantinism, escapism, absolutism, transcendentalism—in short, as completely devoid of social actuality. In many cases no doubt there is psychological justification for this criticism; and the actual state of society—its lack of any realization of the functional importance of the artist—provides a sufficient motive. But personally I do not think that the social relevance of abstract art is so remote as its critics assume. It may be that as specific works of painting or sculpture, its social function is not obvious, and that its appeal is for ever limited to an extremely restricted élite. The same criticism might be made of higher mathematics, but no one is so superficial as to assert that higher mathematics is a useless and anti-social activity; instead it is freely admitted that many of the greatest advances in civilization

(for example, wireless telegraphy and aeronautics) are dependent on the services of pure mathematicians. The function of abstract art must be envisaged in a similar way, with architecture and the industrial arts as the field of its practical application. These practical arts need for their æsthetic justification a heightened sensibility to the purity of form, the economy of means and the relevance of colour which can best be induced and refined by the creation and appreciation of non-representational works of art.

FUNCTIONAL ART

Art is a practical activity and as such is governed by the methods of its production. So long as the artist is using certain tools and materials—chisel and stone, brush and paint—the works of art so produced will have a certain basic similarity determined by these methods of production. It is a commonplace of architectural history that styles have, at least in their general features, been determined by the materials available—wood, stone, brick, cement, steel—and by the tools or machines with which these materials are handled.

When the work of art is also, as in architecture, a work serving a utilitarian purpose, then the form of the art will be further affected by its function. Admittedly the same function—for example, to provide a convenient shelter for a family of human beings—may be served equally well in a variety of ways (the notion that there is only one ideal way of solving a fundamental problem is an idealistic myth); nevertheless, the functional purpose does set limits to the creative freedom of the artist. It introduces another element into the dialectic of that particular art, though function may be regarded as an aspect of reason, reflection, utility, etc., whose dialectical opposites are unreason, impulse, imagination, etc.; and an art like architecture, *in so far as it is an art*, is a synthetical resolution of just these contradictions. It is true that there is an extreme school of functional engineers for whom there is no antithesis to reason; but their works make no claim to be considered as works of art. On the other hand, there are modern architects, and among these the most notable, who fully recognize the necessity of

allowing some play to impulsive and irrational elements. Walter Gropius, for example:

'As our struggle with the prevailing ideas proceeded, the Bauhaus was able to clarify its own aims in the process of getting to grips with the problem of design from every angle and formulating its periodic discoveries. Our guiding principle was that artistic design is neither an intellectual nor a material affair, but simply an integral part of the stuff of life. Further, that the revolution in æsthetics has given us fresh insight into the meaning of design, just as the mechanization of industry has provided new tools for its realization. Our ambition was to rouse the creative artist from his other-worldliness and reintegrate him into the workaday world of realities; and at the same time to broaden and humanize the rigid, almost exclusively material, mind of the business man. Thus our informing conception of the basic unity of all design in relation to life was in diametrical opposition to that of "art for art's sake", and to the even more dangerous philosophy it sprang from: business as an end in itself.'[1]

This passage clearly implies an opposition between intellectual (imaginative, creative) activity and practical, mechanical activity, and their integration in a unity which is precisely the art of architecture. It does not imply, however, that this identical opposition is present in every work of art. Professor Gropius would be the first to admit that other arts have other ends, and though there may not be such a thing as 'art for art's sake', the other element in art is not necessarily a practical one. What in the end I think we have to admit is a distinction on the lines of the old dichotomy of the Fine and the Applied Arts—a distinction which, because it has been so much abused and misunderstood, many critics, including the present writer, have often strongly resented. The fallacy which arose in this connection was perhaps too stupid to be taken seriously—I mean the notion that art was some kind of decorative façade which had to be applied (literally 'stuck on') to any utilitarian object merely to hide its naked purpose. I have discussed this question at length in another book, *Art and Industry*, and I do not propose to return to it. But once that old confusion has been

[1] *The New Architecture and the Bauhaus*. By Walter Gropius. Trans. by Morton Shand. London, 1935.

removed we may perhaps return to a valid distinction between art which has an ideological function—the function of realizing our mental perceptions in a material form—and art which has a utilitarian function—the function of making instruments which satisfy our practical needs. It is true that those needs do not strictly require more than a practical solution; but that solution will be in conflict with other and essential instincts if it does not at the same time provide an æsthetic solution. The totality of the human being includes—it is my central hypothesis—an æsthetic impulse as well as various practical impulses; a concern for the form as well as for the efficiency of the instruments of production. Unless this instinct for form is satisfied at the same time as the functional need, a disturbance will be set up within the social totality: the pattern of the culture will not be integral.

The world has probably never exhibited such a lack of cultural integrity as now exists in the capitalist form of modern society. At times—when, for example, we see a typical suburban development —it would seem that the æsthetic instinct itself has atrophied; that men are no longer sensitive to form, but content to live in a chaos of styles, or rather, in a complete æsthetic nullity. But on analysis it appears that these developments are inherent in the methods of production: they are determined, that is to say, not by free choice, but by economic necessity—by the direct necessity of profit-making implied in the methods of production and distribution, and in any case by the ultimate lack of cultural unity implied in the structure of a society organized on a competitive rather than a co-operative basis. There is no escaping the patent fact that the degradation of art during the last two centuries is in direct correspondence with the expansion of capitalism.

SOCIALIST REALISM

Such being the case, we naturally expect to find in the one part of the world where capitalism has been overthrown, an abandonment of the debased ideals of capitalist art and a return to creative realities. But this is far from being the case. It is now nearly thirty years since the Union of Socialist Soviet Republics was established, and thirty years is admittedly not sufficient time in which to build

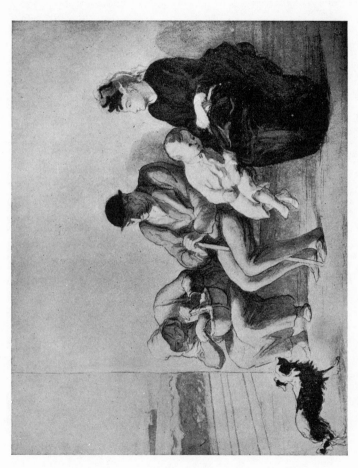

PLATE 58. The Third-class Waiting-room. Drawing by Daumier (1808–1879)

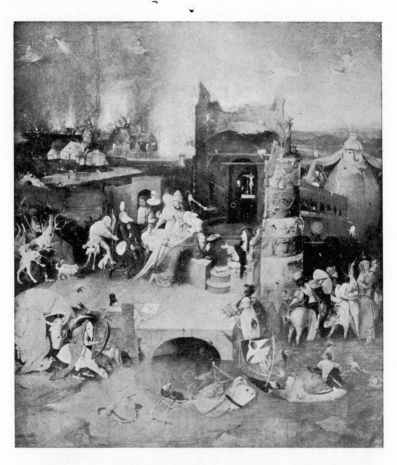

PLATE 59. The temptation of St. Anthony, by Jerome Bosch
(1450–1516)

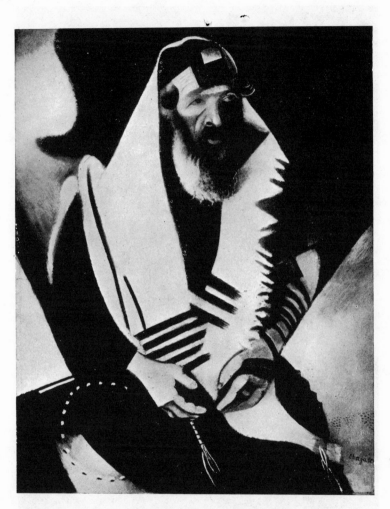

PLATE 60. An old Jew, by Marc Chagall

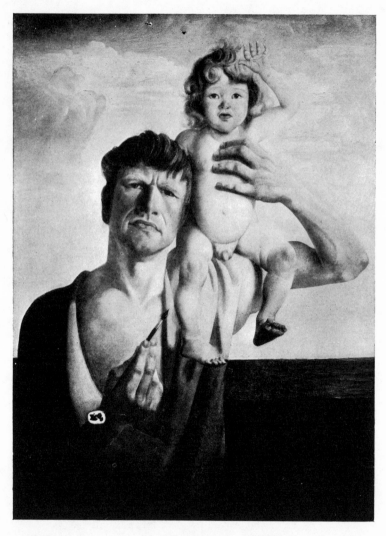

PLATE 61. Self-portrait, by Otto Dix

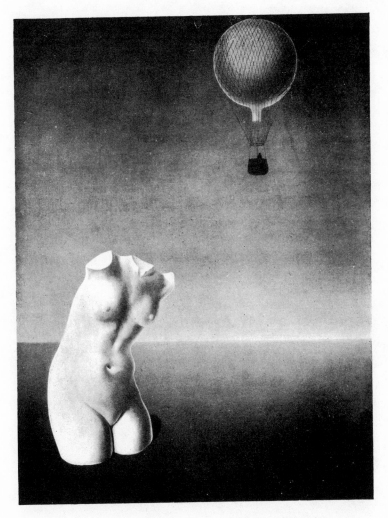

PLATE 62. 'Quand l'heure sonnera . . .', by René Magritte. 1933

PLATE 63. Relief, by Ben Nicholson (1935)

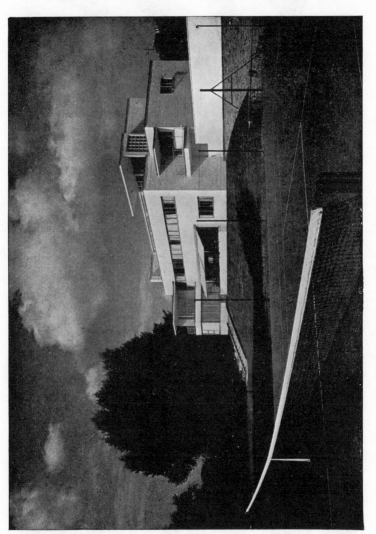

PLATE 64. House at Coombe, Surrey. Architect: Maxwell Fry

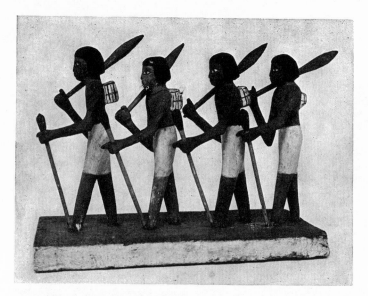

PLATE 65. Porters. Ancient Egyptian wood carving

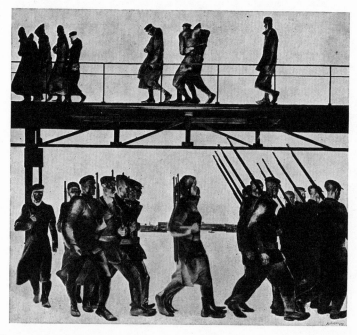

PLATE 66. The Defence of Petrograd. By Alexander Deineka. (1927)

up a new culture. If, in that process, art had been allowed to evolve organically, as a dialectical synthesis of imagination and reality, all might have been well; but in actual practice the most fatal of procedures has been adopted: the imposition of an intellectually predetermined conception of what art should be in a socialist community. That this conception should have been derived from the general nature of popular art in various epochs is only natural; but, as we have seen, such art has never been of any great cultural or æsthetic significance, and the reason for this we have ascribed to its realistic nature—the very quality which is extolled in Russia as the supreme aim of art.

In so far as the doctrine of 'socialist realism' is a coherent theory, it seems to reaffirm the general principles of naturalism in art in the form practised by the bourgeois poets, novelists and painters of the second half of the nineteenth century, with the addition of a purposive or dogmatic aim. We may take as representative and even authoritative the views expressed by the members of the first All-Union Congress of Soviet Writers held in 1934.[1] Karl Radek, who was at that time the most influential critic in Russia, defined their position in the following terms:

'The search of Soviet art for its own creative methods has been a long one, for it has had to overcome the old traditions in art and to explore a new trail, leading to *the portrayal of our life as it is*. This trail has been found. The methods of Soviet art have been found, and they are commensurate with the tasks which revolutionary literature sets itself. . . . Realism means giving a picture not only of the decay of capitalism and the withering away of its culture, but also of the birth of that class, of that force, which is capable of creating a new society and a new culture. Realism does not mean the embellishment or arbitrary selection of revolutionary phenomena; *it means reflecting reality as it is, in all its complexity, in all its contrariety*, and not only capitalist reality, but also that other, new reality—the reality of socialism.'

Here already we have a certain equivocation in the use of the word 'reality'. Reality, if it means anything at all, means the totality of phenomena present to the senses, and as such cannot be qualified as 'socialist' or 'capitalist'; it is 'life as it is', and if it is the

[1] See *Problems of Soviet Literature* (London: Martin Lawrence, Ltd.).

artist's duty to reflect such life, he is a passive, or at any rate a disinterested, instrument. But, Karl Radek says in anticipation of this objection, 'there is no such thing as static realism, no such thing as realism which portrays only what is. And if all the great realists of the past, even though unaware of the fact, were dialecticians, portrayed development through the conflict of contradictions, then this dialectic character of our realism is still more strongly stressed by us, when we speak of socialist realism.

'Socialist realism means not only knowing reality as it is, but knowing whither it is moving. It is moving towards socialism, it is moving towards the victory of the international proletariat. And a work of art created by a socialist realist is one which shows whither that conflict of contradictions is leading which the artist has seen in life and reflected in his work.'

It seems to me that this passage reveals a complete misunderstanding of the application of dialectics to the province of art. It assumes that the dialectical character of art is sufficiently indicated if it reflects the contradictions present in the social organism; art, that is to say, is not in itself a dialectical process, but merely the reflection of such a process. It is scarcely necessary to point out the superficiality of such a point of view, and I have already indicated what I consider to be the true dialectic of art: a synthesis of the contradictions of reality and unreality, of reason and imagination. Soviet realism, as a doctrine, seems to be unaware of this dialectical problem. Art in fact becomes, not a dialectical process, but a premium on a particular kind of idealism. Karl Radek makes this quite clear in the following remarks:

'We do not photograph life. In the totality of phenomena we seek out the main phenomenon. Giving everything without discrimination is not realism. That would be the most vulgar kind of naturalism. We should select phenomena. Realism means that we make a selection from the point of view of what is essential, from the point of view of guiding principles. And as for what is essential —the very name of socialism tells us this. Select all phenomena which show how the system of capitalism is being smashed, how socialism is growing, not embellishing socialism but showing that it is growing in battle, in hard toil, in sweat. Show how it is growing in deeds, in human beings.'

SOCIALIST REALISM

Admirable sentiments which, elected into a dogma and given the official support of a totalitarian state, provide the true and only necessary explanation of the retarded development of art in Soviet Russia.

A somewhat different view of 'socialist realism' was expressed at this same Congress by Nikolai Bukharin. Bukharin was dealing more objectively with a specific art—poetry—and his real understanding of the actual process of poetic thought leads to a much more dialectical approach to the problem:

'The process of life, taken as "experience", has its intellectual, emotional and volitional sides. We make a conventional distinction between logical thought, thought in terms of concepts, and "thought in terms of images", the so-called "realm of emotion". True, in actual life the stream of experience is integral and undivided; nevertheless, in this very unity, we have the intellectual pole and the emotional pole, even though they may not exist in their "pure form", even though they may merge into one another. But it would be entirely and essentially wrong to make an absolute mechanical division of the so-called "spiritual life" into watertight compartments of feeling and intellect, or of the conscious and unconscious, or of the directly sensory and the logical. These are not separate domains of abstract categories. They are dialectical magnitudes composing a unity.

'Logical thinking employs concepts, which range themselves into a whole ladder of thought, with various rungs, or degrees, of abstraction. Even when we are dealing with the highest type of logical thought—dialectical logic—where the abstract concept includes its concrete attributes, the very concept, as such, causes sensory colours, sounds and tones to lose their vividness. Moreover, perceptive action oversteps the bounds of the senses, although it has its source in them. . . . In science, the entire qualitative diversity and multiformity of the world take on other forms, quite distinct from immediate sensation, but giving a much more adequate reflection of reality—that is, more true.

'On the other hand, the entire world of emotions—love, joy, terror, grief, rage, and so on to infinity—the entire world of desire and passion, not as the object of research, but as experience, as well as the whole world of immediate sensations, also have their points

of condensation—thought in terms of images. Here, there is no abstraction from what is directly experienced. Here the process of generalization does not take us beyond its limits (as is the case in logical thought and in its highest product, scientific thought). Here this very sensory experience—doubly concrete and doubly "alive"—is itself condensed. Here we have, not a scientific reflection of real existence, but a sensorily generalized picture of a phenomenological series, not of the "essence", but of the "phenomenon". . . . The type of thinking here is not the same as in logical thought. Here generalization is achieved not by extinguishing the sensory, but by substituting one complex of sense symbols for a great multitude of other complexes. This "substitute" becomes a "symbol", an "image", a type, an emotionally coloured unity, behind which and in the fold of whose garments thousands of other sensory elements are concealed. Every such unity is sensorily concrete. To the extent that such unities are selected and fixated, i.e., that these experiences are constructively, creatively reproduced, to this extent we have art.'

All this is so just, that one wonders how such a critic is going to reconcile his true perception of the nature of art with the official doctrine of socialist realism. We find that he begins by admitting that socialist realism cannot set out to solve the same problems as dialectical materialism in science—'a fact which follows from the very essence of the difference between science and art.' Art must employ images, and 'even intellectual elements receive a definite emotional tinge.' 'But realism generally and socialist realism in particular, as a method, is the enemy of everything supernatural, mystic, all other-worldly idealism. That is its principal and definite attribute.'

This is already a different emphasis. For Karl Radek the principal attribute of socialist realism was not negative, but positive—in short, an affirmation of socialism. And even when the positive consequence of Bukharin's definition is explained—'that sensory reality and its motion, and not its fictitious sublimations, that real feelings and passions, real history, and not various versions of the "world spirit", provide the material which realism portrays'—even then nothing has been said which in any way distinguishes socialist realism from other kinds of realism—even from super-

realism. Indeed, the only way in which Bukharin can bring art into conformity with 'socialist realism' is by imposing on it the wholly intellectual aim of 'focussing attention on the portrayal of the building of socialism, the struggle of the proletariat, of the new man, and all the manifold complexities of "connections and settings" of the great historical process of our day.' Socialist realism, we are told 'dares to "dream"'; but its very dreams must be controlled, based 'on real trends of development'. Bukharin may protest that 'an antithesis between romanticism and socialist realism is devoid of all meaning,' and for a moment we may hope that the imaginative activity has been reinstated in all its freedom and ecstasy; but by romanticism we soon find that this critic means no more than the intelligent anticipation of further socialist developments.

In effect, then, socialist realism is but one more attempt to impose an intellectual or dogmatic purpose on art. It may be that the actual circumstances of the moment—the revolutionary urgencies to which most intellectuals and artists subscribe—demand a temporary supersession of the primary conditions of a great art: that art, like much else, must be sacrificed to the common good. If this is so, let it be clearly recognized, and do not let us deceive ourselves into imagining that a great art can be created under conditions which both the history of art and the psychology of the artist prove to be impossible.[1]

THE PRICE OF REVIVAL

A a general description of the present phase of cultural development in Europe and America, there seems no reason to doubt Hegel's conclusion 'that Art is no longer able to discover that satisfaction of spiritual wants which previous epochs and nations have sought for in it, a satisfaction which, at least on the religious side, was associated with art in the most intimate way.' And we may further agree with Hegel's explanation (which I have already

[1] The fact that both Radek and Bukharin have been 'liquidated' since this chapter was originally written in no way invalidates their exposition of socialist realism. No better exposition has been forthcoming, and socialist realism, now that it must dispense with the able theoretical structure given to it by these two critics, is left as a naked political dogma of no philosophical significance.

quoted more fully[1]) of this state of artistic impotency: 'The reflective culture of our life of to-day makes it inevitable, both relatively to our volitional power and our judgment, that we adhere strictly to general points of view, and regulate particular matters in consonance with them, so that universal forms, laws, duties, rights, and maxims hold valid as the determining basis of our life and the force within us of main importance.' But such a conclusion only holds good if we accept that judgment of values which regards a reflective culture as superior to all other types of culture. Hegel's view is based on his particular hierarchy of values, a hierarchy which gives the supreme place to the intellectual concepts of philosophy and religion. Hegel did not despise art. His *Æsthetik* is, all things considered, the most complete and the most profound treatise ever devoted to the subject by a philosopher. But his very comprehension of æsthetic realities brought him to the point of view that these realities were inconsistent with the transcendental truths which he regarded as the final achievement of the human mind.

A whole century has passed since Hegel expressed these particular views, and now we are no longer quite so confident. We have learned to respect the instinctive forces of life more fully. We can no longer regard the sensuous embodiment of experience or truth as merely an early historical phase in the development of human culture—a phase which has been superseded by the world of ideas. Hegel could go so far as to say that he regarded a *science* of art as a far more urgent necessity than art itself. We still act under that assumption; we still treat art as an aid to thought, or as an interpretation of thought, instead of as a mode of thought in itself. It would be impossible to hold the point of view of the socialist realist, for example, on any other assumption.

The necessity for the future, then, is a reintegration of art as an independent mode of apprehension and expression; as the sensuous correlative, equal and opposite, of intellectual abstraction. It may be that intellectual elements enter into the artist's mind, there to be given their concrete and objective symbols; and it may be that since, in Hegel's words, 'reality anywhere and everywhere, whether the life of Nature or mind, is defaced and slain by its

[1] See pp. 50–1.

comprehension; that so far from being brought more close to us by the comprehension of thinking, it is only by this means that it is in the complete sense removed apart from us, so that in his attempt to grasp through thought as a *means* the nature of life, man rather renders nugatory this very aim'—it may be that for this reason a philosopher must first reach a comprehension of reality through the sensuous medium of art. In any case, art is the fundamental necessity, and the maintenance of art in its full creative vitality requires that open cultivation of the sensuous and instinctive elements of the personality which were described in Chapters V and VI. Indeed, we may confidently assert, on the evidence of the facts there reviewed, that nothing like the full creative vitality of art has ever yet been realized by a civilized society. That general release from fear and repression which is promised by the technique of modern psychology no less than by the growing determination to win for humanity the benefits of modern methods of production will recreate the conditions of a great art. This, at least, is a possible faith to oppose to all who would leave us in despair and cynicism, without pleasure, without joy, without that highest and subtlest ecstasy of which the human mind is capable —the ecstasy of art, of poetry, the creation of a world of imaginative reality.

Appendix

WILLIAM HOGARTH
(1697-1764)

In England Hogarth is still perhaps the most familiar of English artists. Since his time the whole range of European painting has been made available by various processes of reproduction, and public galleries have given us the basis for a wide eclectic taste. But in spite of this competition some more or less debased print from the *Harlot's Progress* or *Marriage à la Mode* may still be found in country inns and farmhouse kitchens. Hogarth has not been denied a more critical appreciation; Lamb's and Hazlitt's essays have, indeed, established his reputation beyond any serious question. But it has not always been recognized that the qualities for which Hogarth is rightly praised by Lamb and Hazlitt have little or nothing to do with the art of painting. There is hardly a phrase in either of those famous essays which might not be about a fellow writer. Hazlitt, indeed, included the painter in a series of lectures on the English Comic Writers. More significantly still, Hogarth himself in some of his advertisements speaks of himself as the 'author'; and quite explicitly, in a much-quoted passage, confesses that he has 'endeavoured to treat my subject as a dramatic writer; my picture is my stage, and men and women my players, who by means of certain actions and gestures, are to exhibit a dumb show.'

I shall return presently to this aspect of Hogarth. First let us note a few details of his life. He was born in London in 1697, the son of parents who had migrated from Westmorland and who belonged to that same sturdy yeomanry which was later to produce Wordsworth. His stock is worth noting, for Hogarth possessed something of that shorthorn stolidity and staying-power which characterizes men of that region. His lack of education has often been held against him, but his father was a schoolmaster and there is no reason to suppose that he was any less cultured than Gains-

borough or Turner, or for that matter, than Shakespeare. In the note-books of his contemporary, the connoisseur George Vertue, whose manuscripts have only recently been transcribed and published, there occurs a brief account of Hogarth which may be quoted as an illustration of this attitude, and as a lively summary of the essential features of the painter's career:

'As all things have their spring from nature, time and cultivation —so Arts have their bloom & fruite &, as well in other places in this Kingdom. On this observation at present a true English Genius in the Art of Painting has sprung and by natural strength of himself chiefly, begun with little & low-shrubb instructions, rose to a surprizing hight in the publick esteem & opinion. As this remarkable circumstance is of Mr. Hogarth whose first practice was as an aprentice to a mean sort of Engraver of coats of arms, wch he left & applying to painting & study drew and painted humorous conversations, in time with wonderful succes—& small also portraits & family-peces &c. From thence to portrait painting at large, & attempted History, thro' all which with strong and powerfull pursuits & studyes by the boldness of his Genious—in opposition to all other professors of Painting, got into great Reputation & esteem of the Lovers of Art, Nobles of the greatest consideration in the Nation, & by his undaunted spirit, dispisd undervalud all other present & precedent painters, such as Kneller, Lilly, Vandyke—those English painters of the highest Reputation —such reasonings or envious detractions he not only often or at all times made the subject of his conversations & observations to Gentlemen and Lovers of Art, but such like invidious reflections he woud argue & maintain with all sorts of Artists, painters, sculptors, &c. . . .

'Admitt the Temper of the people loves humorous, spritely, diverting subjects in painting, yet surely *the Foxes tale* was of great use to him. As Hudibrass expresseth:

> *yet He! that hath but Impudence,*
> *to all things has a Fair pretence.*' [1]

That was written in 1745, but already in 1730 Vertue had noted that 'the daily success of Mr. Hogarth in painting small family

[1] *Transactions of the Walpole Society.* Vol. XXII (1933-4), pp. 123-4.

peices & Conversations with so much Air & agreeableness causes him to be much followd & esteemed, whereby he has much imployment & like to be a master of great reputation in that way.' At his own instigation Hogarth had left school at an early age to become apprenticed to a silver-plate engraver, having discovered in himself a natural ability for drawing. 'My exercises when at school were more remarkable for the ornaments which adorned them, than for the exercise itself.' But long before the end of his apprenticeship he was looking farther afield. 'Engraving on copper was, at twenty years of age, my utmost ambition.' That meant, in effect, engraving plates for illustrated books, and this was work requiring a high degree of skill in draughtsmanship. The way in which Hogarth set about securing this skill is very characteristic of the man, and shows that from the beginning he was possessed of that independence of spirit which gives us the clue to his whole career. In the normal course he should have attended an academy, drawing from the life and from the antique, thus undergoing several years of arduous training. Hogarth had neither the temperament nor the time for such a procedure. He therefore invented his own 'method', 'laying it first down as an axiom, that he who could by any means acquire and retain in his memory, perfect ideas of the subject he meant to draw, would have as clear a knowledge of the figure as a man who can write freely hath of the twenty-four letters of the alphabet and their infinite combinations . . . and would consequently be an accurate designer.' Whether by virtue of practising such exercises, or from some innate talent, there is no doubt that Hogarth possessed a visual memory of exceptional acuteness and retentiveness. At first he put it to humble uses: coats of arms and shop-bills, plates for booksellers and caricatures. In 1724 he issued his first independent engraving, a satirical design entitled *Masquerades and Operas*. In 1726 he engraved the illustrations for an edition of *Hudibras* and gained some fame, but little fortune. Meanwhile he was getting 'some little insight & instructions in Oyl Colours, without copying other paintings or masters immediatly', as Vertue puts it, and finding this technique more agreeable to his mind, he 'took up the pincill & applyd his studyes to painting in small conversations or fancyes.' These pictures, 'from twelve to fifteen inches high,' proved to be

WILLIAM HOGARTH

very popular, and for a time procured him a living. But not a
living on the scale he contemplated. In 1729 he had run away with
the daughter of Sir James Thornhill, one of the most distinguished
and successful painters of the day; and we may assume that he was
anxious to win the approval of his outraged father-in-law. He was
soon to succeed in this ambition, and in the process to effect some-
thing like a revolution in the history of English painting.

To understand the significance of what follows, we must realize
the condition of English art at this period. During the Middle Ages
this country had been famous all over Europe for its artists:
English manuscripts, English embroideries, English alabasters
were all much sought after, and there is a growing belief that even
English painting had far more influence on Continental schools
than has hitherto been recognized. Some exquisite miniaturists,
such as Nicholas Hilliard, maintained the art in a minor strain,
but by 1530 at the latest we had lost our reputation, and for two
centuries the people at large seem to have maintained a puritan-
ical indifference or even hostility towards all native art. Such art
as the Court required for its dignity was imported from abroad—
Holbein, Vandyck, Lely, Kneller, were all of foreign origin, and
with a few exceptions such as Johnson, Walker, Riley, Greenhill
and Bacon—names which have made no great impression on the
public mind—such English painters as attained contemporary fame
were comparatively feeble exponents of a foreign style. It is to
Hogarth's eternal credit that he revolted against this enervate
condition of our native art, and fought with all his lustiness against
the snobbery and cant on which it subsisted. We are lucky to
possess a letter, written to the *St. James's Evening Post* in 1737, in
which he gives forceful expression to his point of view:

'There is another set of gentry more noxious to the art than
these [certain critics], and those are your picture-jobbers from
abroad, who are always ready to raise a great cry in the prints
whenever they think their craft is in danger; and indeed it is their
interest to depreciate every English work, as hurtful to their trade,
of continually importing shiploads of dead Christs, Holy Families,
Madona's, and other dismal dark subjects, neither entertaining
nor ornamental; on which they scrawl the terrible cramp names
of some Italian masters, and fix on us poor Englishmen the char-

acter of *universal dupes*. If a man, naturally a judge of painting, not bigoted to those empirics, should cast his eye on one of their sham virtuoso-pieces, he would be very apt to say, "Mr. Bubbleman, that grand Venus (as you are pleased to call it) has not beauty enough for the character of an English cook-maid." Upon which the quack answers with a confident air, "O Sir, I find that you are no connoisseur—that picture, I assure you, is in Alesso Baldovinetto's second and best manner, boldly painted, and truely sublime; the contour gracious; the air of the head in the high Greek taste, and a most divine idea it is." Then spitting on an obscure place and rubbing it with a dirty handkerchief, takes a skip to the other end of the room, and screams out in raptures, "There is an amazing touch! a man should have this picture a twelve-month in his collection before he can discover half its beauties." The gentleman (though naturally a judge of what is beautiful, yet ashamed to be out of the fashion in judging for himself) with this cant is struck dumb, gives a vast sum for the picture, very modestly confesses he is quite ignorant of painting, and bestows a frame worth fifty pounds on a frightful thing, without the hard name on it not worth as many farthings.'

All of which shows, not only an admirable sense of humour, but a healthy attitude towards the art of painting. But it did not mean, unfortunately, that Hogarth was altogether disabused of the ambition to rank as a painter in 'the Great Style'. It is quite impossible, as we shall presently see, to rank Hogarth as a great original genius of the type of Giotto or Cézanne; he did not seek to transform or redirect a tradition. He merely sought to re-establish a native school, and if the method he was to adopt might fairly be described as a stroke of genius, the genius must then be qualified as commercial rather than artistic.

Let me, for the last time, quote Vertue's quaint account of the matter:

'Amongst other designs of his in painting he began a small picture of a common harlot, supposed to dwell in drewry lane, just riseing about noon out of bed and at breakfast, a bunter waiting on her— this whore's desabillé careless and a pretty Countenance & air. This thought pleasd many; some advisd him to make another to it as a pair, which he did. Then other thoughts encreas'd & mul-

tiplyd by his fruitfull invention, till he made six different subjects which he painted so naturally the thoughts & strikeing the expressions that it drew every body to see them. Which he pro-posing to engrave in six plates to print at one guinea each sett, he had daily Subscriptions came in, in fifty or a hundred pounds in a Week—there being no day but persons of fashion and Artists came to see these pictures, the story of them being related, how this Girl came to Town, how Mother Needham and Col. Charters first deluded her, how a Jew kept her, how she livd in Drury lane, when she was sent to Bridewell by Sr. John Gonson, Justice, and her salivation & death.

'Before a twelve month came about whilst these plates were engraving he had in his Subscription between 14 *or fifteen* hundred (*by the printer* I have been assured 1240 setts were printed) Sub-scribers that he publickly advertiz'd that those that did not come in before a certain day should be excluded. . . .' (*Loc. cit.*, p. 58.)

Such was the origin of *A Harlot's Progress*, the first of that series of 'moral subjects' by which Hogarth made his fame and earned his living. What in effect Hogarth had done was to open up a completely new market. He had devised a means by which the artist's invention could be broadcast. The technical means, it is true, existed before; but he had hit upon an idea for exploiting that means, and this he had done quite shrewdly and deliberately. 'This I found was most likely to answer my purpose,' he confesses, 'provided I could strike the passions, and by small sums from many by the sale of prints which I could engrave from my pictures, thus secure my property to myself.' From the engravings we may reckon he secured £1,300; the originals he sold thirteen years later for only £88 4s. But when the present value of these sums is computed, it will be realized that Hogarth was at last a man of substance. And in effect Sir James Thornhill no longer delayed to recognize him as his son-in-law.

The only fault in the scheme was due to the lack of any legal protection for such an original kind of traffic; no sooner were his engravings issued than they were extensively pirated. So before continuing in this career, Hogarth set about to get the law amended, and as a result of his activities a Bill was introduced into Parliament and duly passed which gave to designers and engravers

an exclusive right to their own works and enabled them to control the multiplication of copies. With this security Hogarth then launched another series, *A Rake's Progress*, which was equally successful. Piracy continued in spite of the Act, so Hogarth himself issued small copies of the series at 2s. 6d. the set, at which price the pirates presumably could not compete. At every stage, indeed, Hogarth pursued the commercial possibilities of his engravings; incited all the more because he soon discovered that the broad-casting of the engravings deprived the original paintings of their proper value 'as (according to the Standard of Judgment, so righteously and laudably establish'd by Picture-Dealers, Picture-Cleaners, Picture-Frame-Makers, and other Connoisseurs) the Works of a Painter are to be esteem'd more or less valuable, as they are more or less scarce. . . .' He resorted to ingenious methods of auctioning these original paintings, but without much success. The eight paintings of *A Rake's Progress*, for example, only fetched twenty-two guineas each.

There is no point in recounting the rest of the engravings issued by Hogarth; he continued to issue them throughout his life and on them he depended for his livelihood. We must, however, examine their general character, for they offer perhaps the best possible opportunity for considering one of the central problems of art—a problem which seems to divide critics into two irreconcilable camps. It must be clearly realized that two distinct factors were involved in Hogarth's scheme; one financial (obtaining, instead of a large sum from one purchaser, small sums from many) the other psychological ('provided I could strike the passions'). It is to this psychological factor that we should now give our attention. It was the factor on which the whole success of the scheme de-pended, for though any artist could engrave his paintings and sell the prints for a few shillings apiece, only a rare genius like Hogarth could devise subjects which would so 'strike the passions' that the public would flock to buy them.

It is the distinction of Hogarth that more than any other artist he has been responsible for the habit, inveterate with the English, of judging a work of art by its subject-matter, to the almost com-plete neglect of its form. The fact that his own paintings are not without fine qualities, both of composition and handling, does not

alter the fact that he appealed beyond these, and laid his full stress on the picture's moral theme.

'I . . . wished to compose pictures on canvas, similar to representations on the stage; and farther hope, that they will be tried by the same test, and criticized by the same criterion. Let it be observed, that I mean to speak only of those scenes where the human species are actors, and these I think have not often been delineated in a way of which they are worthy and capable. In these compositions, those subjects that will both entertain and improve the mind, bid fair to be of the greatest public utility, and must therefore be entitled to rank in the highest class.' In this manner Hogarth described his aims, and his reference to the drama is no idle analogy. To understand its force we must consider for a moment the place occupied by the stage at the time we are speaking of. Ever since Jeremy Collier's famous attack on the excesses of Restoration comedy (1698), the English stage had shown a definite tendency to reform itself. The sincerity of these good intentions may perhaps be doubted; often enough it amounted to romping through four acts with all the old gaiety and licence, and pulling up suddenly in the fifth act to dole out the rewards and punishments demanded by the new moral consciousness of the age. Such was the sentimental comedy of Steele and Colley Cibber, of Sotherne and Rowe; and it was exactly contemporaneous with Hogarth's youth. At the precise moment at which Hogarth was looking round for some new device to strike the passions, this comic spirit, which had reached its highest point in *The Beggar's Opera* (1728) was given a tragic twist. In June 1731 George Lillo's 'domestic tragedy' *The London Merchant, or the History of George Barnwell*, was produced and was one of those wild popular successes which though of no lasting importance, at the time seemed to transform the whole course of life. In theme this play was based on 'an excellent ballad of George Barnwell, an apprentice of London who . . . thrice robbed his master, and murdered his uncle in Ludlow', and Lillo did not fail to squeeze every drop of moral unction out of his gloomy career. But the success of the play was due, not merely to its generous cathartic effect on the maudlin emotions of that generation, but also to the fact that Lillo had deserted the Aristotelian canon which requires that the characters

of a tragedy must be persons of rank and fortune, and had written about the humble folk of everyday life. He had struck the petty bourgeois note, just as in our day authors are endeavouring to strike the proletarian note. It was a note that rang so clearly in Hogarth's ear that he set about converting it into the terms of his own art.

Hogarth completed the plates of *A Harlot's Progress* in September 1731, four months after the successful production of *The London Merchant*, and this series of engravings, like the others which were to follow it, was in effect a 'domestic tragedy' in the manner of Lillo's play, and appealed to the same emotions. Hogarth had struck well. His upbringing, his temperament and his manner of life, had supplied him with a rich and varied knowledge of 'the human species'; he had trained himself to store in his mind visual images of human types, actions, expressions, gestures. He needed only the inspiration of Lillo's tragedy to precipitate this wealth of material in a vendable form.

He struck the passions of his contemporaries, and though Lillo's work is dead and forgotten, Hogarth still survives, and in every age his genius has evoked the eulogies of responsible critics. I have already remarked that these critics treat Hogarth as an author. Lamb compares him to Shakespeare, and though Hazlitt demurs against such 'a staggering paradox', he admits that Hogarth had the advantage over Fielding, 'and other of our comic writers, who excelled only in the light and ludicrous'. 'There is a general distinction,' Hazlitt points out, 'almost an impassable one, between the power of embodying the serious and the ludicrous; but these contradictory faculties were reconciled in Hogarth, as they were in Shakespeare, in Chaucer; and as it is said that they were in another extraordinary and later instance, Garrick's acting.'

If, in spite of these comparisons, which we may be prepared to admit, we still deny that Hogarth was a great painter, we must make the grounds of our objection very clear. There are two possible lines of criticism, both decisive in Hogarth's case. The first might be called formal, because it concerns his ability in composition and in the handling of his medium. This may be presented very briefly. 'My picture is my stage,' said Hogarth,

144

'and men and women my players, who by means of certain actions and gestures, are to exhibit *a dumb show.*' That statement, in actual fact, is more than a metaphor. Hogarth's compositions are in a certain sense artless; they are action arrested, but not the action of daily life (as later an impressionist painter like Degas or Manet would arrest it). It is the arrested action of a mechanical play, of figures crowded into the unnatural space between a backcloth and the footlights. The realization of absolute space, such as we get in Raphael; the imponderability of light such as Rembrandt suggested; the organization of colour and mass such as Poussin achieved—these are the major effects of the art of painting, and they are altogether foreign to the homely efforts of Hogarth. Let us admit that he had natural talents of a high order—a lively line, a vigorous, at times a lyrical, brushstroke and a happy instinct for colour. But these gifts were not developed by that passion for the formal qualities of their art which characterizes all great painters. At a certain stage in his career Hogarth must have felt that he had enough for his purpose; but enough, in art, is a confession of defeat.

It may be suggested that these remarks apply only to the art of oil painting, and that Hogarth's chief claim to distinction lies in his engraving. But some of these deficiencies, as in composition, are carried over into the prints, and to match the others there is a certain coarseness in the engraved line which cannot be ignored, and which is obvious enough if we compare his work with that of the great masters of the art, Schongauer and Dürer, or with artists more of his character who worked in a similar technique, such as Goya and Daumier.

Apart from such formal criticism, there is a limitation to Hogarth's genius of a more serious kind, and Hazlitt has already defined it. 'There is a mighty world of sense, of custom, of everyday action, of accidents and objects coming home to us, and interesting because they do so; the gross, material, stirring, noisy world of common life and selfish passion, of which Hogarth was absolute lord and master: there is another mightier world, that which exists only in conception and in power, the universe of thought and sentiment, that surrounds and is raised above the ordinary world of reality, as the empyrean surrounds the nether

globe, into which few are privileged to soar with mighty wings outspread, and in which, as power is given them to embody their aspiring fancies, to "give to airy nothing a local habitation and a name," to fill with imaginary shapes of beauty or sublimity, and make the dark abyss pregnant . . . this is the ideal in art, in poetry, and in painting.' Of that ideal Hogarth was not capable; it was not for him to paint 'faces imbued with unalterable sentiment, and figures, that stand in the eternal silence of thought.' Not to put too fine a point on the distinction, we may affirm that Hogarth had neither the sensibility nor the imagination of a great painter.

Hogarth himself was unwilling to admit his limitations. Throughout his life he 'entertained some hopes of succeeding in what the puffers in books call *the great style of history painting.*' The very words in which he refers to his ambition betray the self-satisfied impudence with which he approached that task; and some of the paintings themselves unfortunately survive to bear witness to his ignominious failure.

And yet, when all is said and done, Hogarth lives! We have, we may feel, reduced to naught his claim to be taken seriously as a painter, and yet, as a genius of some kind, he survives. 'Other pictures we see, Hogarth's we read.' There is some truth in that statement which escapes the narrow categories of criticism. We are faced with a dilemma which Hazlitt stated but did not solve in uttering this sentiment: 'I do not know whether, if the port-folio were opened, I would not as soon look over the prints of Hogarth as those of Raphael; but, assuredly, if the question were put to me, I would sooner never have seen the prints of Hogarth than never have seen those of Raphael.' It is not sufficient to say that it is merely the literary interest which holds us. It is no longer the case of an art

> *Whose pictur'd Morals charm the Mind,*
> *And through the Eye correct the Heart.*

It is one of my strongest convictions that no work of art survives its age which is not justified by some strength of form or grace of execution—that possessing these, even a dictionary may survive. So when we have discounted all that is false in Hogarth's reputa-

tion, when we have waited for the echoes of his contemporary fame to die away in our minds, and then look at his paintings dispassionately, we have to admit that somewhere under the dead skin of varnish there always throbs the life which on a few rare occasions, and supremely in *The Shrimp Girl*, blazed forth in sensuous splendour.

INDEX

(The entries in *italics* refer to the Plates)

INDEX

INDEX